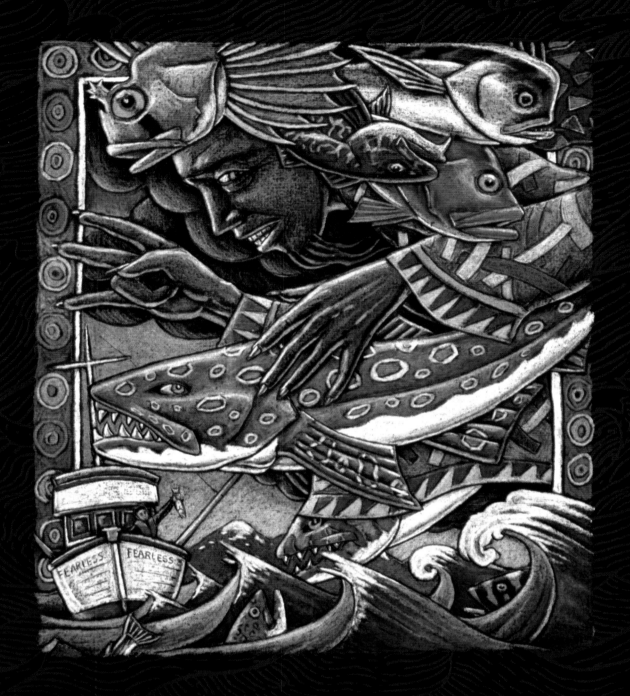

THE FIN ART OF
RAY TROLL

Art by
Ray Troll

Book Design by
Robbie Robbins

Additional Digital Colorists
Grace Freeman, Memo Juargeui, Karen Lybrand, and Terry Pyles

Clover Press offices: 8820 Kenamar Dr. #501, San Diego, Ca. 92121

ISBN: 978-1-951038-98-4

FIRST PRINTING NOVEMBER 2023

4 3 2 1 23 24 25 26

PRINTED IN CHINA

Clover Press:
Matt Ruzicka, President
Robbie Robbins, Vice President/Art Director
Hank Kanalz, Publisher
Ted Adams, Factotum
Mike Ford, Shipping Manager

Clover Press Founders:
Ted Adams, Elaine LaRosa, Nate Murray, Robbie Robbins

www.CloverPress.us

www.TrollArt.com

For Michelle,
My far better half and my rock in the stream of life.
None of this would have happened without you.

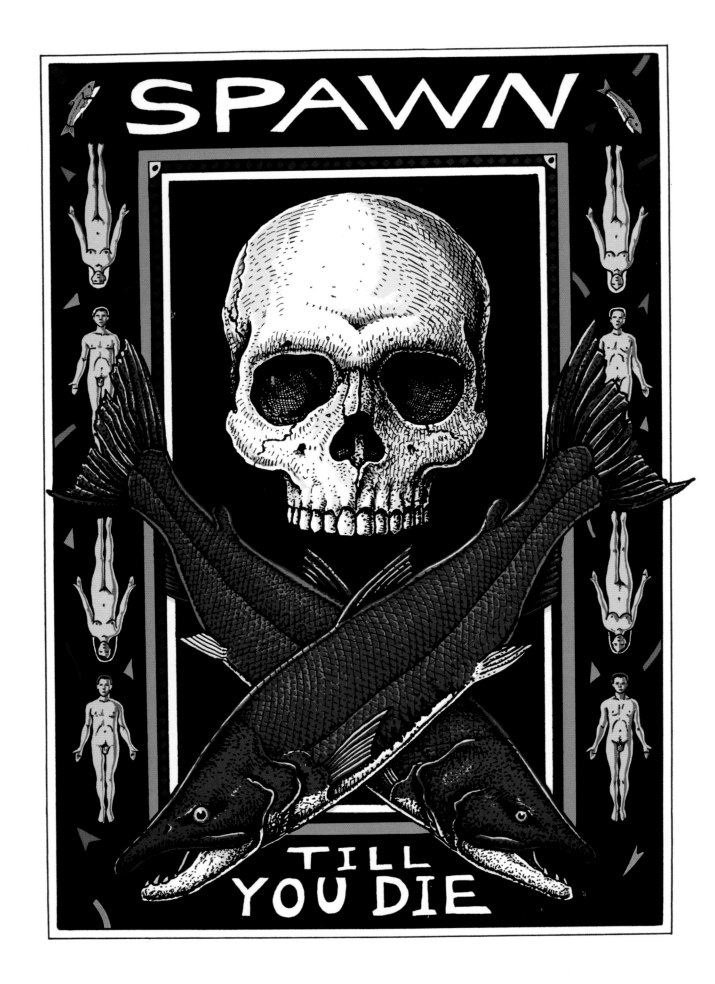

Lessons Learned from Our Troll

emelparous is the technical description of an organism that reproduces exactly once in a lifetime. To bring this vocabulary to life in my college classroom, I project a photo of my favorite T-shirt of all time—Ray Troll's *Spawn Till You Die*. Ray plays with skull and crossbones iconography by replacing the long bones (i.e., humeri) with beautiful salmon. Salmon, of course, are triumphs of perseverance, using all the energy collected in their ocean lives to run a river to the very place their parents spawned years before. Using the last energy of their lives, females and males court and cast their eggs and sperm into the world. Following fertilization, youngsters are on their own and must navigate the world through instincts honed by millions of years of natural selection.

The students love that the border of *Spawn Till You Die* includes eight tiny naked men and women with a bit more genital detail than you would find in a pairing of Barbie and Ken dolls. Details matter a lot to Ray, so those in the know appreciate the presence of a tiny fin on the back of the salmon called the adipose fin. This means the fish is wild. In human-run fish hatcheries, that fin is clipped off. The last lesson in this T-shirt is to contrast the evolutionary mating strategy of those naked people to the fish. If we are lucky, we get to mate many times and not die and do it for decades—the technical term for that strategy is iteroparity. There is always so much to learn in a Ray Troll artwork, and you often get to laugh and wonder.

Details matter a lot to scientists. Ray is an artist with an extraordinary collection of scientists who have sought his creativity to help them communicate with each other and the general public. Ray is generally curious, but he is obsessed with any living thing with fins or all the dead things that are now fossils. In one case, his obsession with a fossil shark directly contributed to advancing research… and making a movie documentary! Details also matter to people branding the spirit of a region. Alaska and the Pacific Northwest have been marketed by Ray Troll for 40 years with the love of someone who knows what's what when it comes to good coffee or beer, how to clean fish, the poetry of rainfall, and the biodiversity of ecosystems defined by the Pacific Ocean. This book is for all of us (many of us nerds) obsessed with Ray Troll's intelligent creativity, beautiful attention to nature, and weirdness.

This book is also for those readers of contemporary art magazines that celebrate lowbrow art and pop surrealism (e.g., *Hi-Fructose* and *Juxtapoz*). Ray's work is not urban, so enjoy it like a field trip into the wild. Ray's work matches Josh Keyes for details that matter, the compositional design of Robert Xavier Burden, and the comix energy and subversive edge of Robert Crumb. There is also the humor and wit of Gary Larson's *Far Side* cartoons. In Ray's artwork, you will connect to the cult artist whose work decorates the walls of every science building and natural history museum. By exploring his intriguing work, you can join the subculture of folks who appreciate Ray Troll's unique take on nature, deep time, and smart-ass humor.

David P. Craig
Willamette University, Salem, Oregon

hen *Spawn Till You Die* arrived on Earth in the fall of 1986, Ray was living in a small studio apartment on a clear flowing stream in Alaska. He still lives a stone's throw from it. Every autumn, Ketchikan Creek swarms with salmon surrendering their eggs and milt to create another generation and then dying in tatters to complete their mortal mission. Ray had been drawn to Alaska by youthful wandering from his earlier life in Kansas to art school in Washington State, where his teachers and influencers celebrated a sense of place in their work with the plain speaking of the American West in their artistic expression. What he saw in that cold Alaskan creek when the salmon returned and rotted on its banks delivered an unavoidable, beautiful truth: live and love now because you will certainly die.

It is not in the nature of an artist to enjoy his work becoming "iconic." The term implies something too final about the creative process, especially when a drawing, painting, or sculpture emerges early in his life and work. Among the seductions of art is its power to transform an artist, so a particular piece anchoring him to the past can inhibit that from happening. Ray Troll's *Spawn Till You Die*, though, has the power and genesis of something so inevitable it seems to have existed even before his artistic impulse brought it to life. He was simply the medium for its expression.

Ray's earliest iteration of such fish worship and wisdom was a silk-screened T-shirt depicting a school of wild-eyed, toothy salmon with the caption *Let's Spawn*. In a town of commercial fishermen, loggers, adventurous young men and women of every stripe, and lots of bars, the shirt sold out in days. One morning, as Ray's connection to fish was beginning to gain momentum in his artistic vision, he was again watching salmon churn their way up the creek when a thunderbolt of inspiration hit him. "Salmon. Humans. We're all doing the same thing as we make our ways from birth to death. Birth. Sex. Death." Back in the studio, he sketched the first version of *Spawn Till You Die*, a horizontal pastel with a pair of spawning salmon and human skulls and bones. He knew right away that he had hit upon another primitive message that would resonate with lots of people. And it was slyly funny, already an essential element of his artistic vision. After a few more revisions, a fellow Alaskan artist and cloisonné jewelry creator, Bill Spear, thought *Spawn Till You Die* would make a great pin. Maybe Ray could redraw it as a kind of Jolly Roger so it would fit better into the much smaller format. Soon, that revised version appeared as a best-selling pin, as a poster in black and white and color, and to the delight of all who want to shout out its sage, wry, and powerful message, as a T-shirt.

For more than three decades, *Spawn Till You Die* has been part of thousands of wardrobes and appeared in movies and on rock and roll stages, worn by superstar performers and their audiences. Ray doesn't mind at all that people call it iconic. These days, as he navigates through his later innings, he calls it his Tombstone Drawing.

Brad Matsen
Port Townsend, Washington 2023

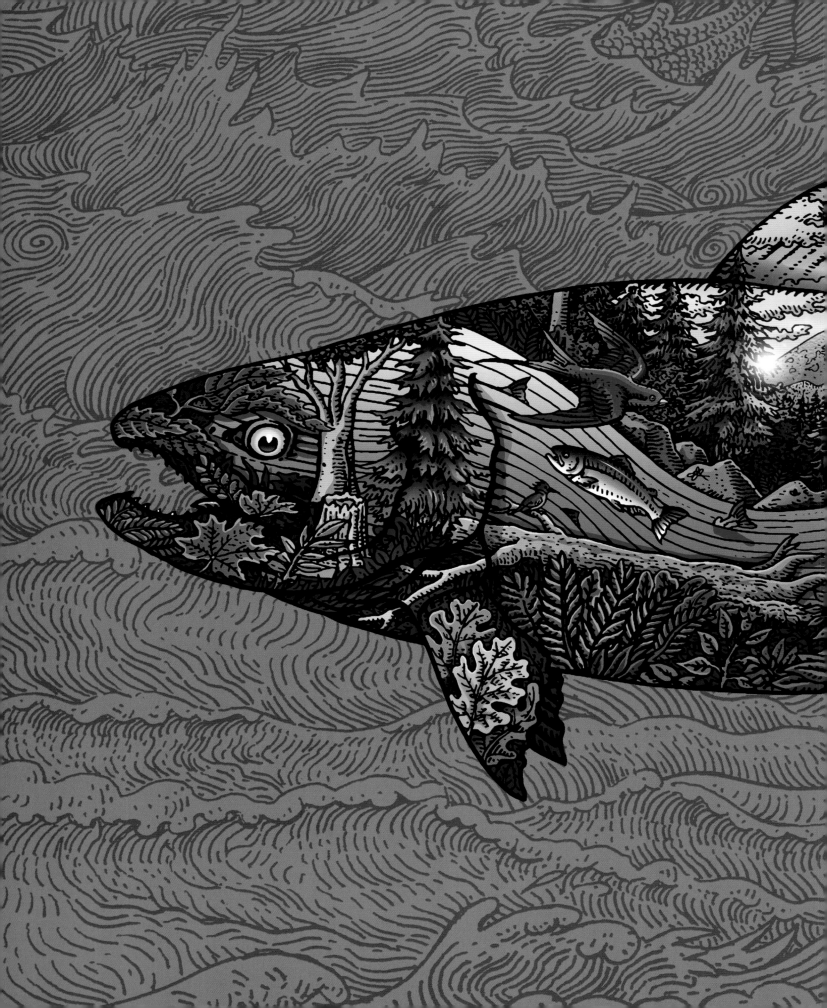

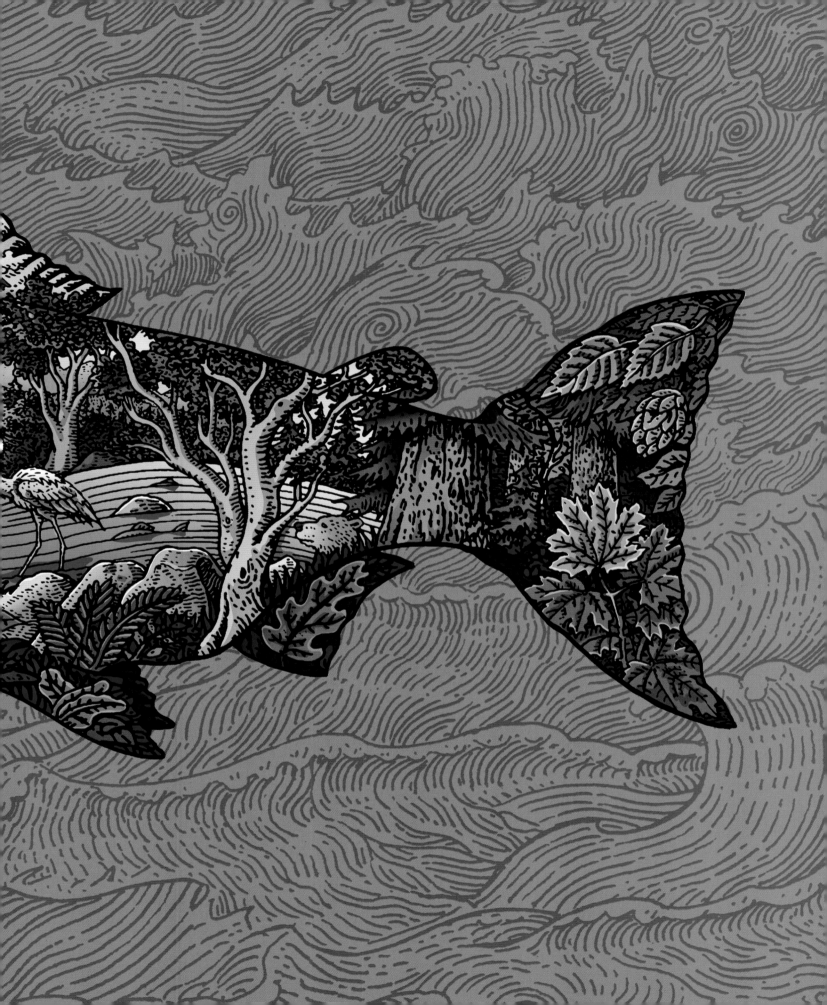

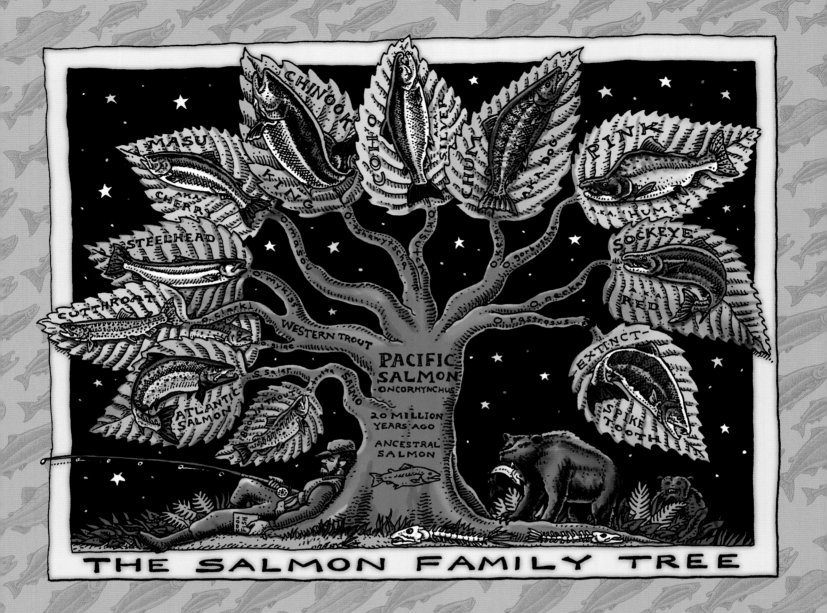

THE SALMON FAMILY TREE

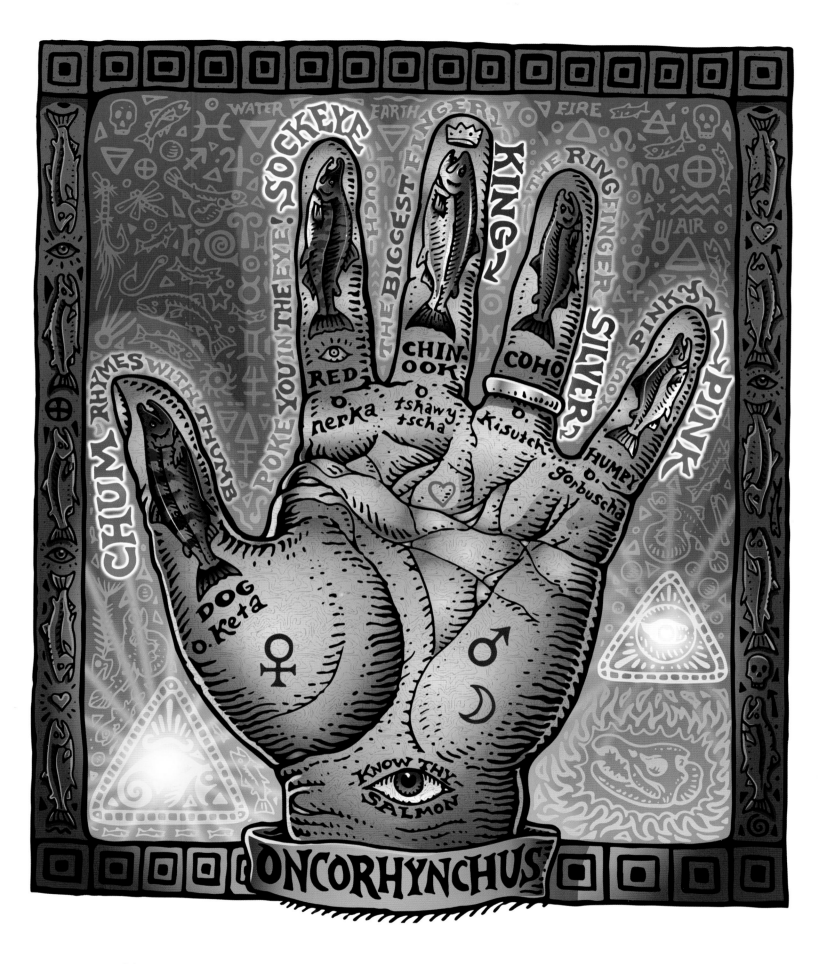

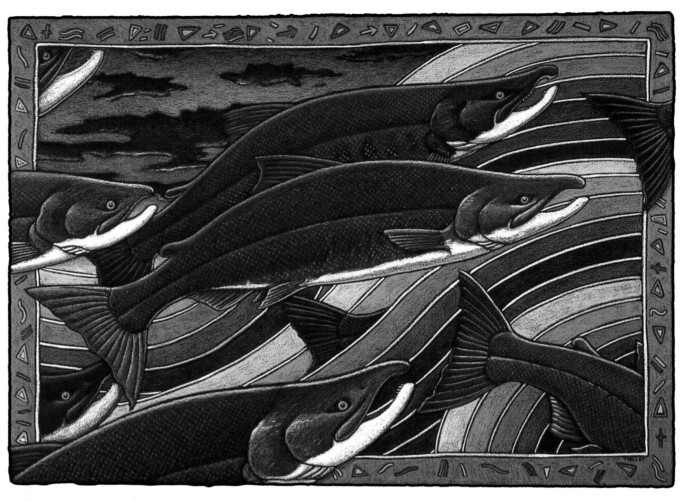

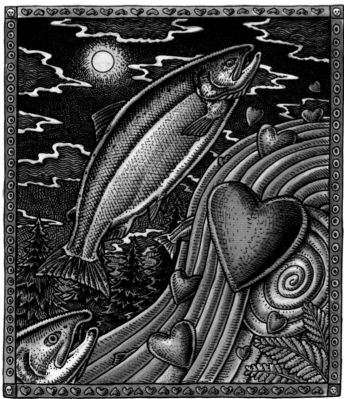

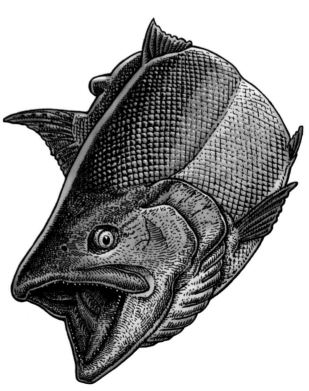

CLOCKWISE FROM TOP: Sockeye Sunset, Leaping King, Salmon: The Fish That Dies for Love

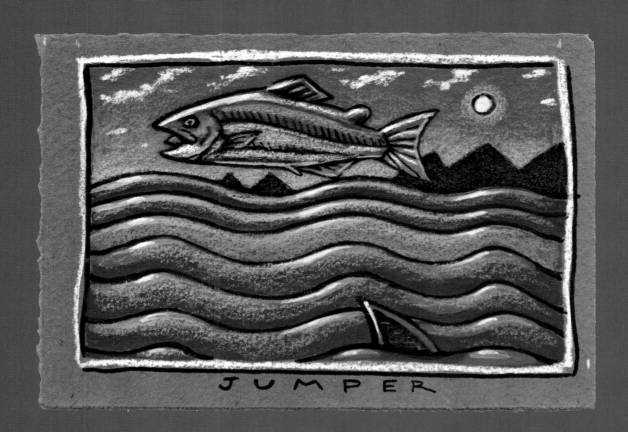

JUMPER

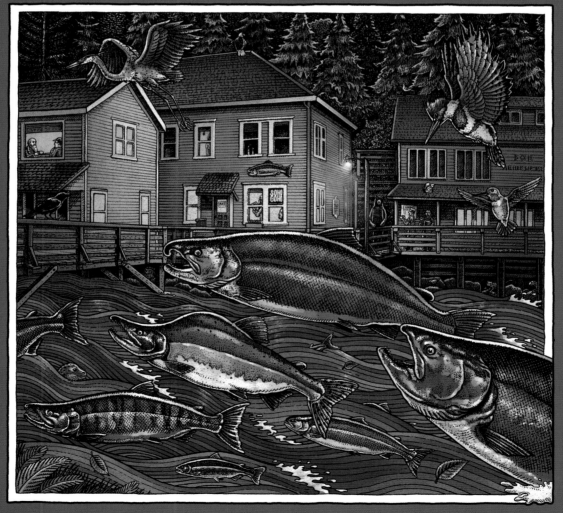

BOTTOM: Creek Street Wildlife

13

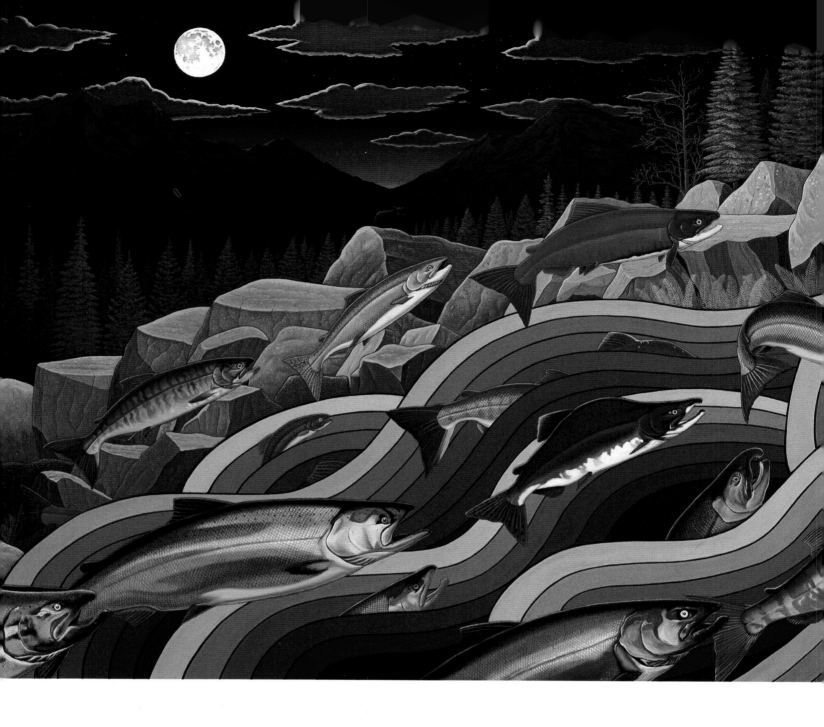

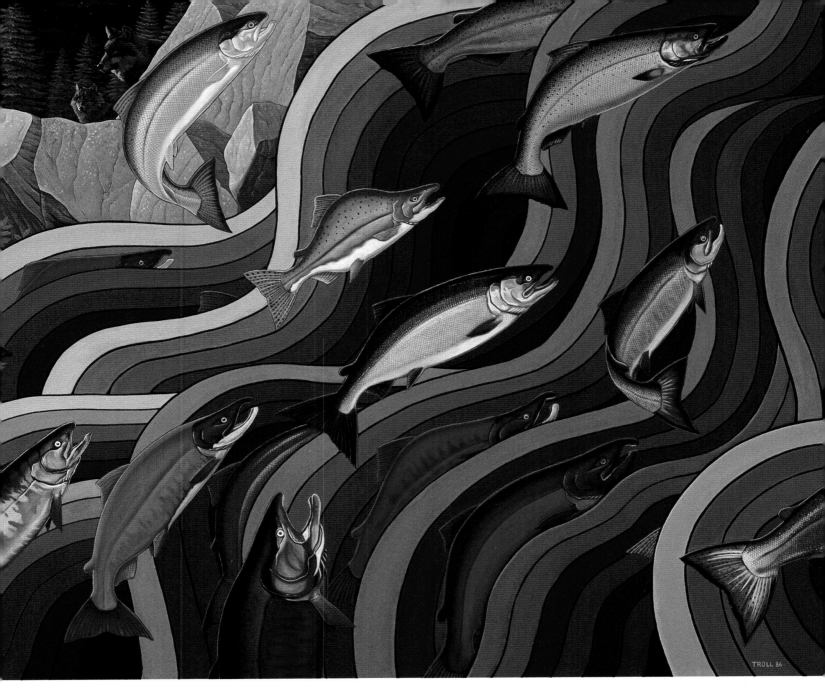

Midnight Run

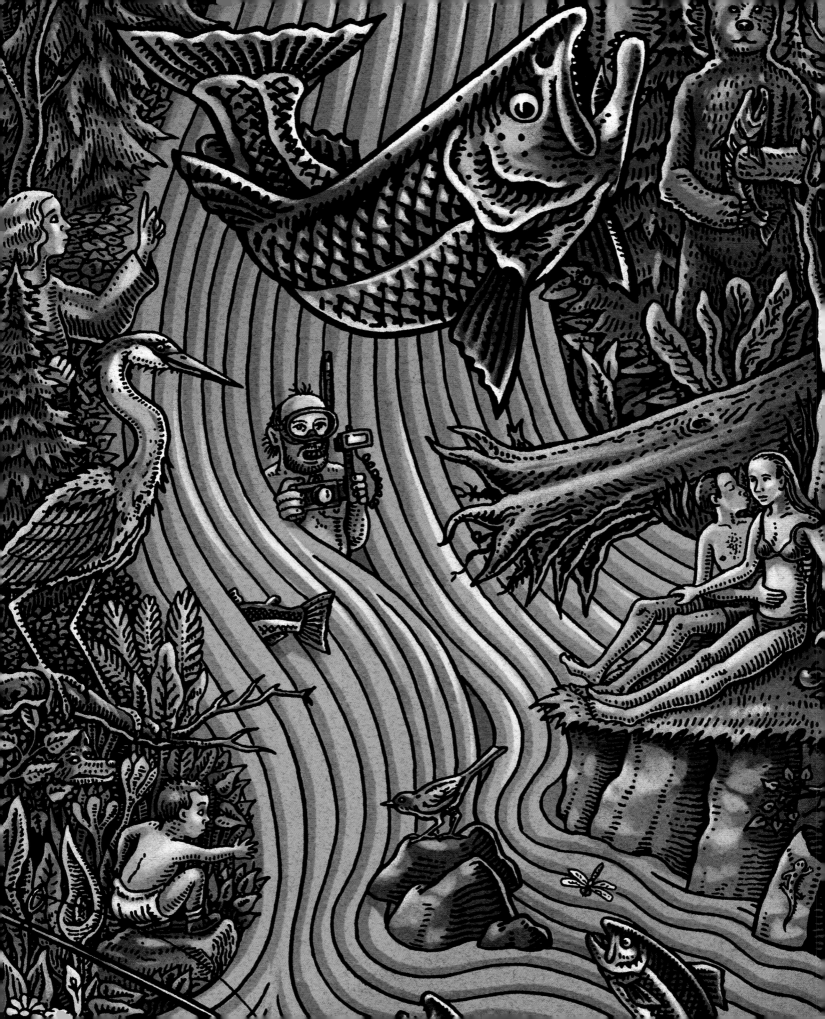

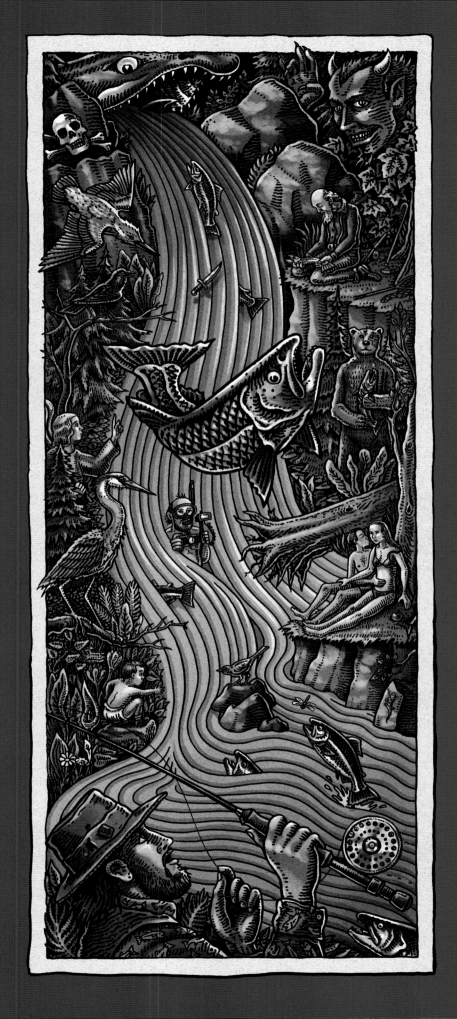

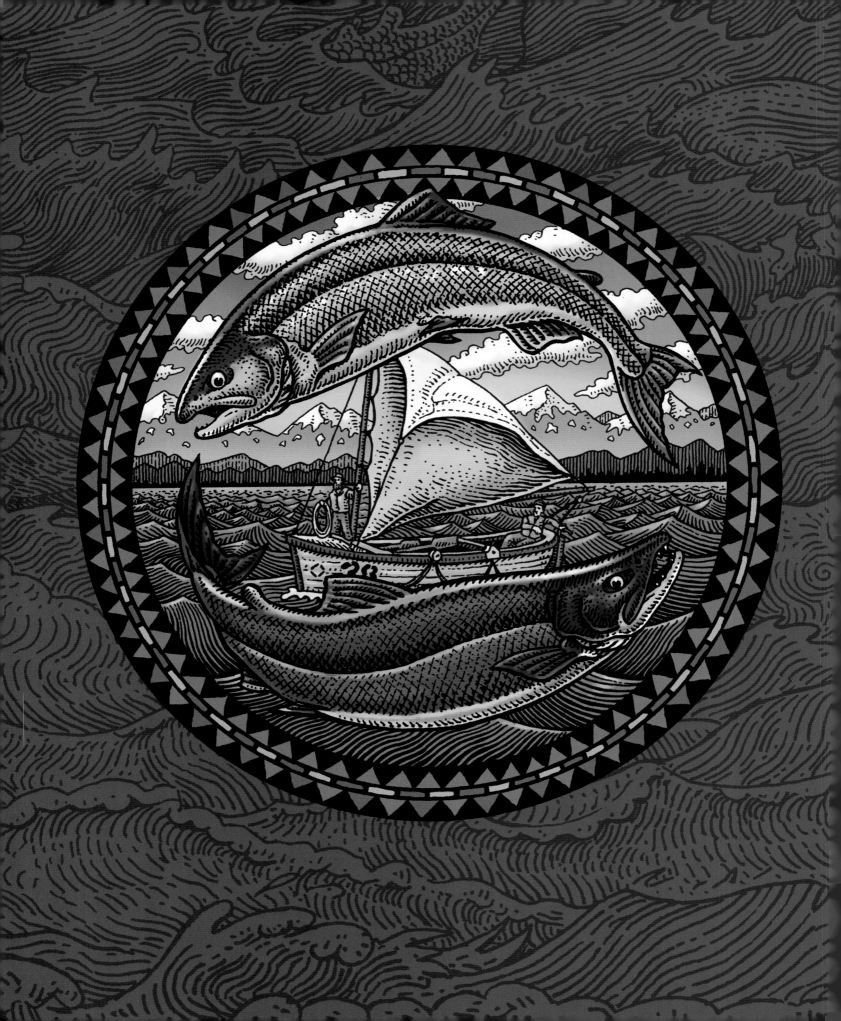

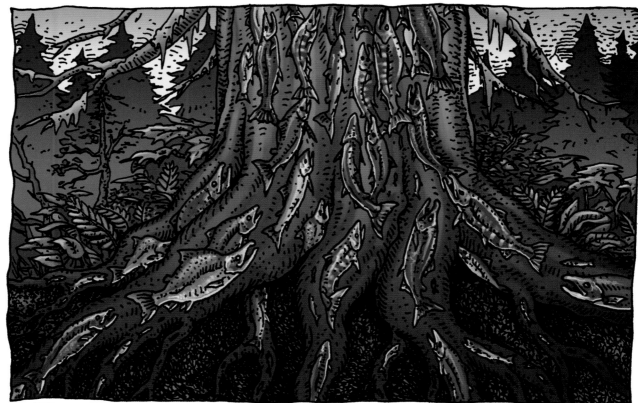

DEEP ROOTS

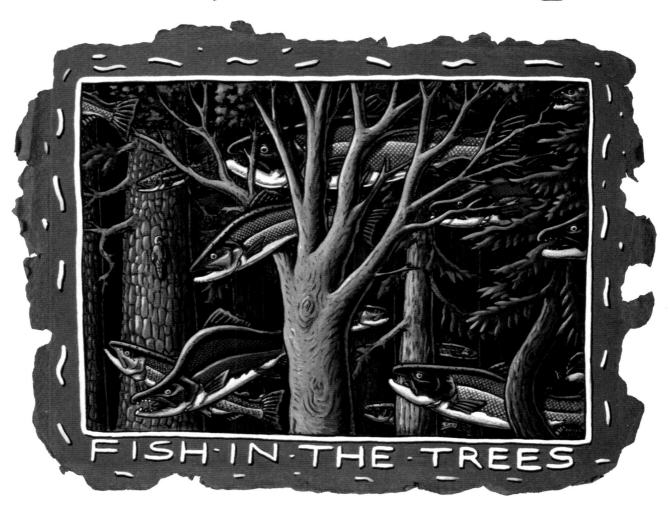

FISH·IN·THE·TREES

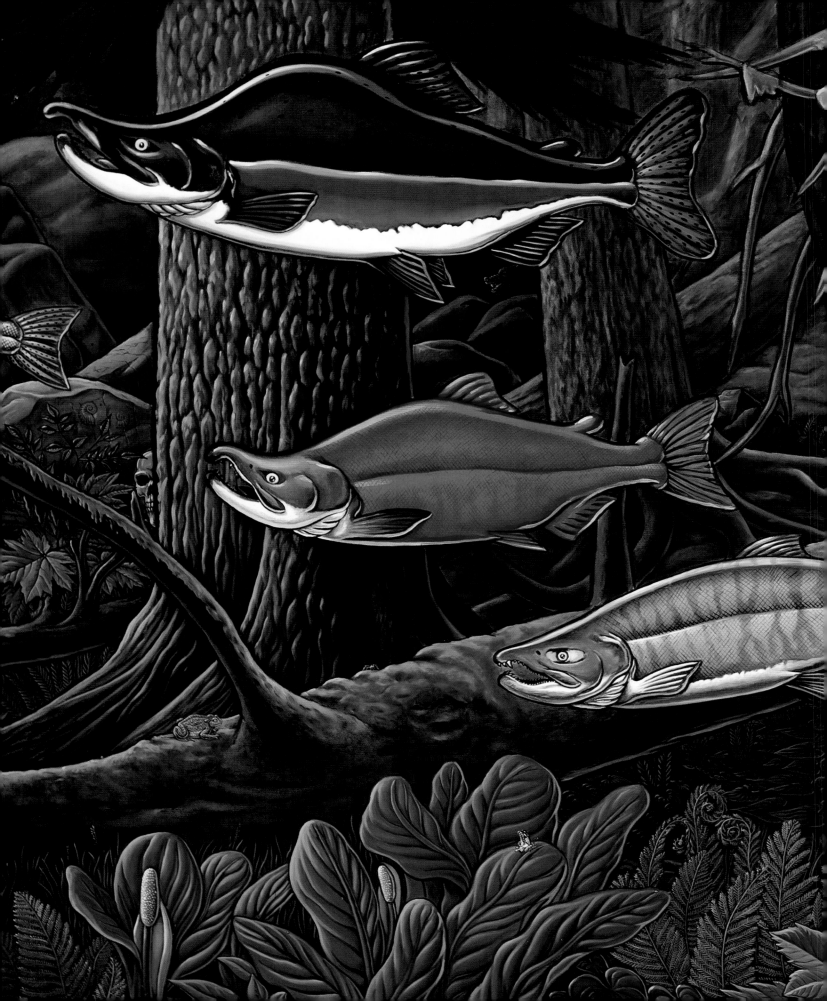

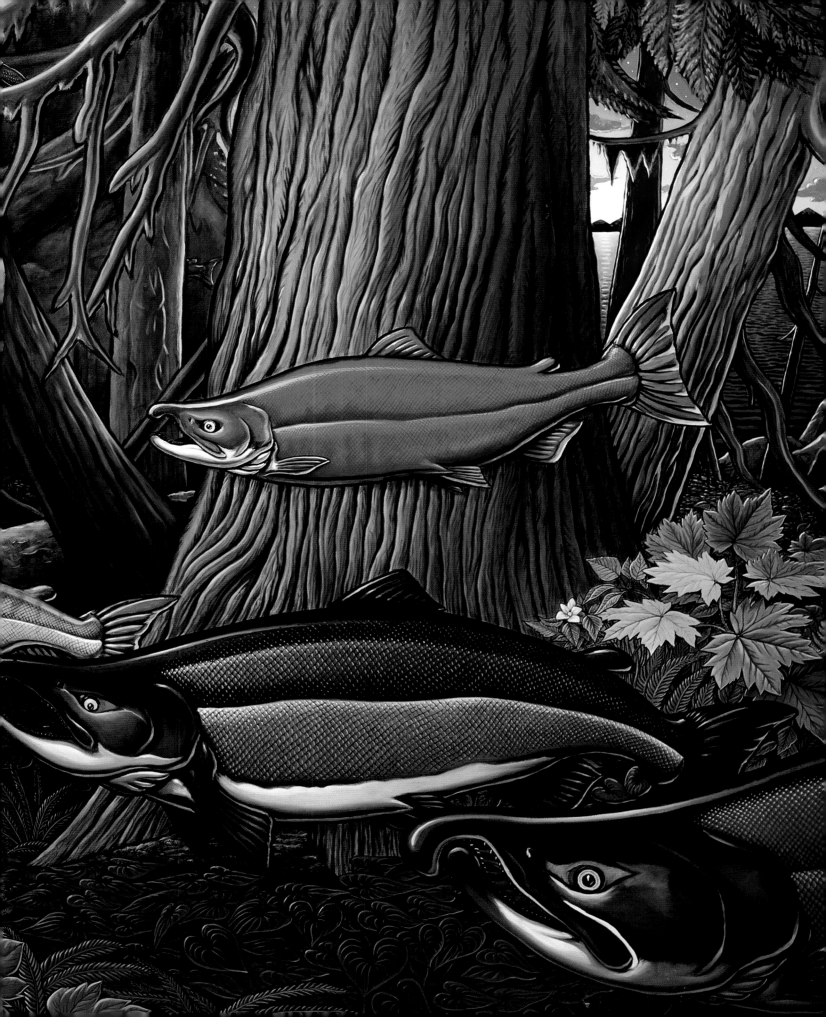

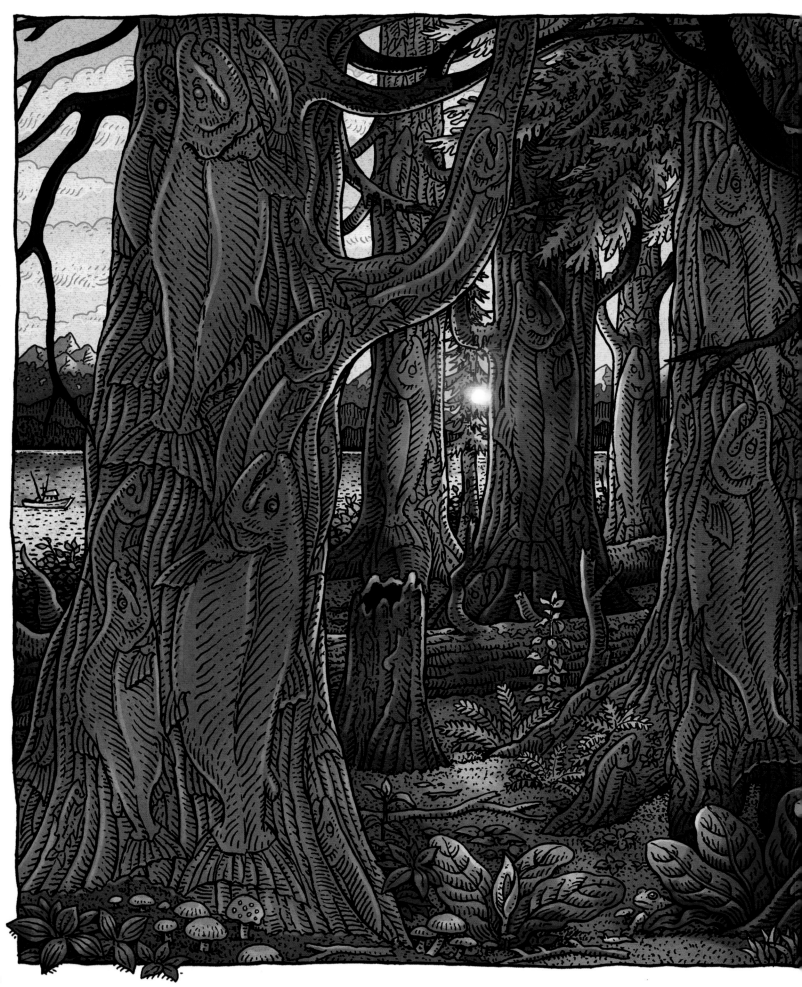

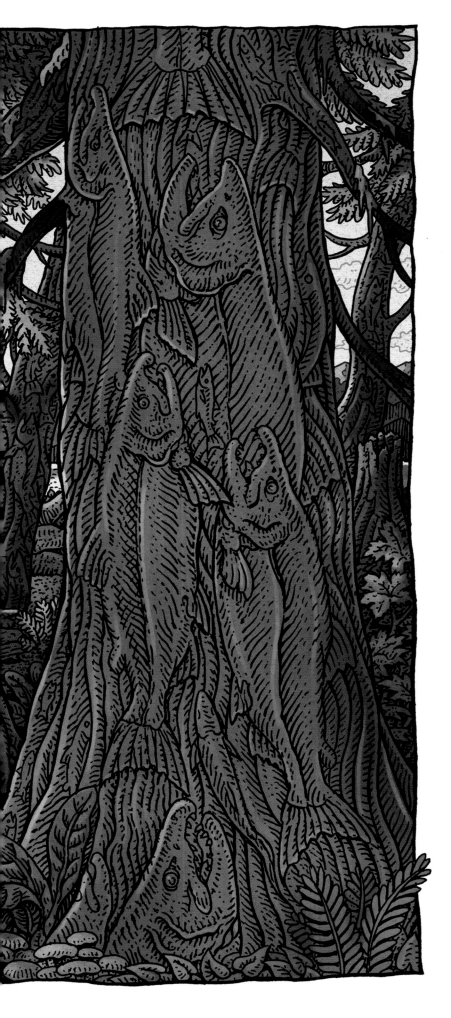

Salmon Forest

IT'S THEIR WATER TOO

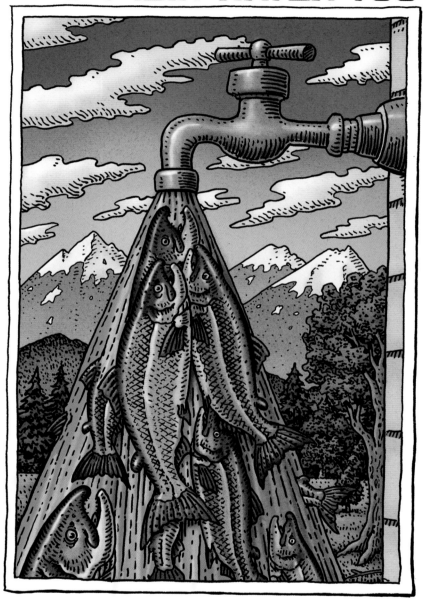

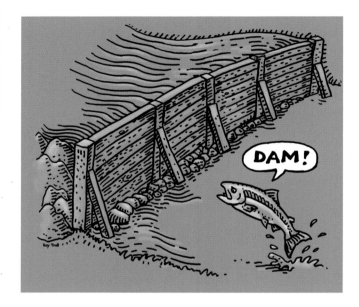

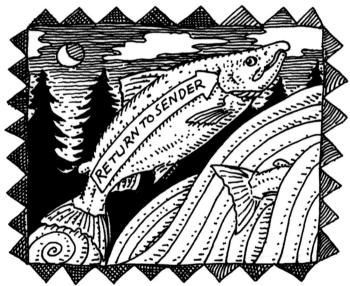

SALMON TO WATCH OVER ME

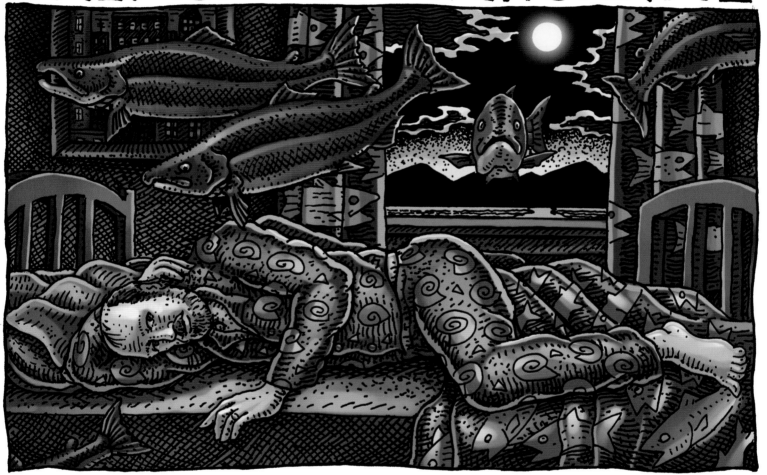

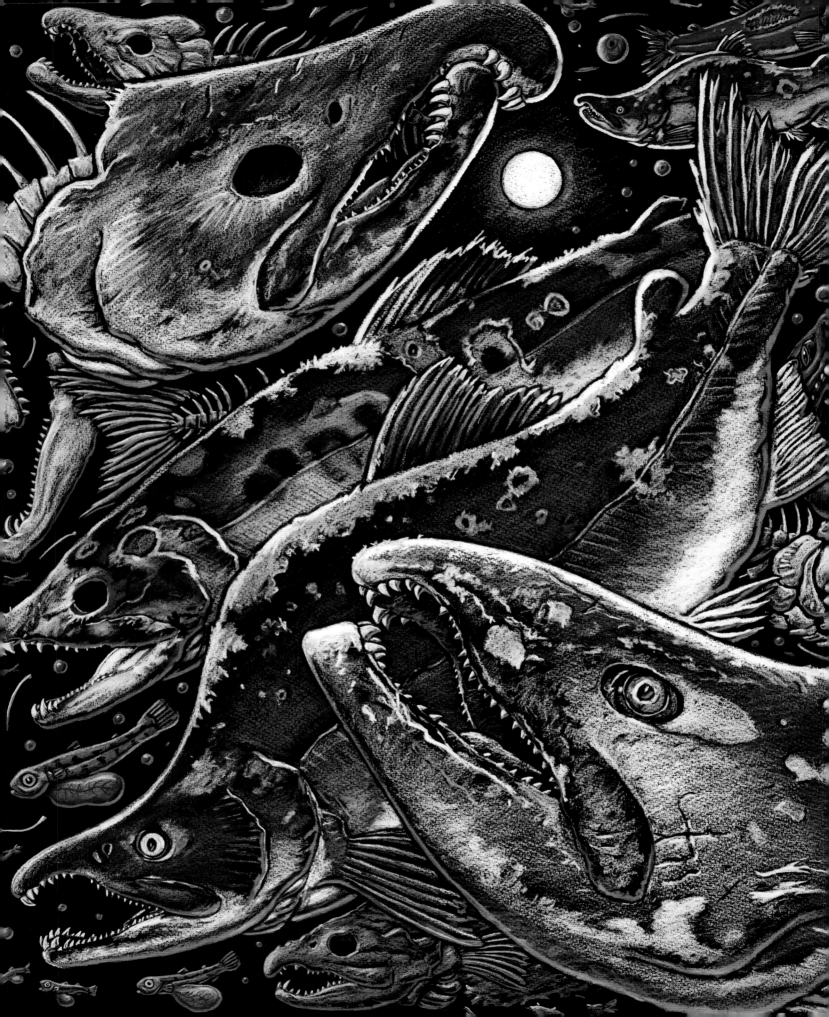

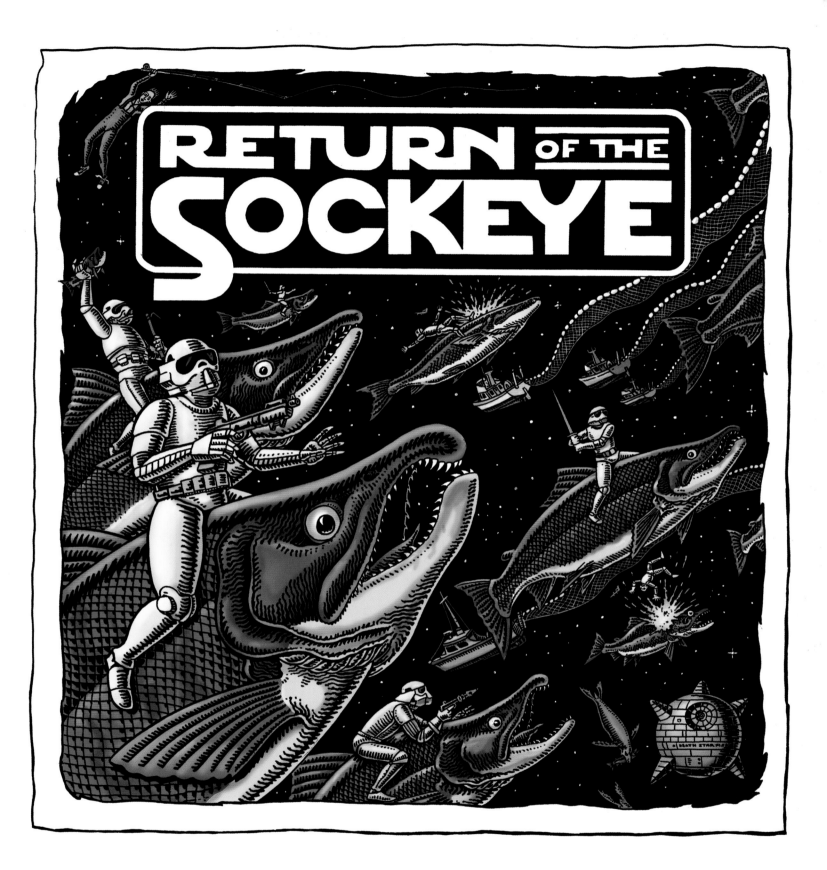

OPPOSITE PAGE: Spawn of the Dead

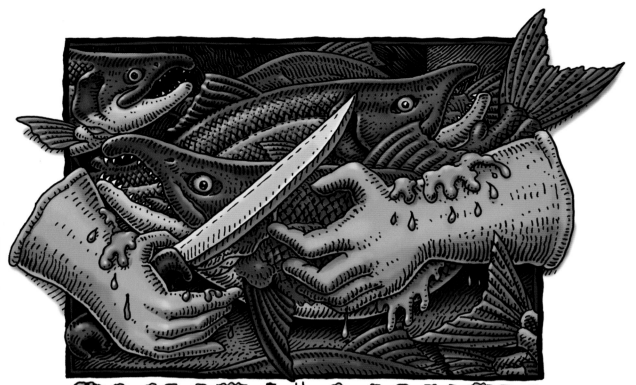

SLIME I$ MONEY

SOCKEYE KILLER

QU'EST-CE QUE C'EST?

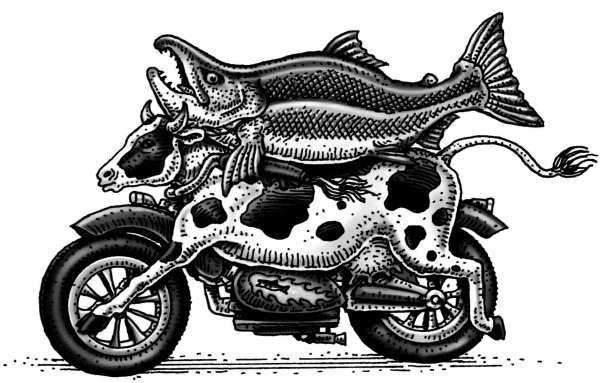

COWASOCKEYE

PULP FISHIN'

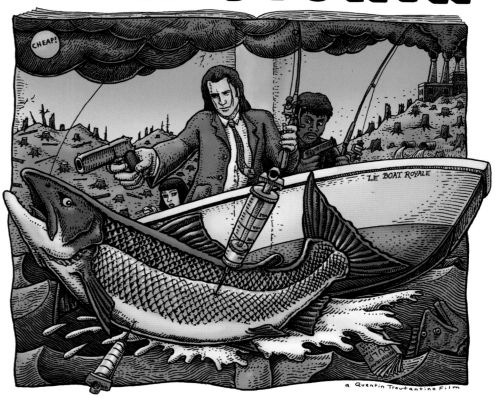

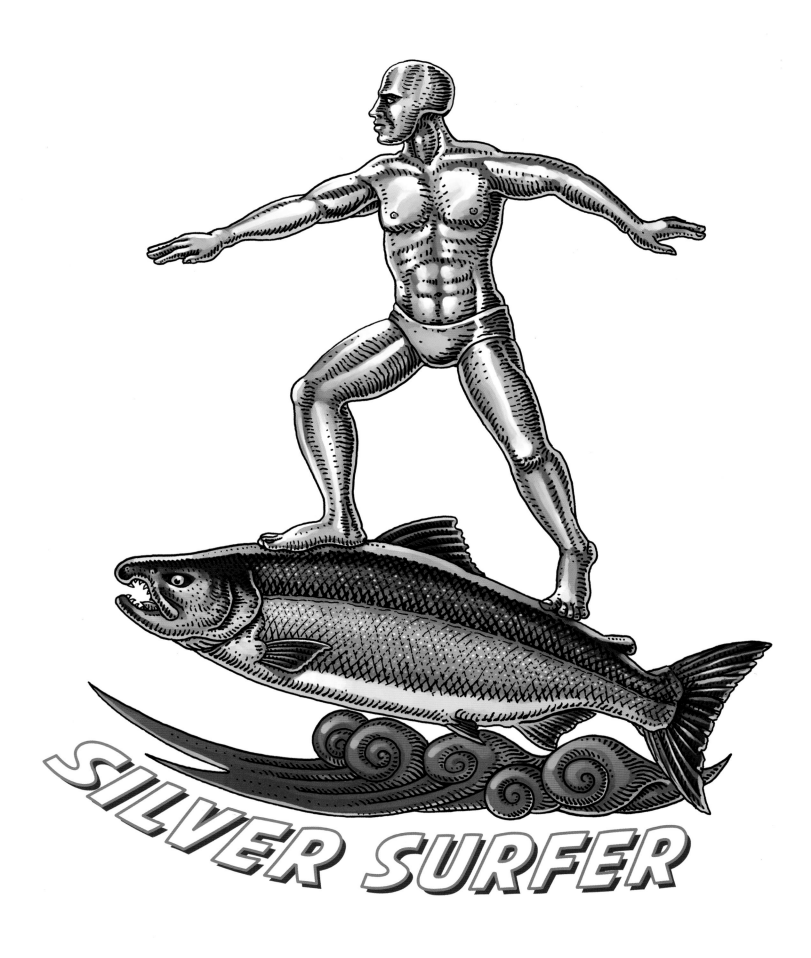

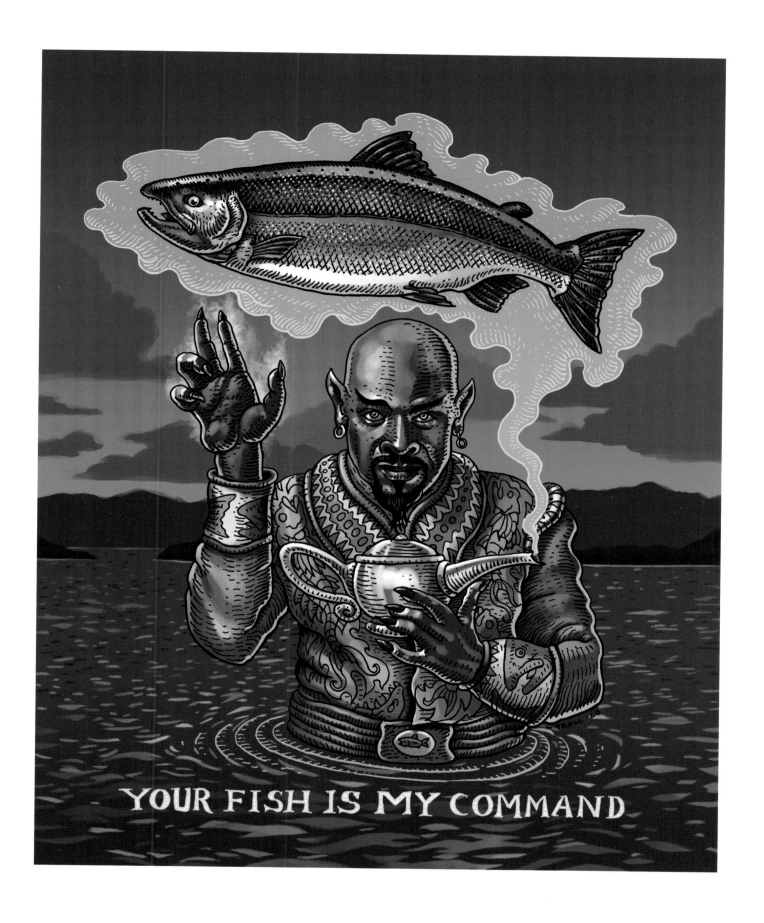

YOUR FISH IS MY COMMAND

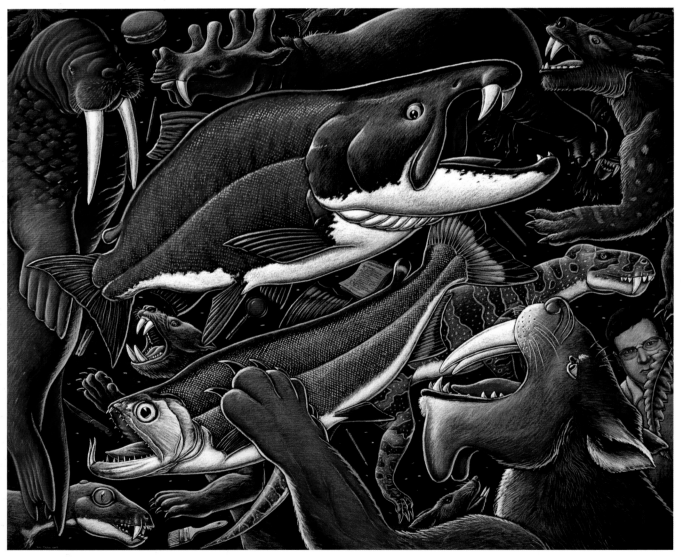

TOP: Spike Tooth Salmon and Angler　　　*BOTTOM:* Saber Toothed Everything

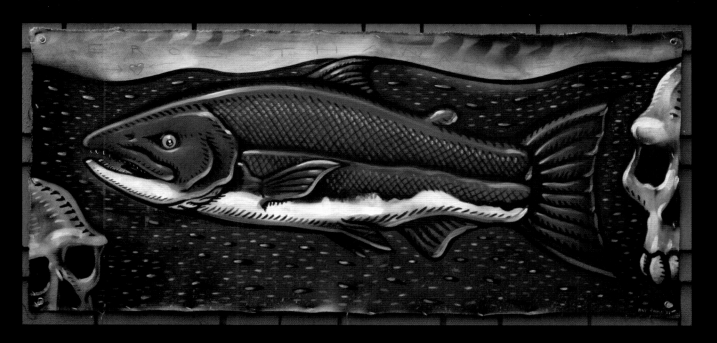

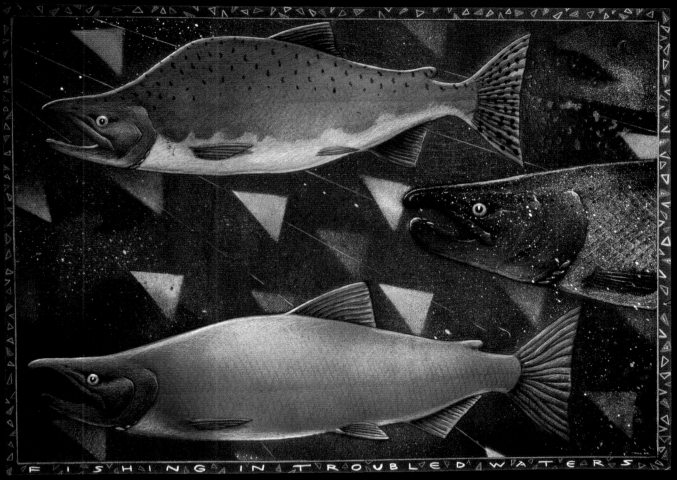

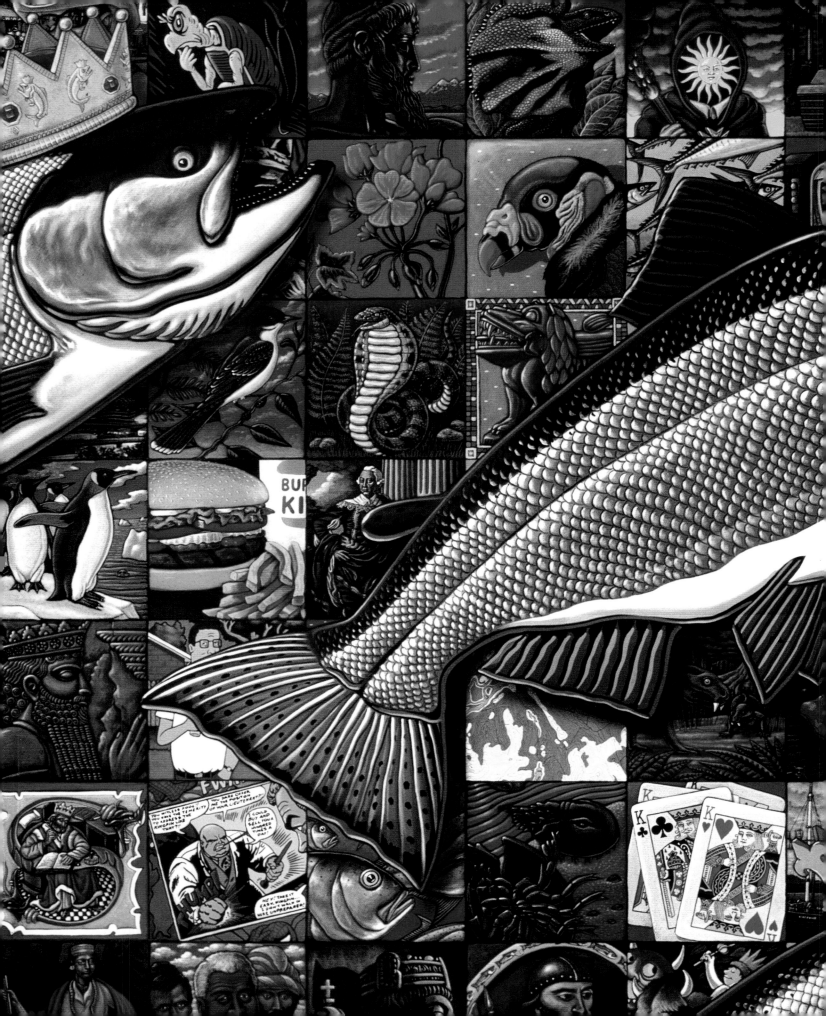

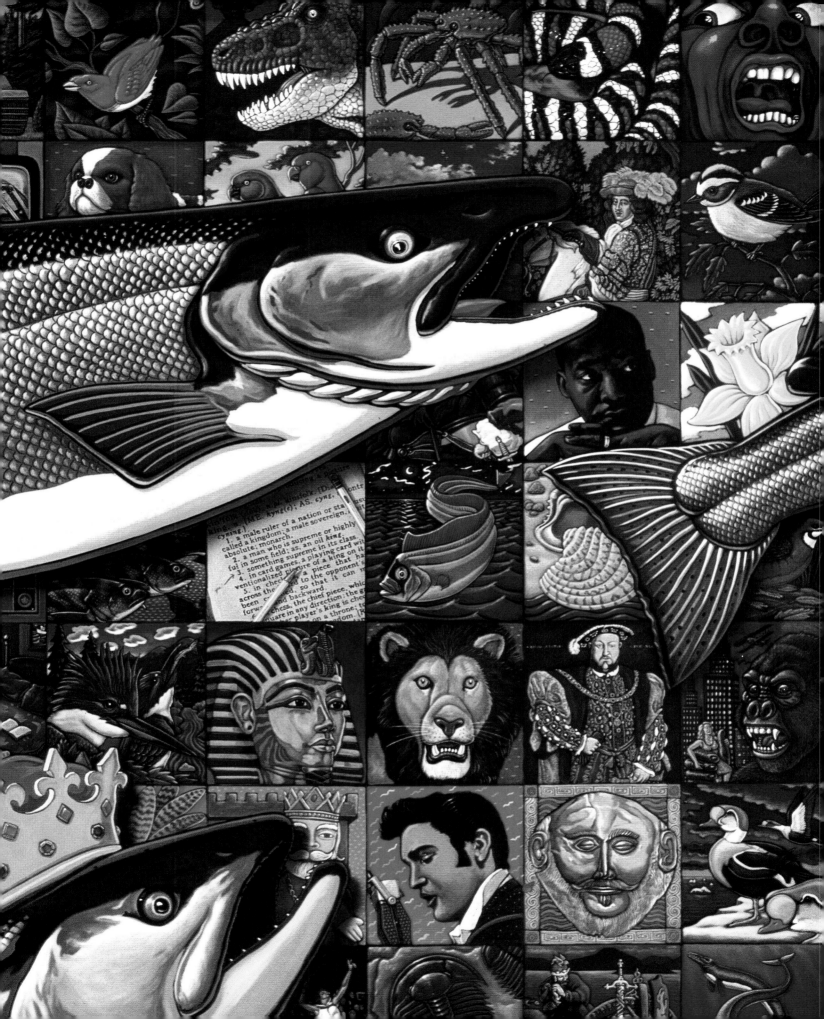

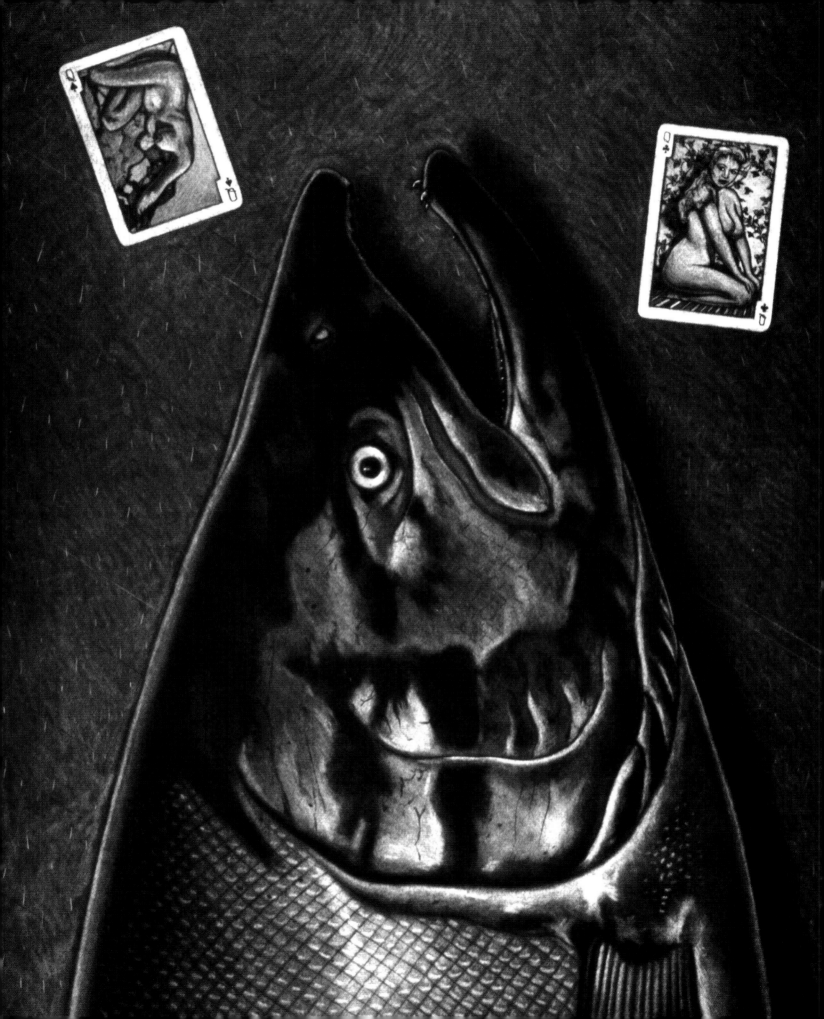

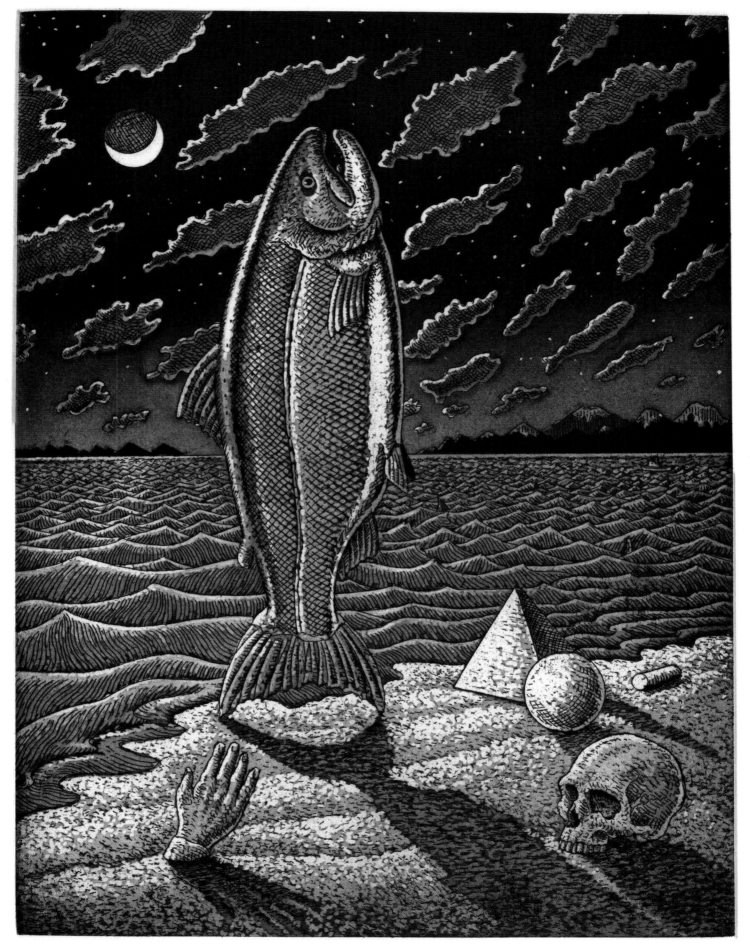

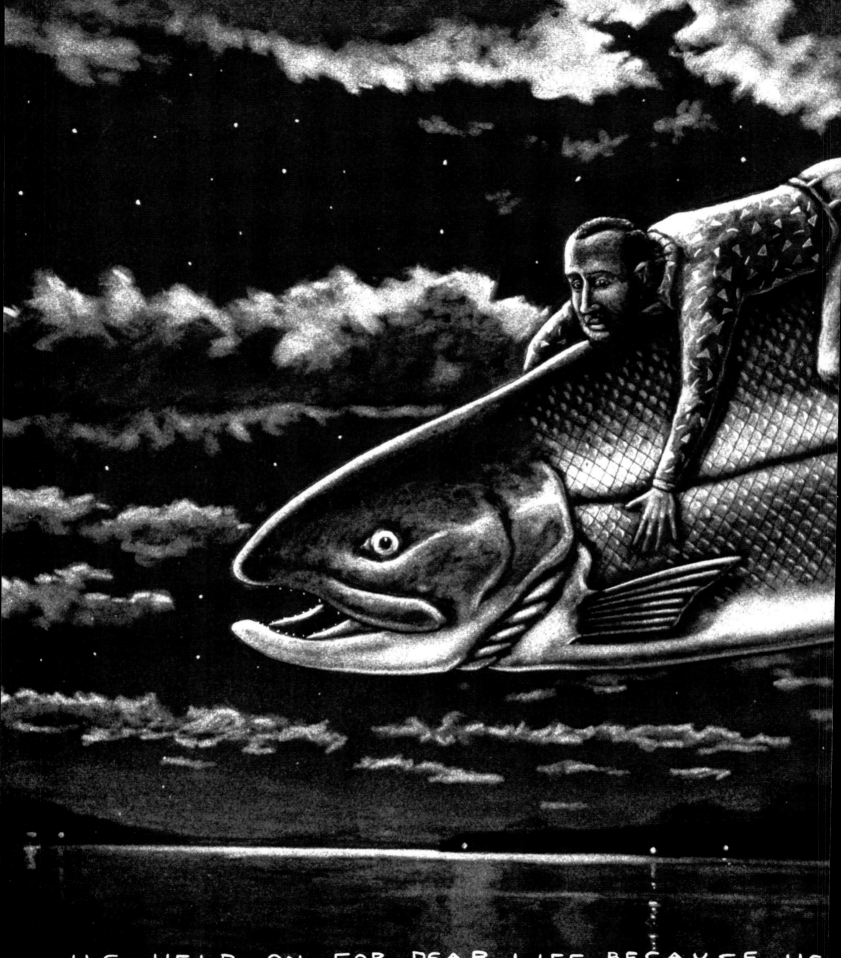

HE HELD ON FOR DEAR LIFE BECAUSE HE

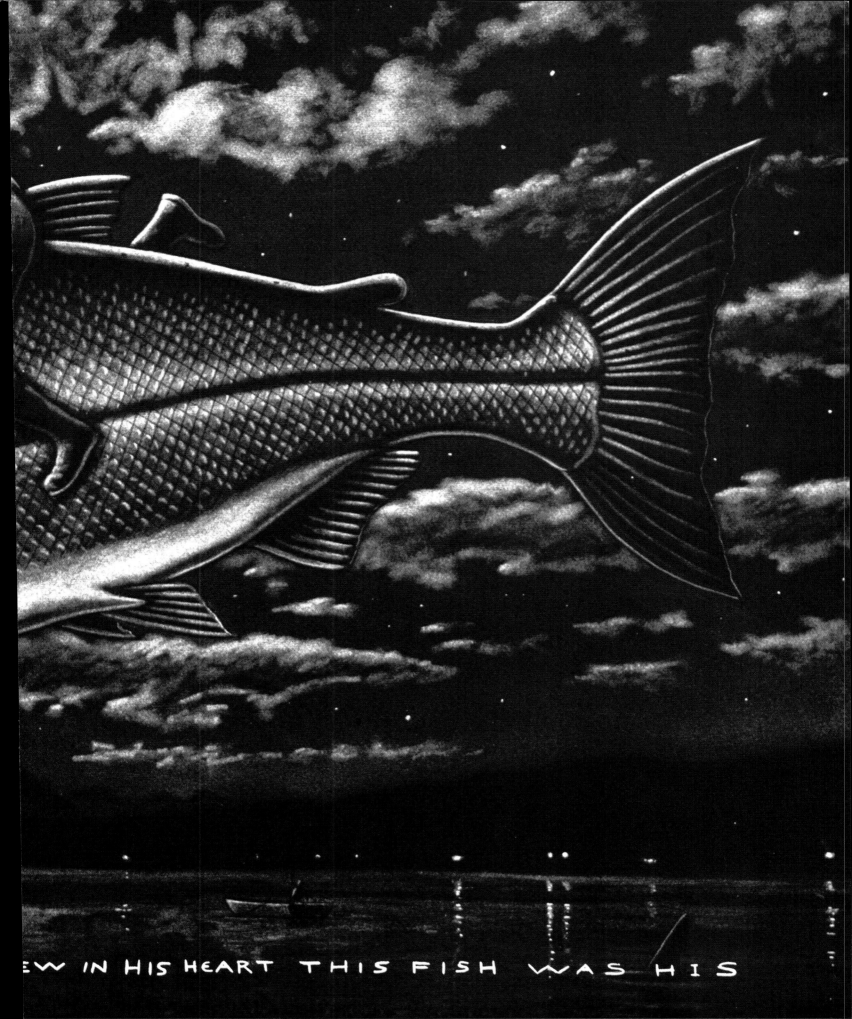

EW IN HIS HEART THIS FISH WAS HIS

SALVADOR

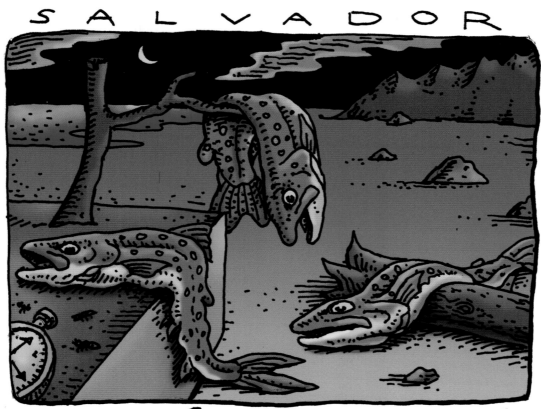

DALÍ VARDEN

FISH RITE R.T.

HOOK LINE &

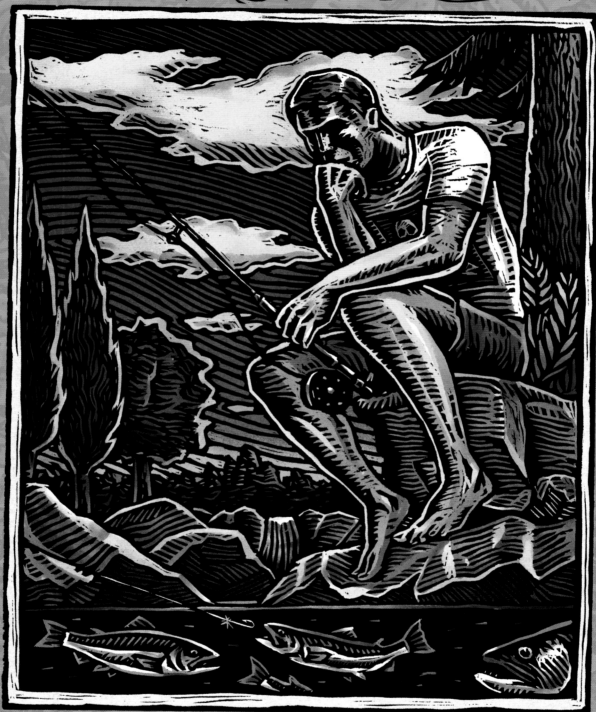

THINKER

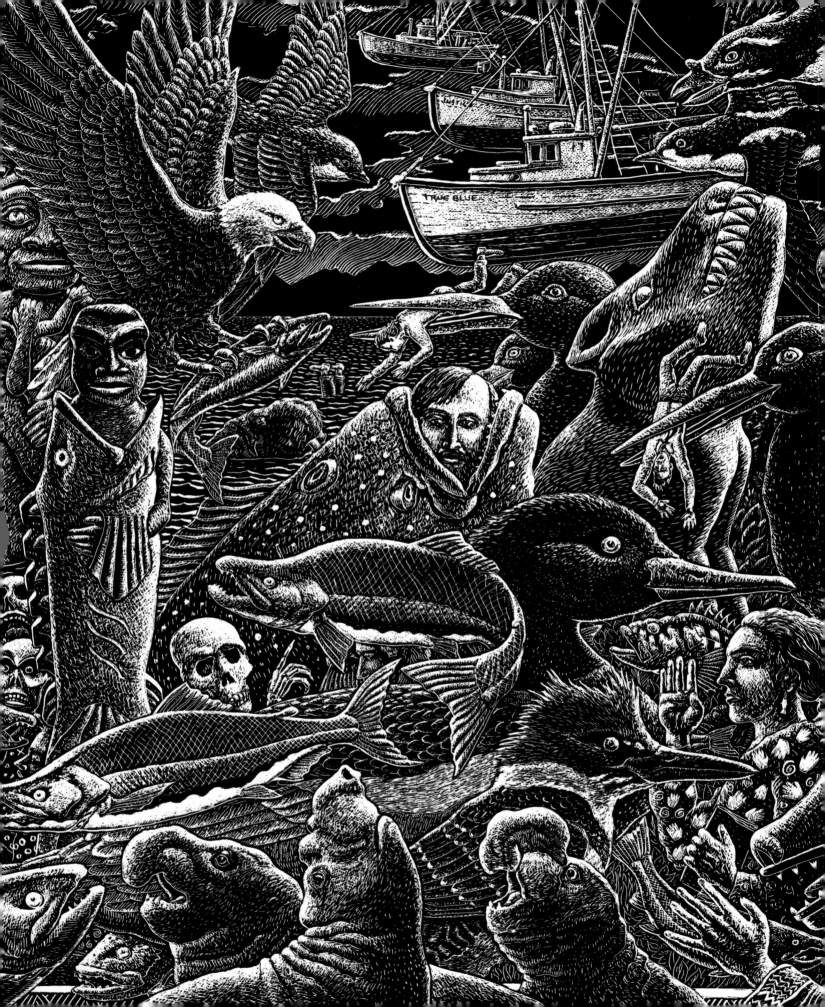

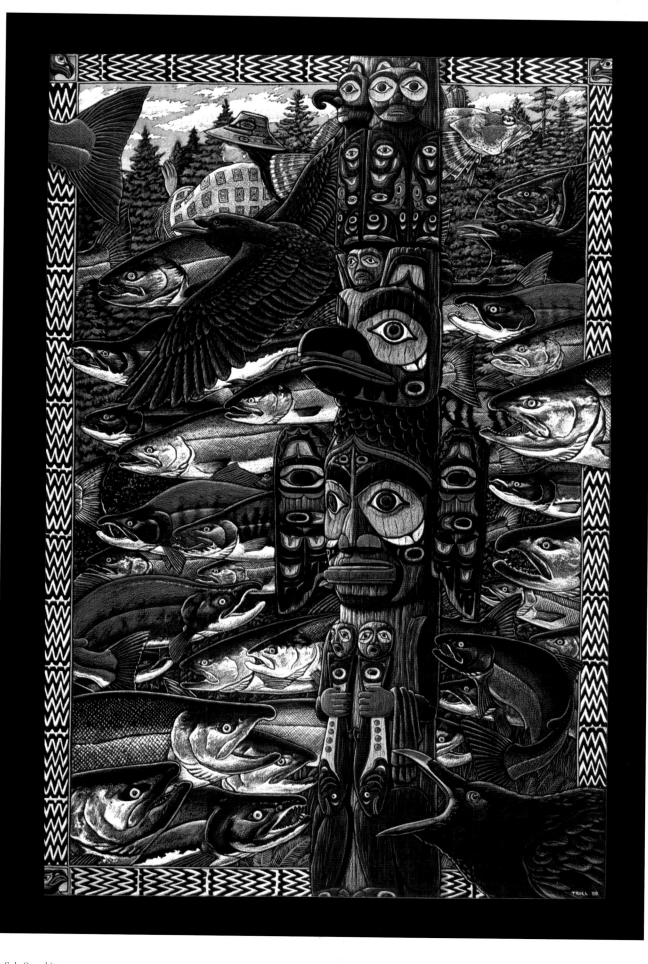

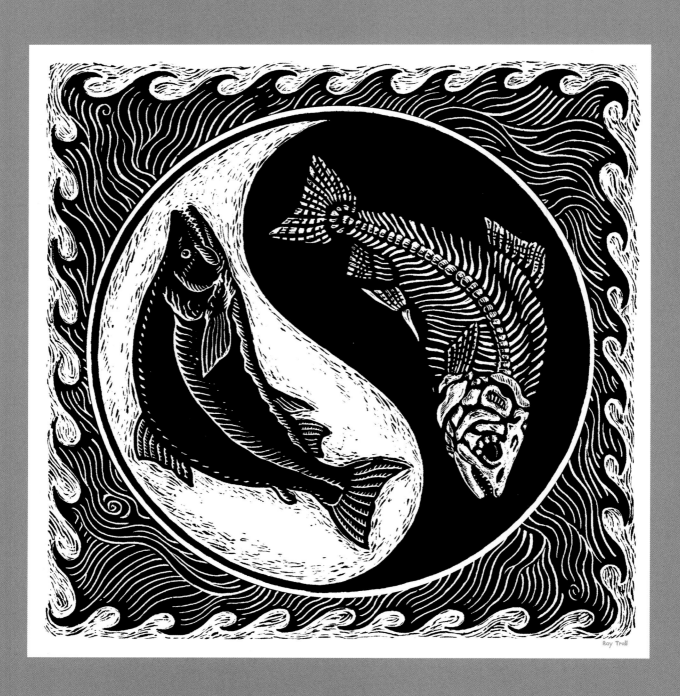

Yin Yang

44

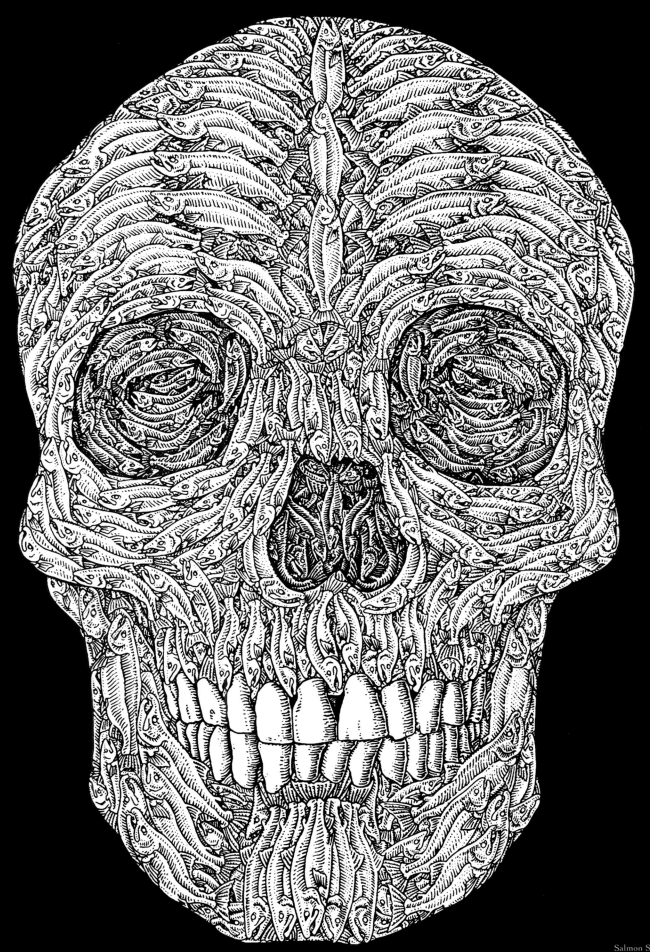

Salmon Skull

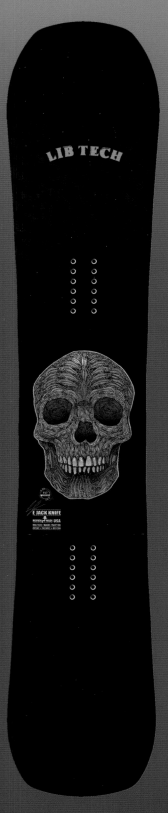
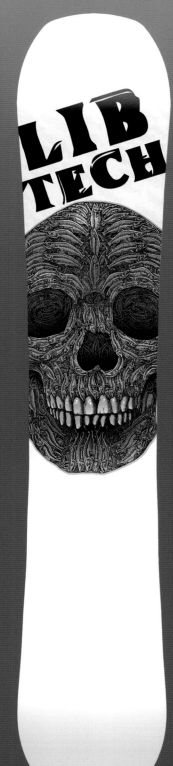
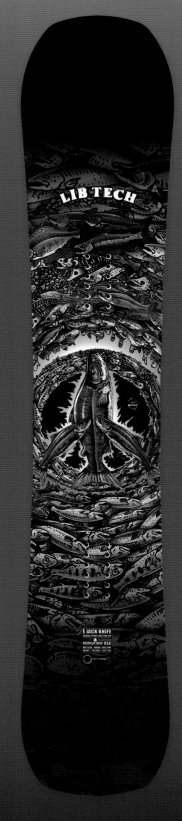
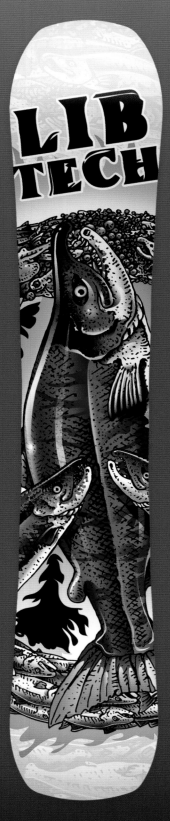

Lib Tech Snowboards designed by Annette Veihelmann

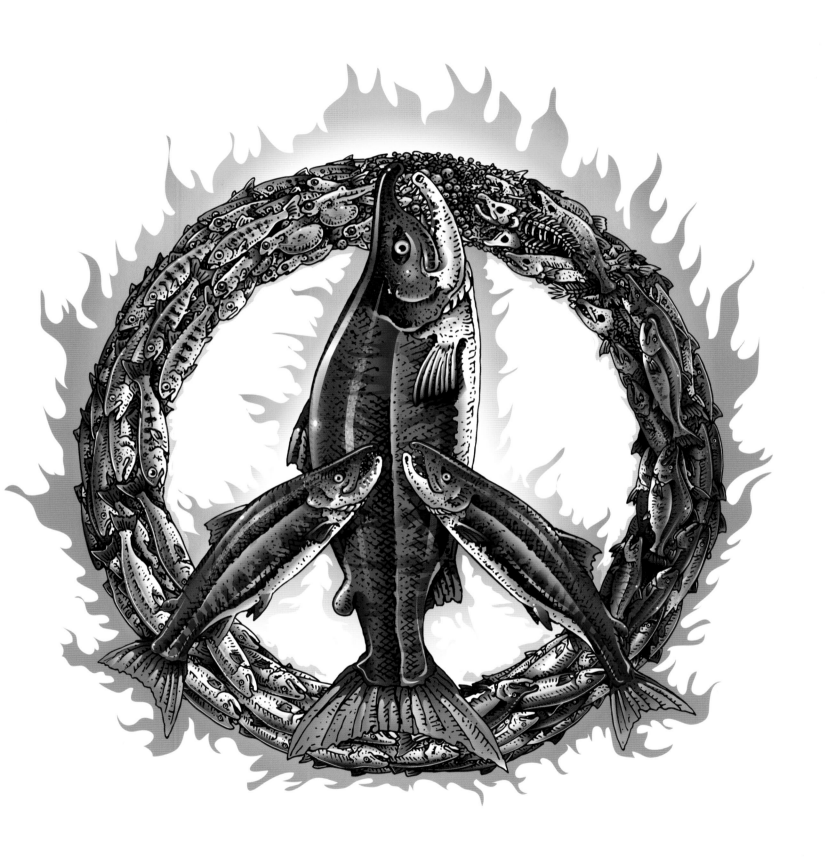

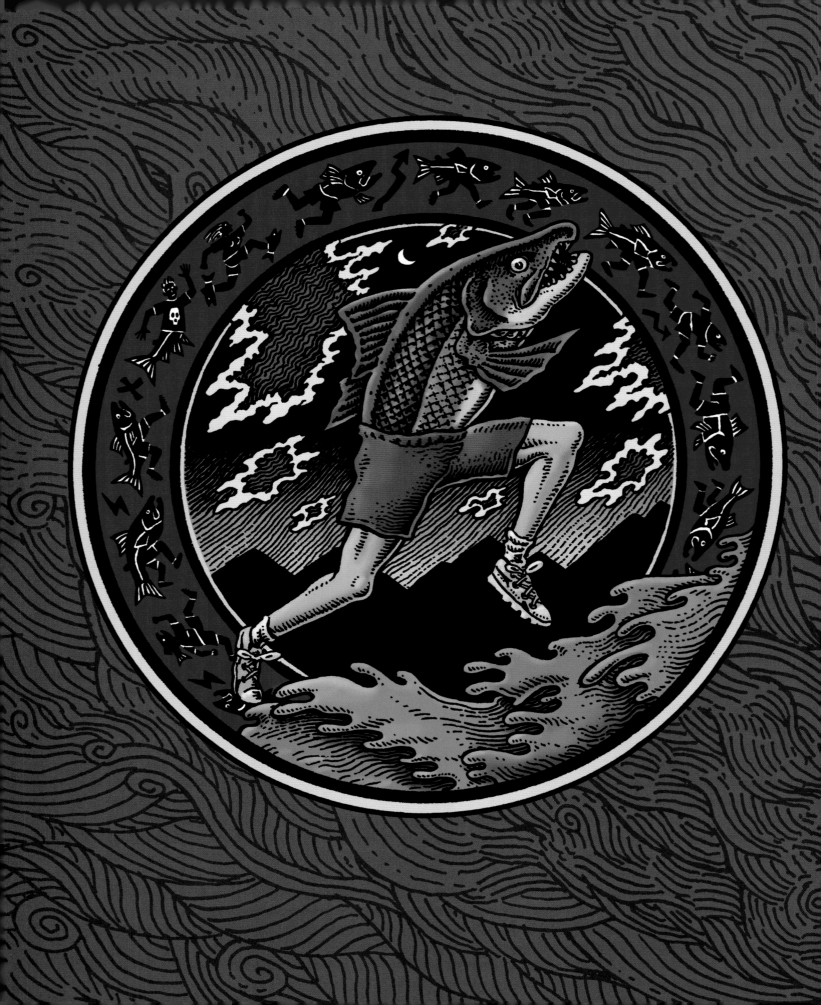

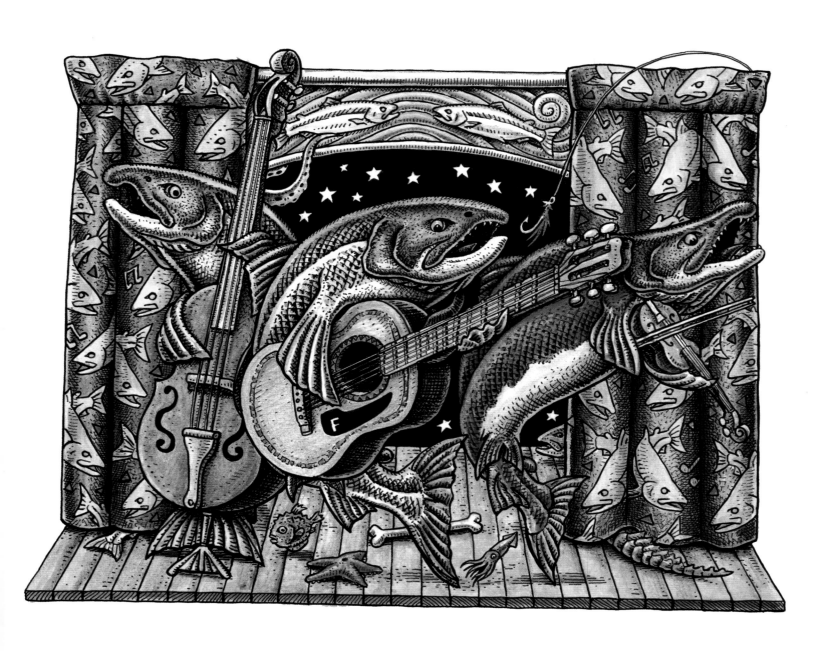

IT'S THE ~40TH~

ALASKA FOLK FESTIVAL

FUNKY DORY

JUNEAU, ALASKA

APRIL 7-13, 2014

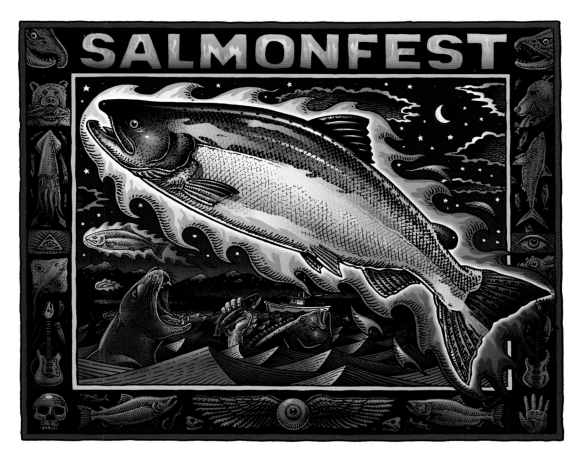

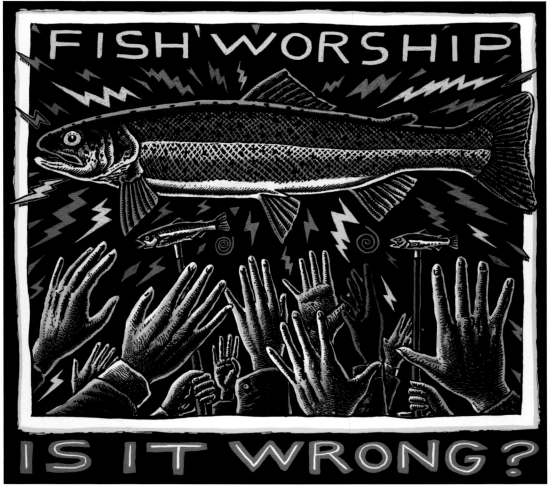

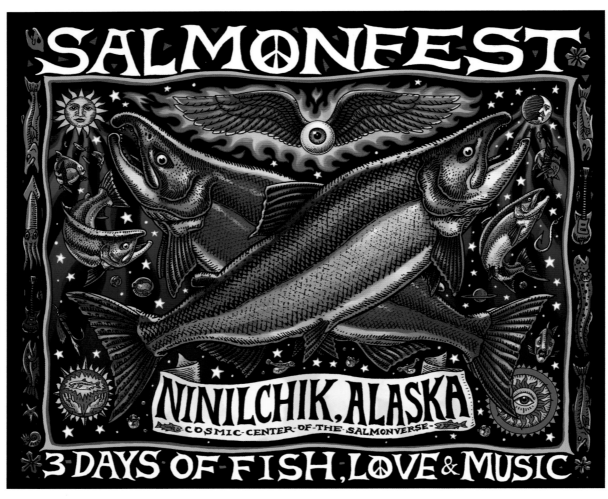

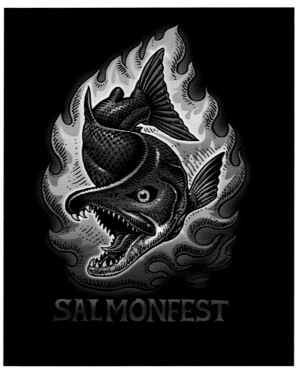

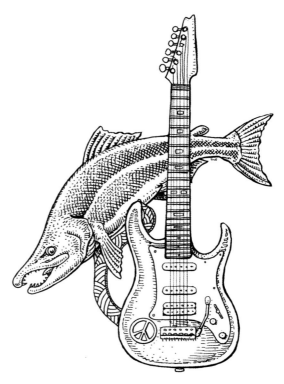

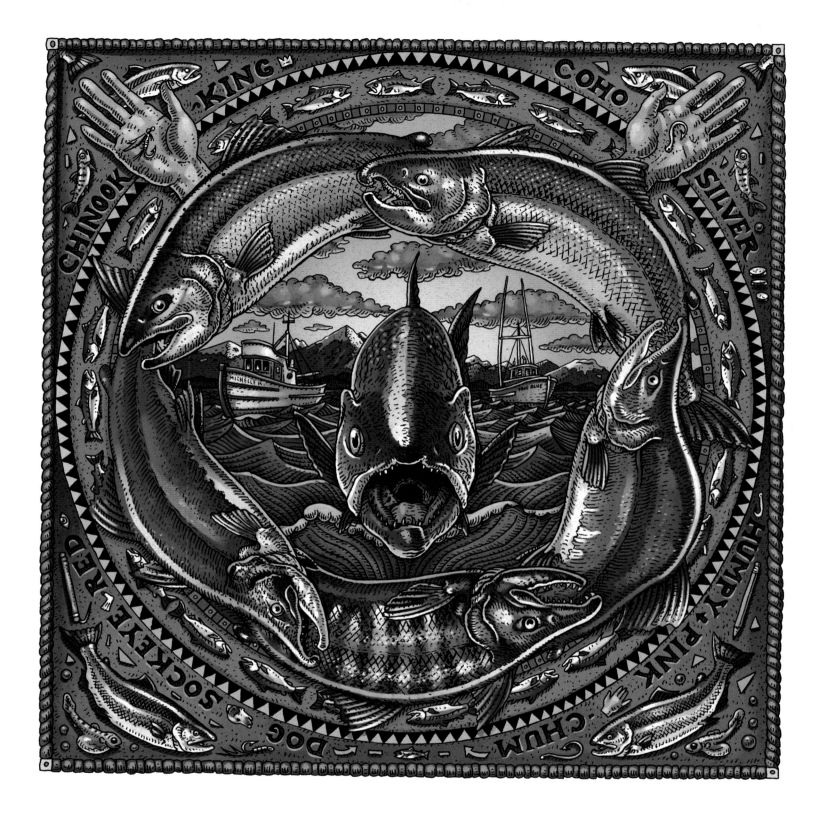

Five Salmon, Ten Names

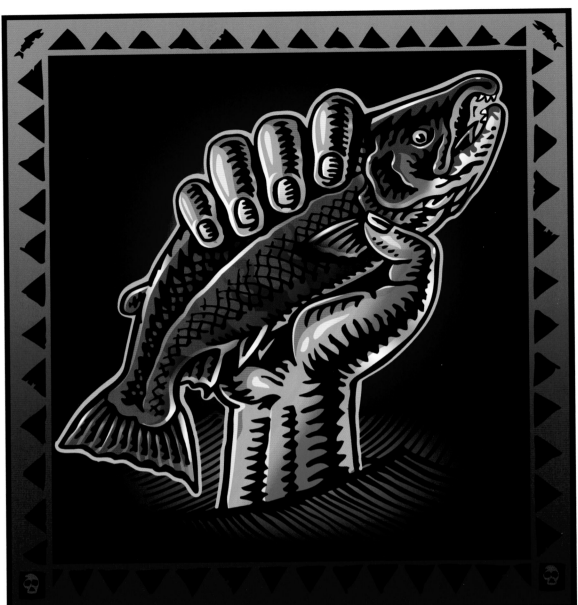

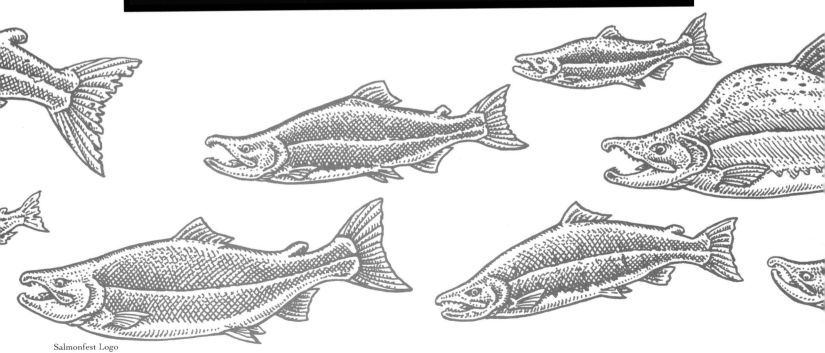

Salmonfest Logo

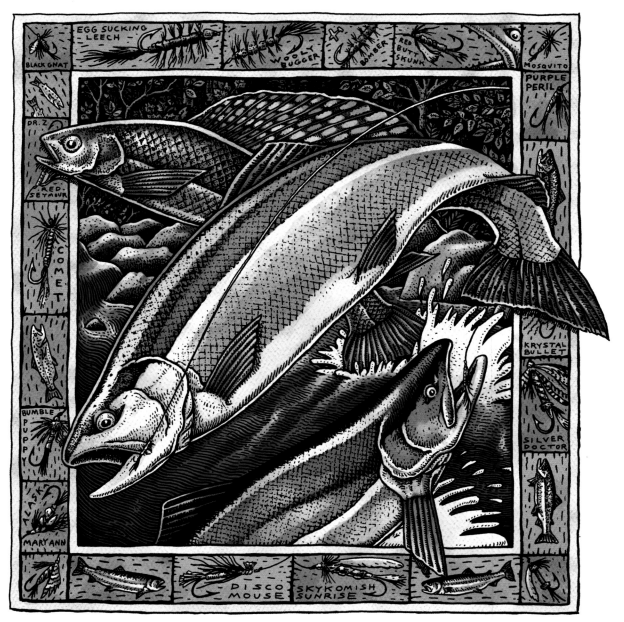

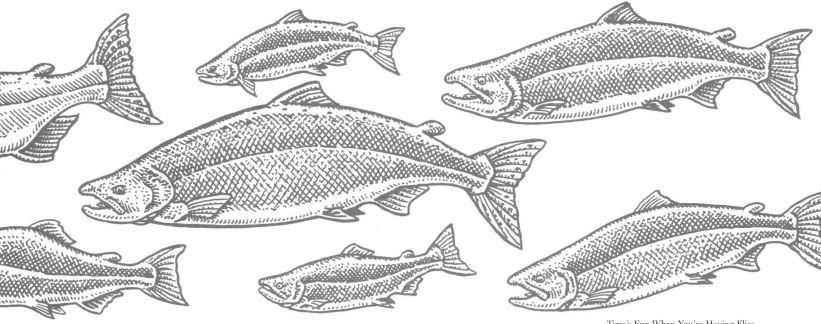

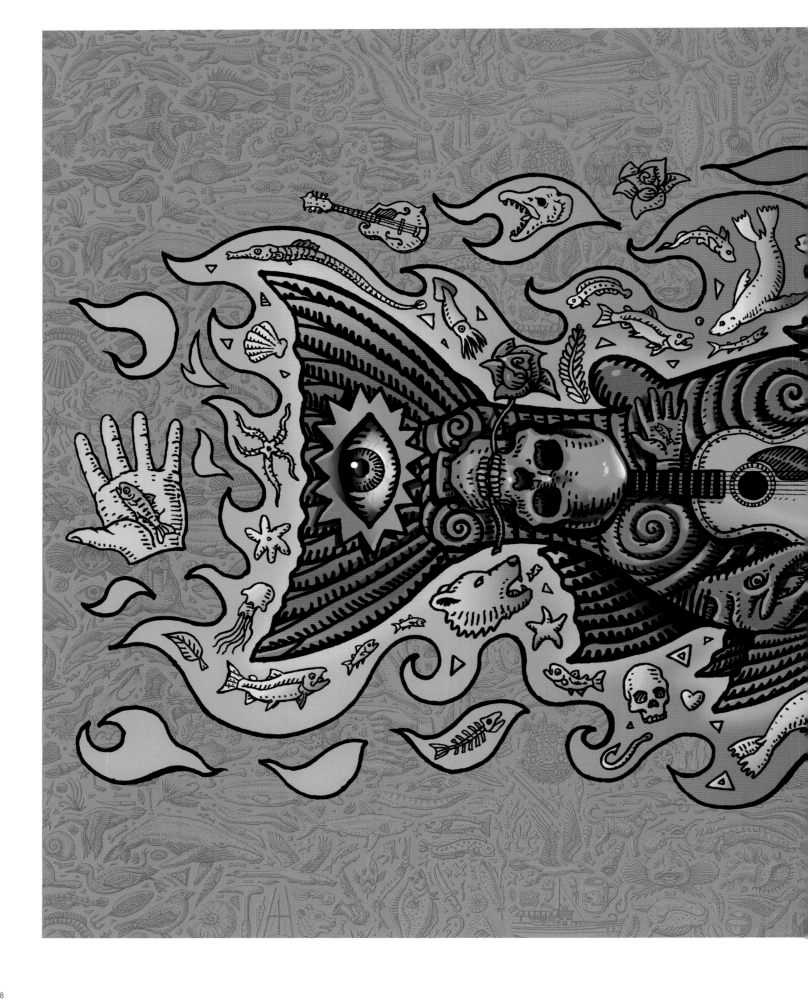

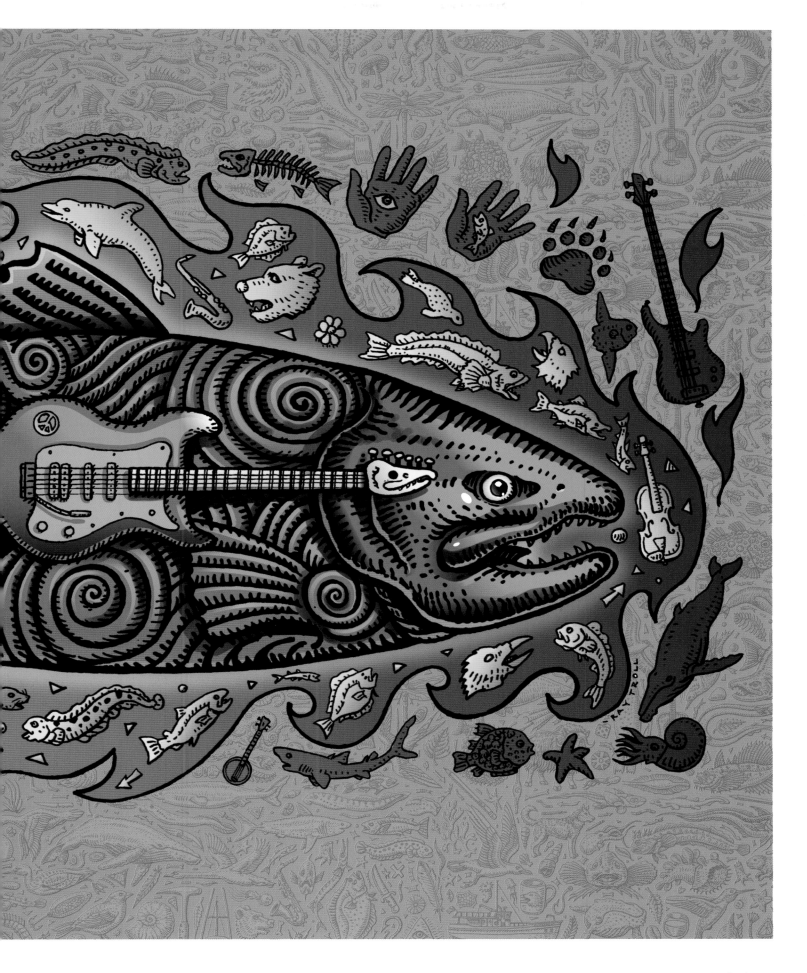

Spawntaneous Combustion

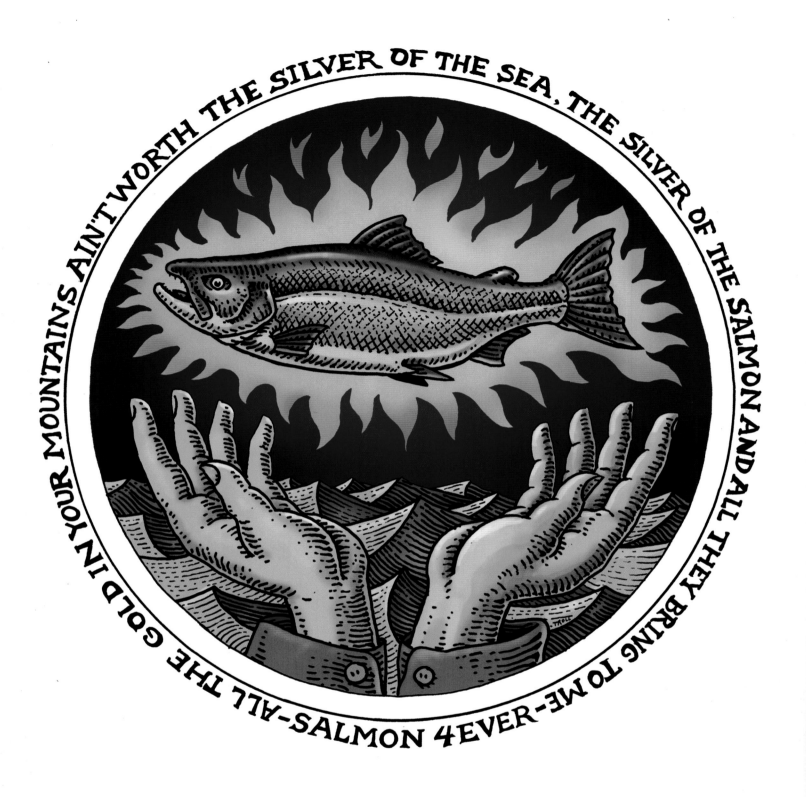

ABOVE: Salmon 4 Ever

OPPOSITE PAGE: Dancing to the Fossil Record

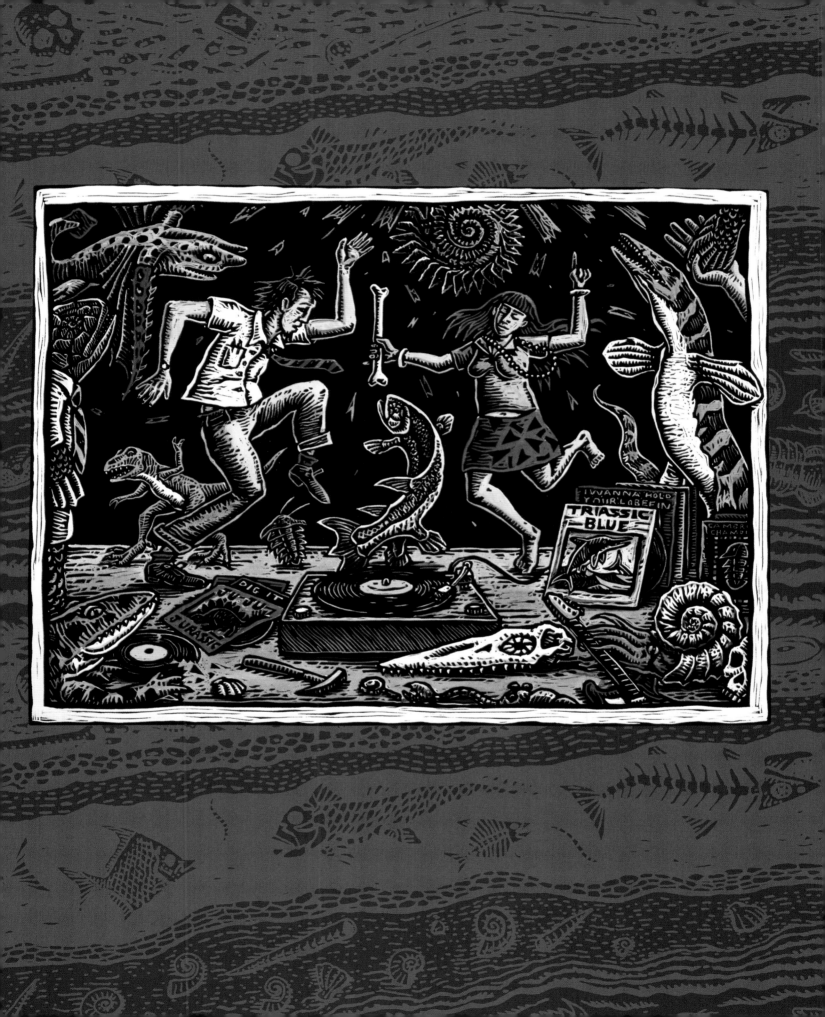

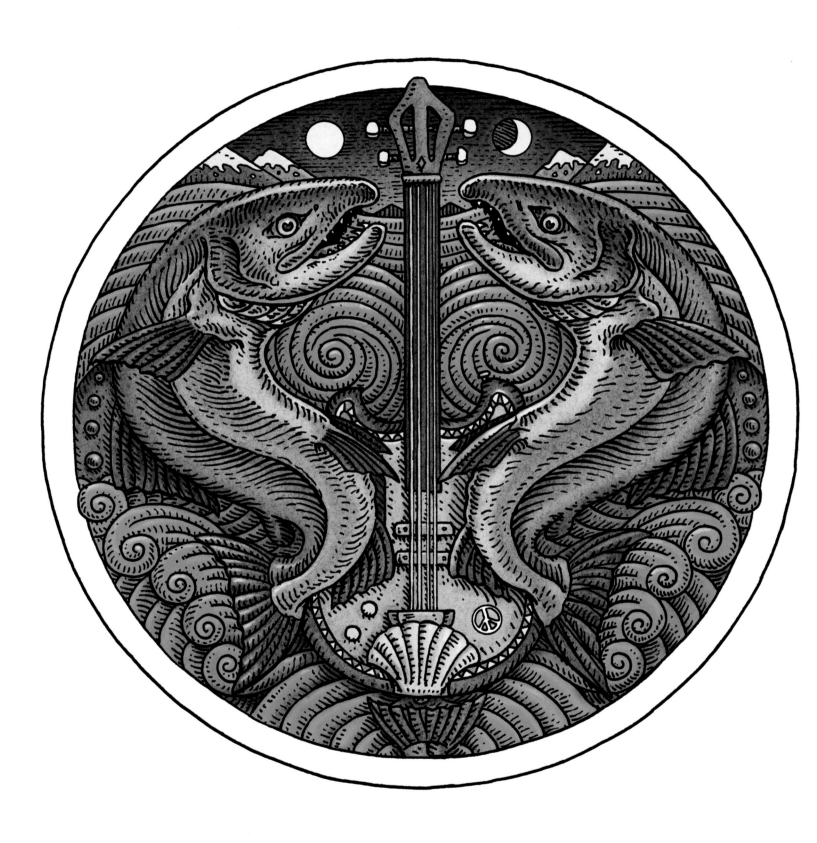

Salmon Duo

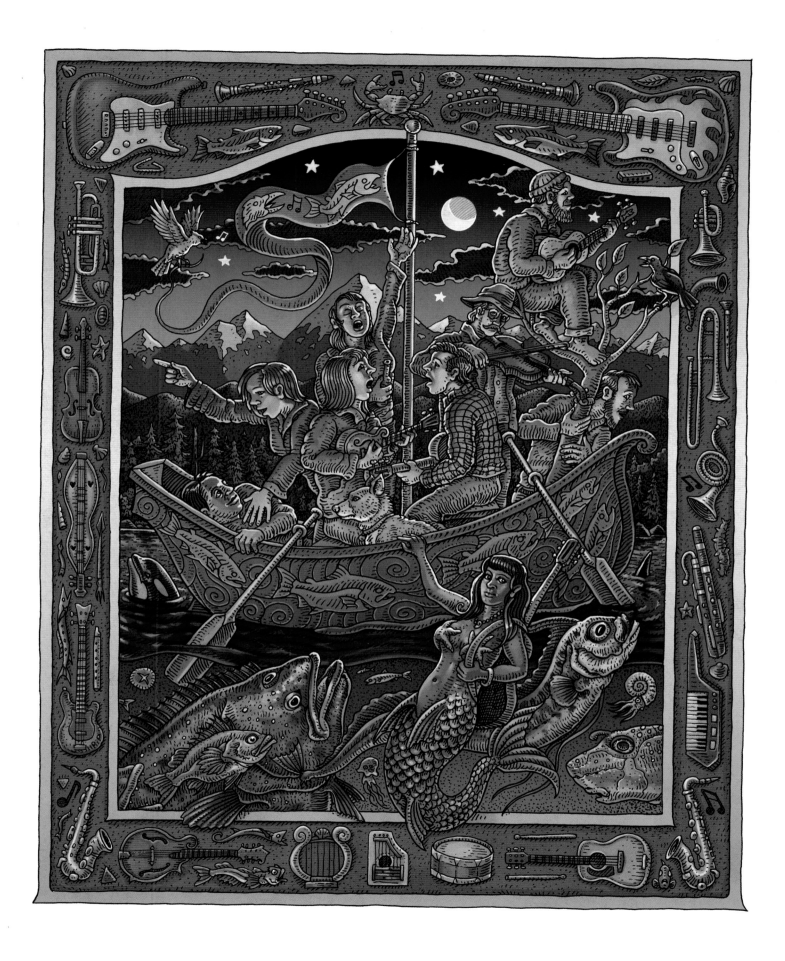

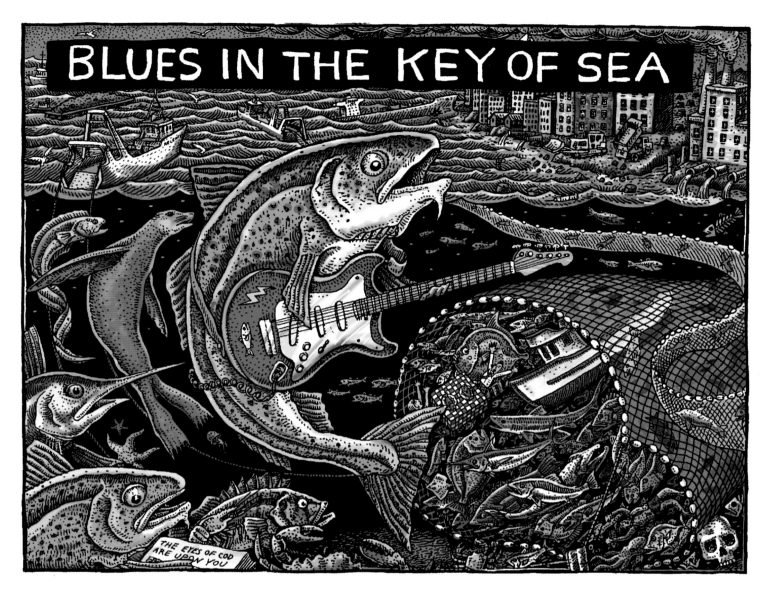

BELOW: Party Animals

BAITBALLS OF FIRE!

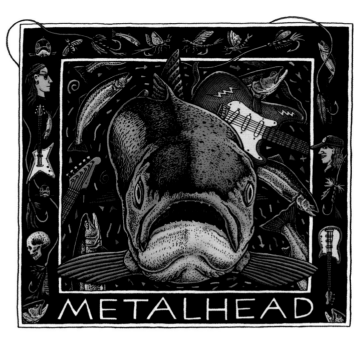

METALHEAD

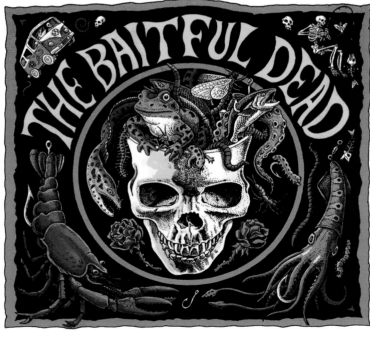

THE BAITFUL DEAD

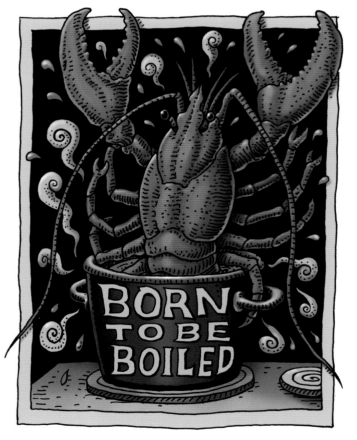

BORN TO BE BOILED

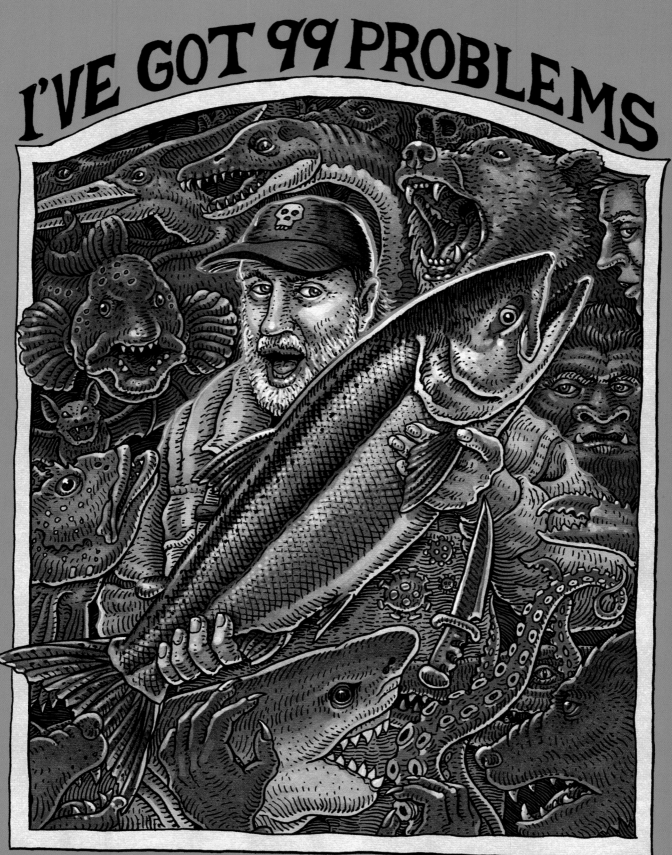

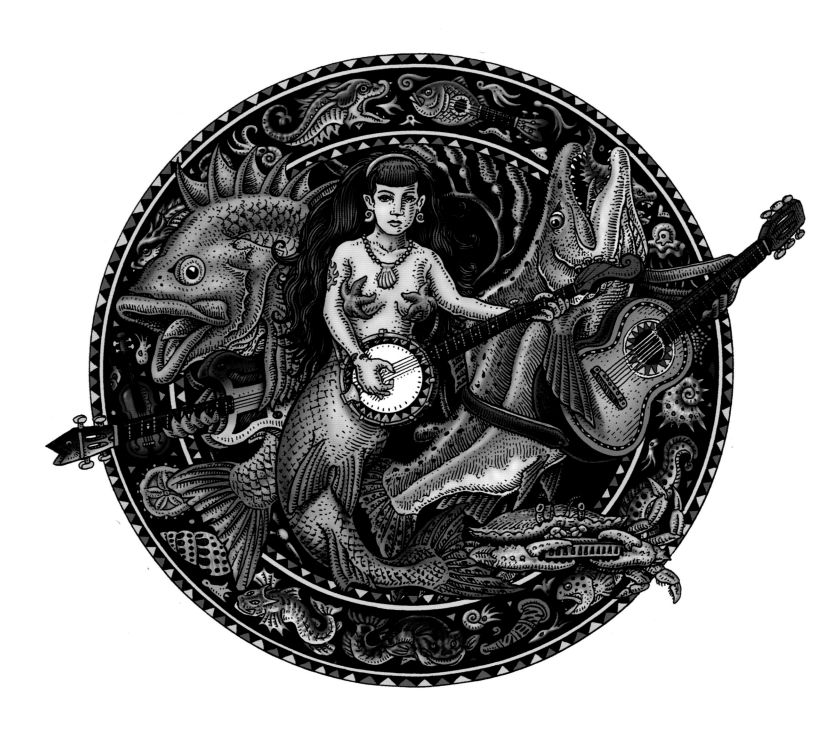

Mermaid Music

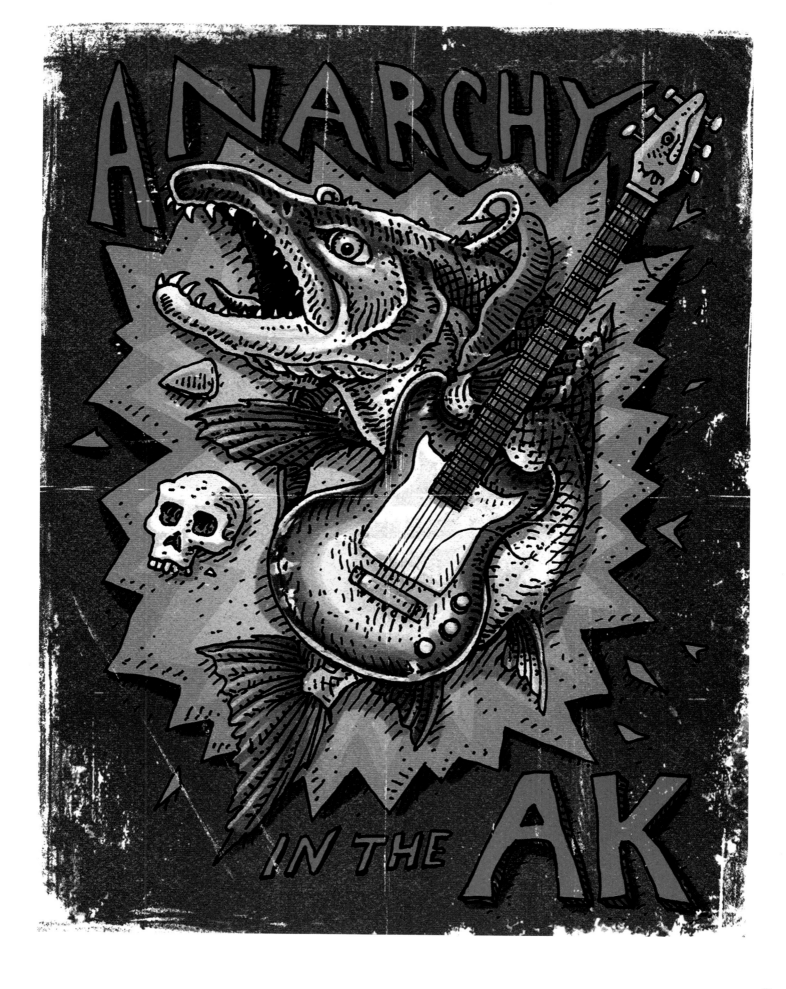

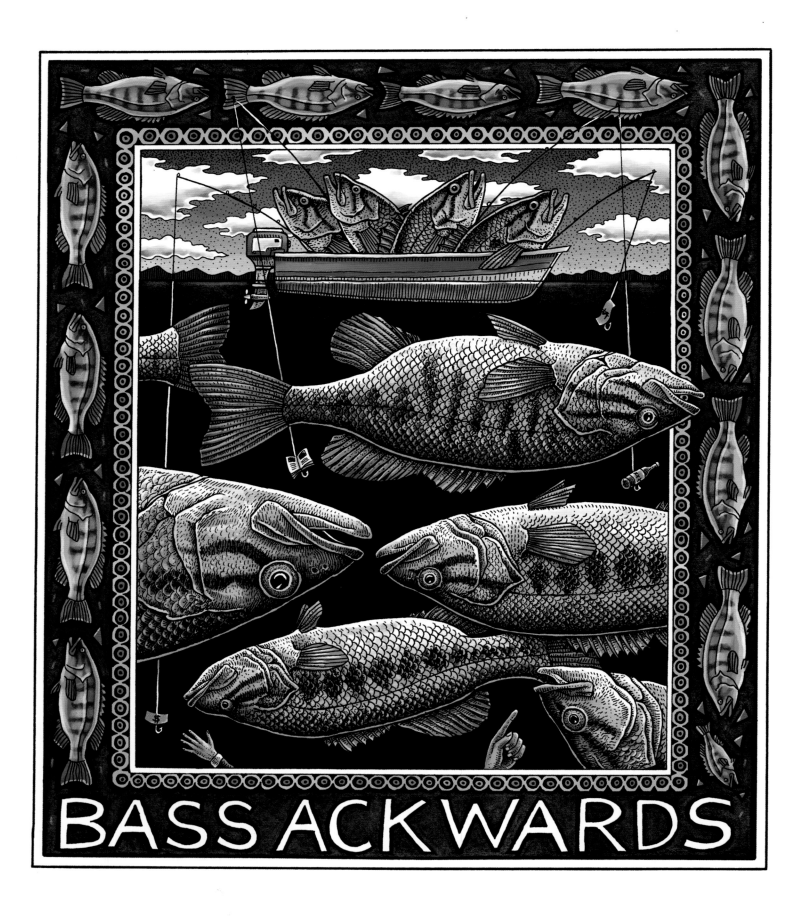

BASS ACKWARDS

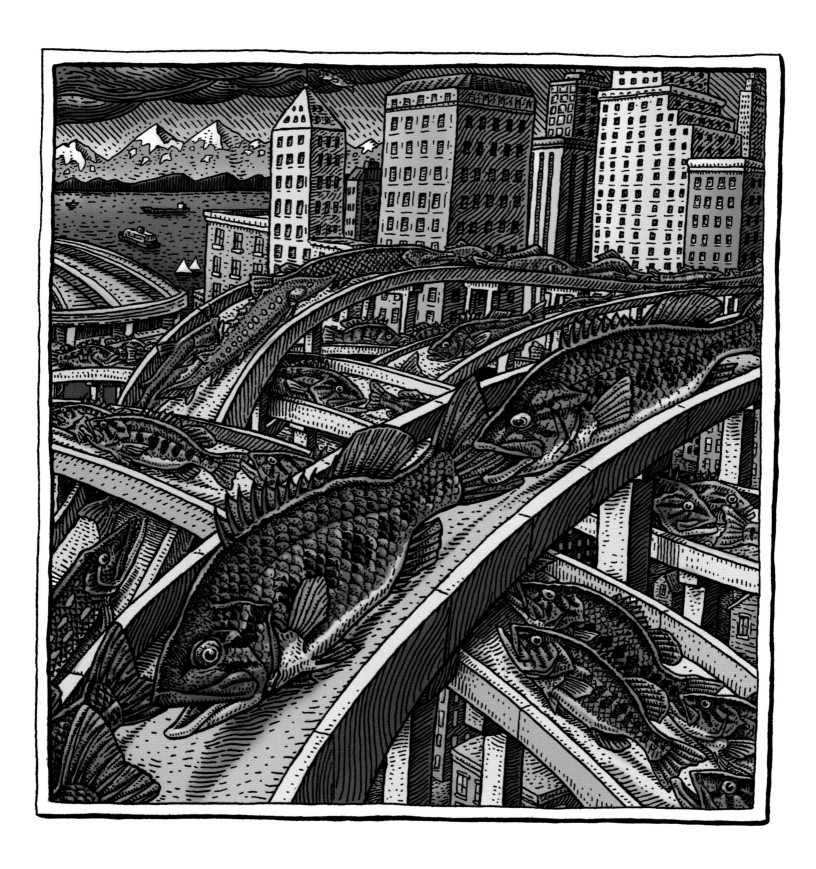

Life in the Bass Lane

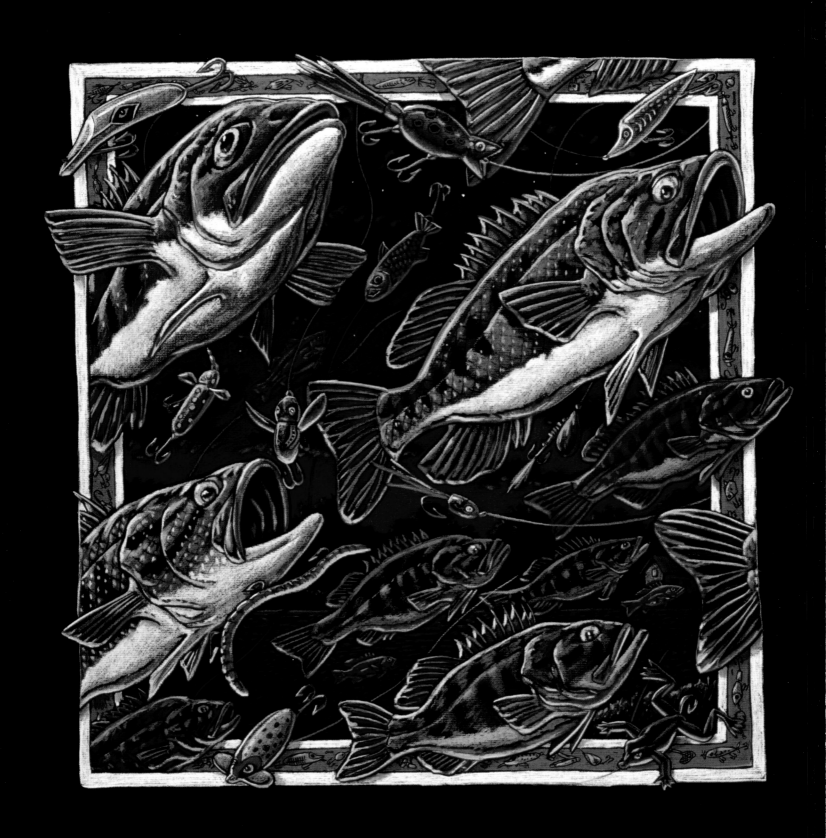

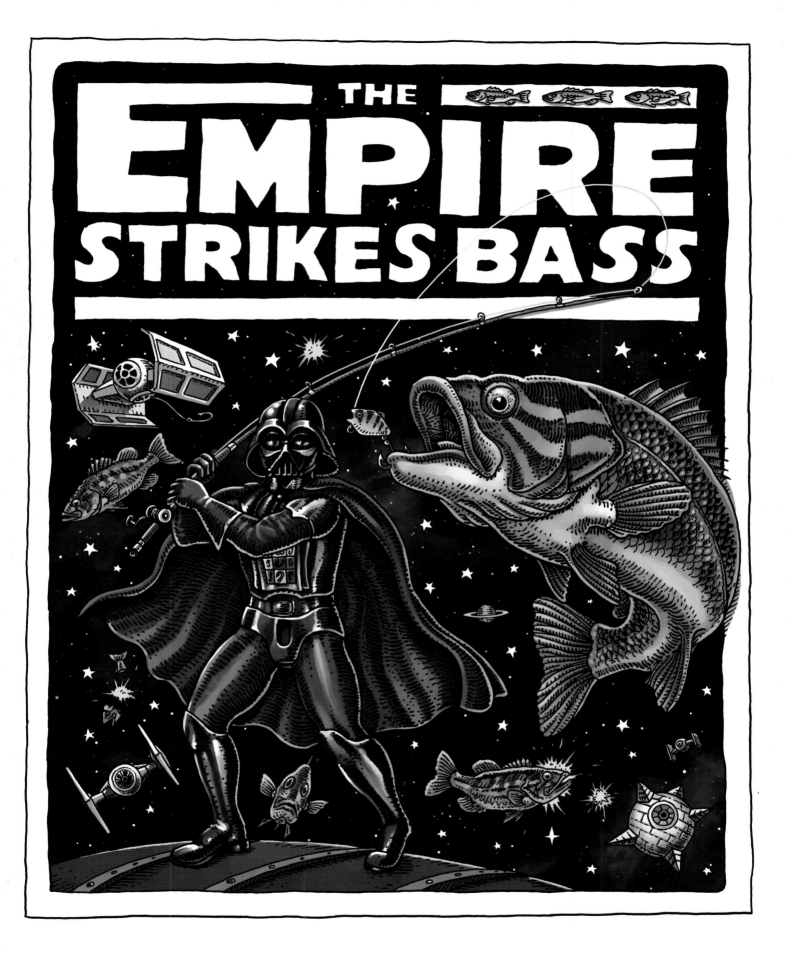

CRABBIN' FEVER!

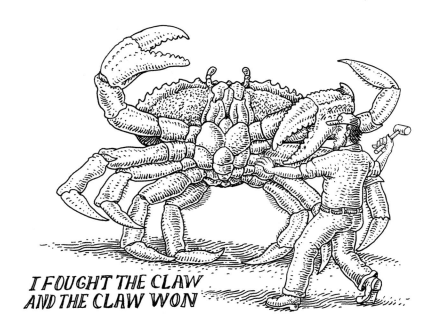

I FOUGHT THE CLAW
AND THE CLAW WON

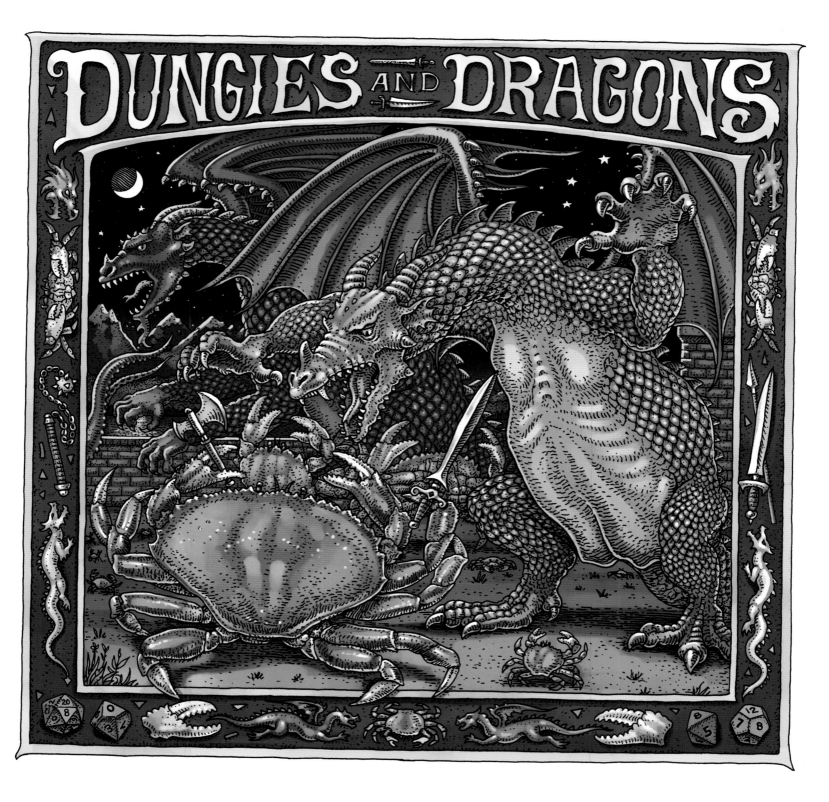

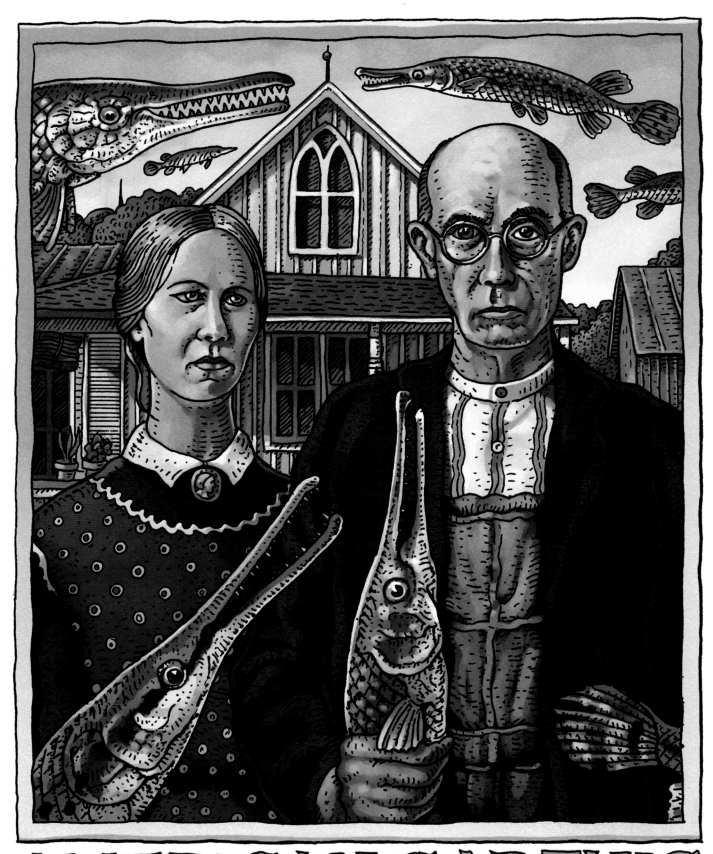

AMERICAN GARTHIC

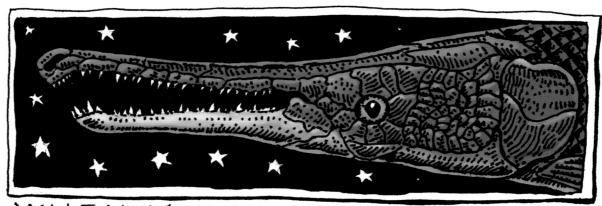

WHEN YOU WISH UPON A GAR

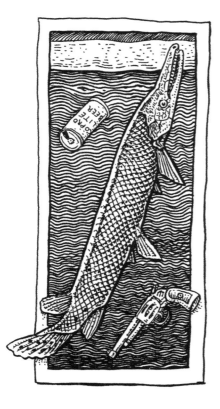

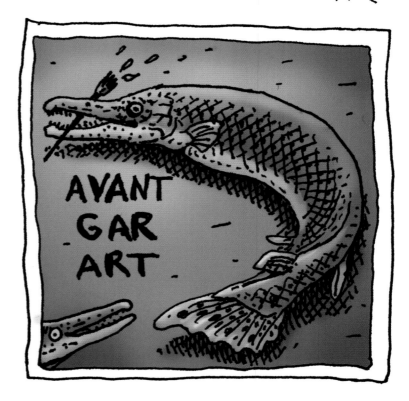

AVANT
GAR
ART

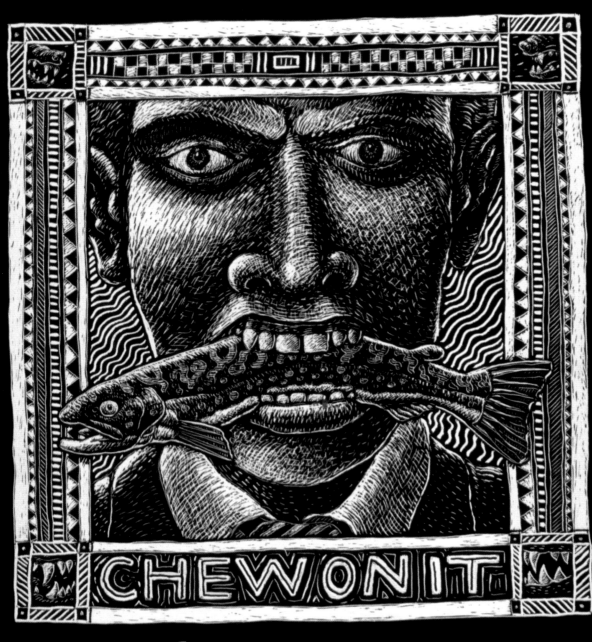

CHEW ON IT

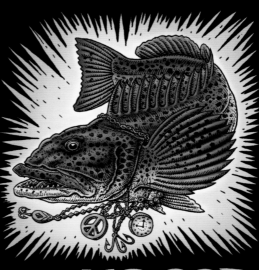

BLING COD

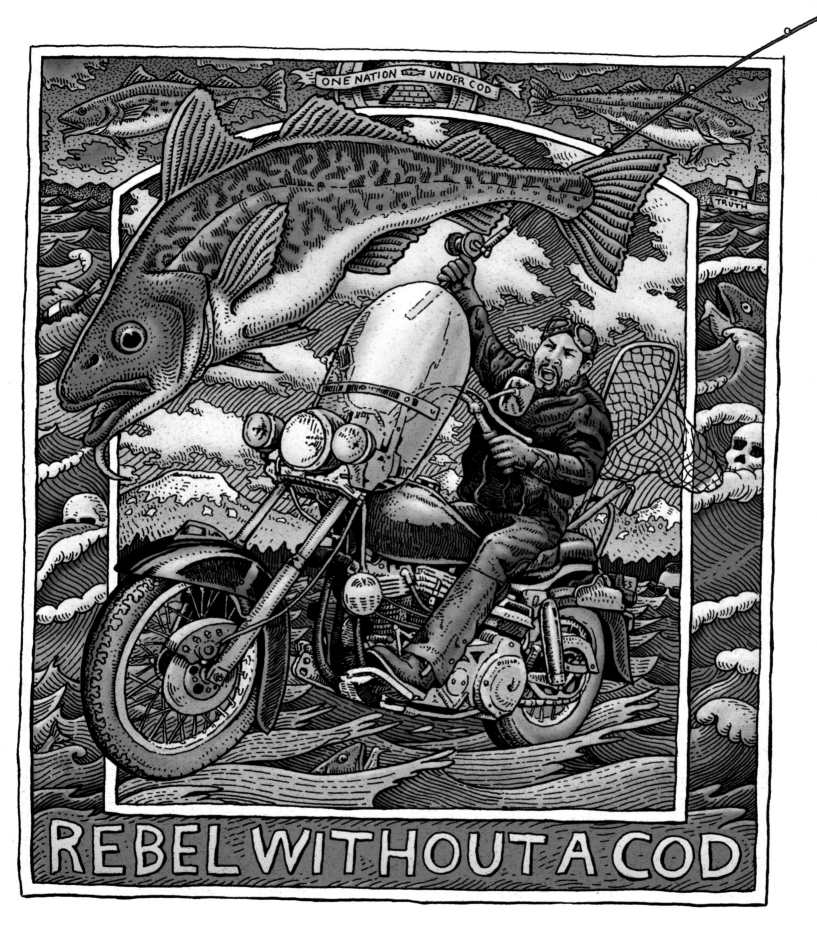

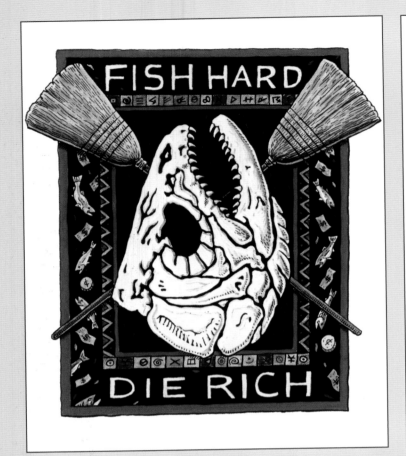

FISH HARD
DIE RICH

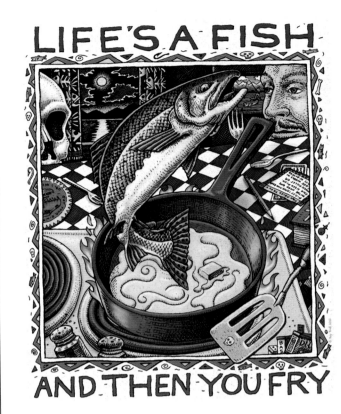

LIFE'S A FISH
AND THEN YOU FRY

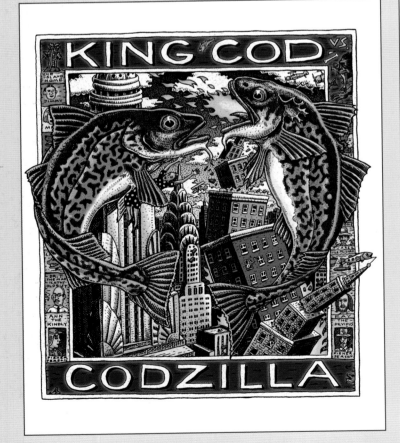

KING COD VS.
CODZILLA

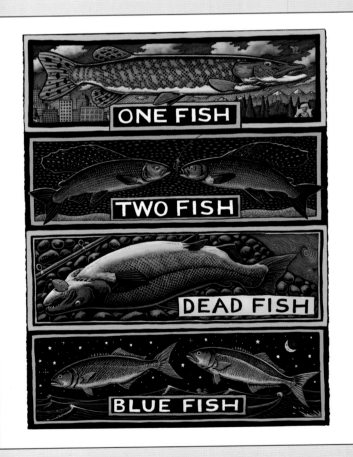

ONE FISH
TWO FISH
DEAD FISH
BLUE FISH

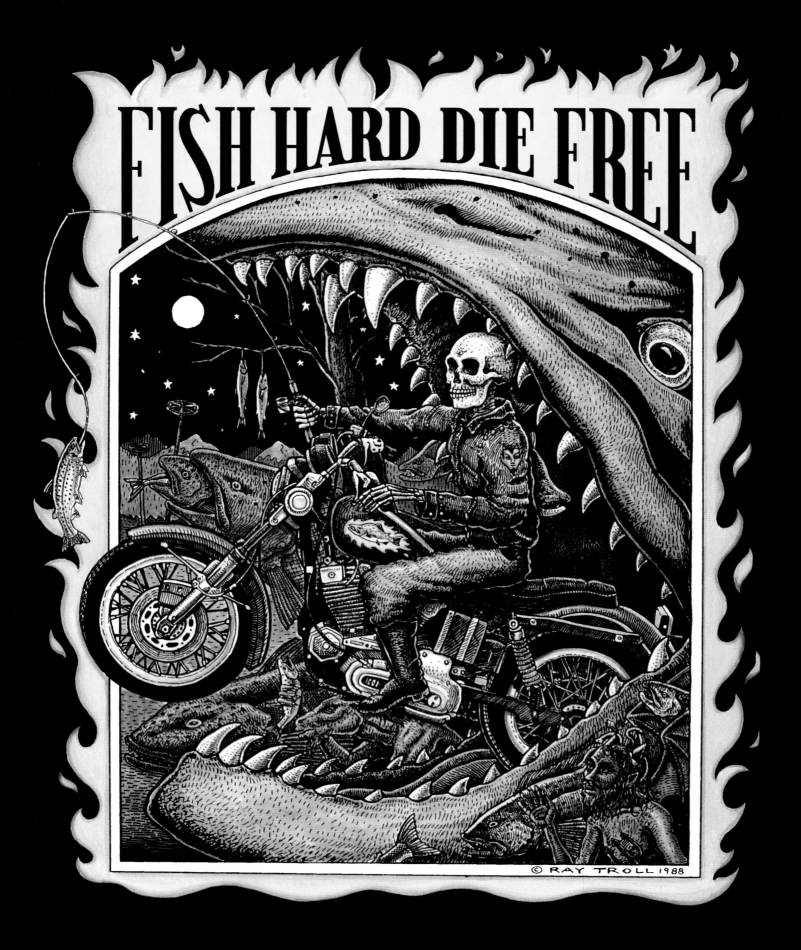

FISH HARD DIE FREE

© RAY TROLL 1988

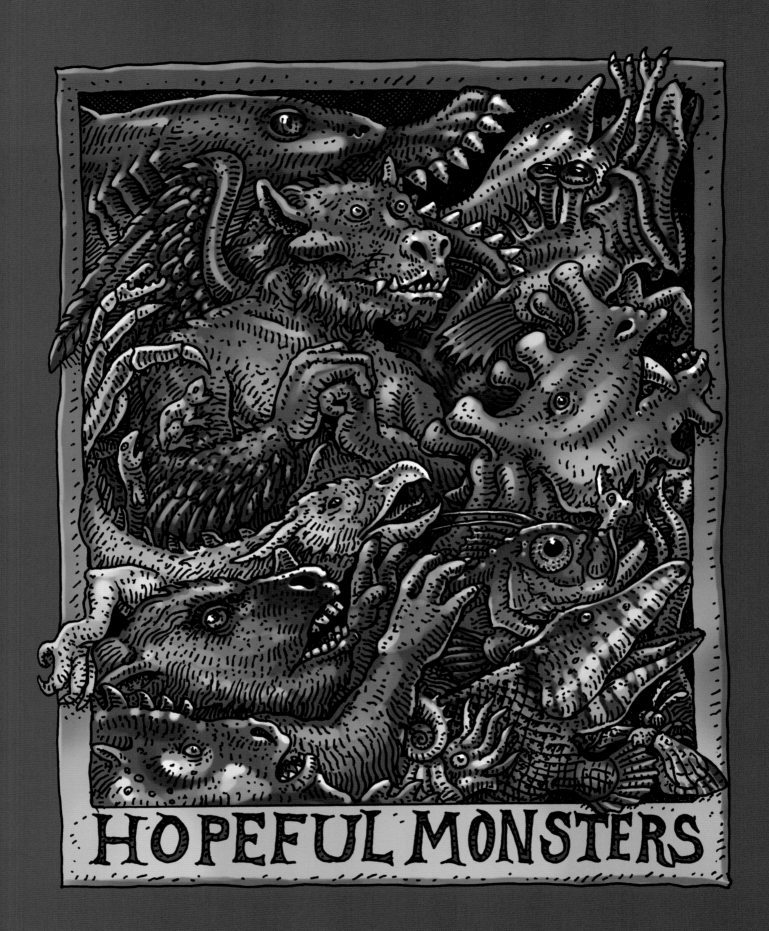

HOPEFUL MONSTERS

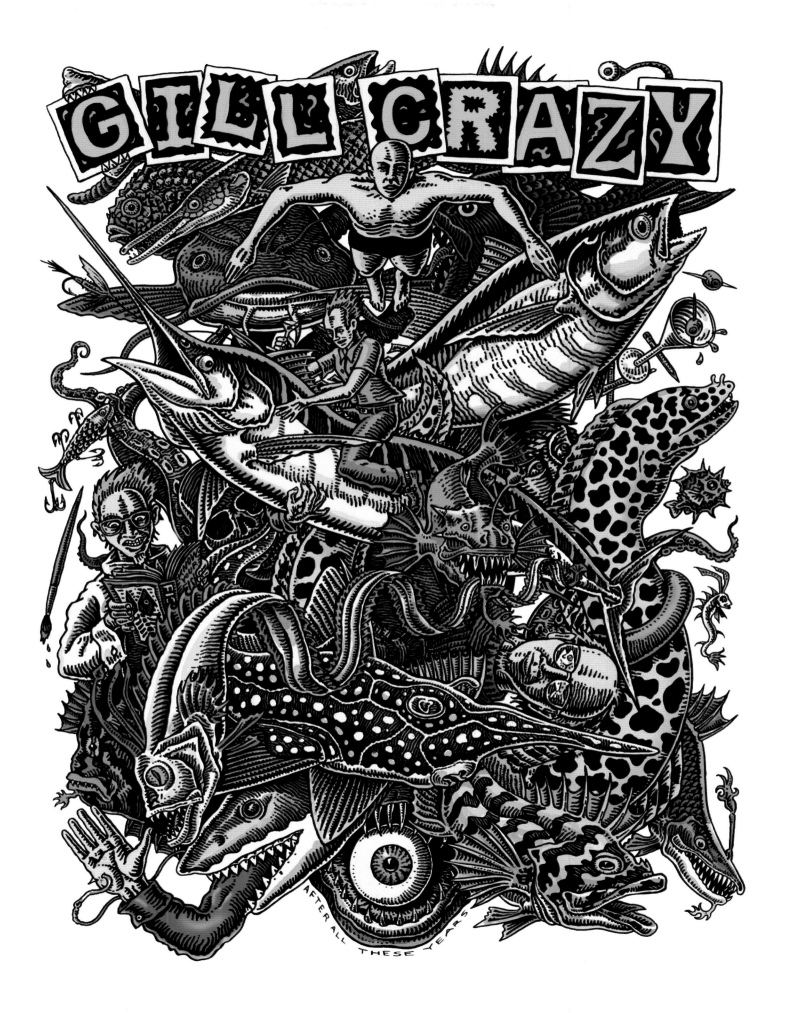

GILL CRAZY

AFTER ALL THESE YEARS

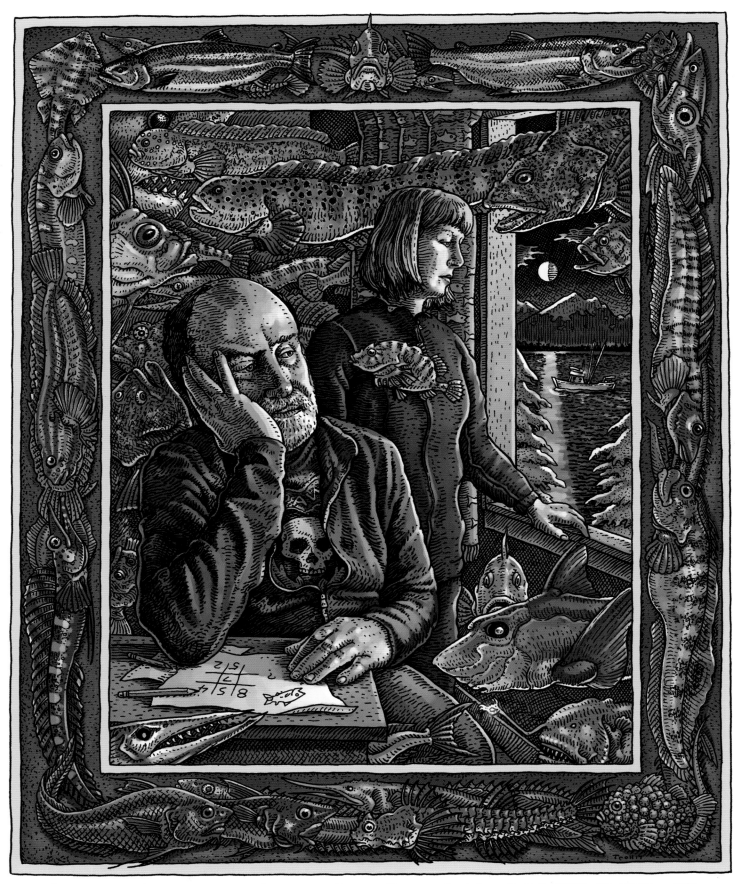

THE WINTER OF OUR FISHCONTENT

FISHFUL THINKING

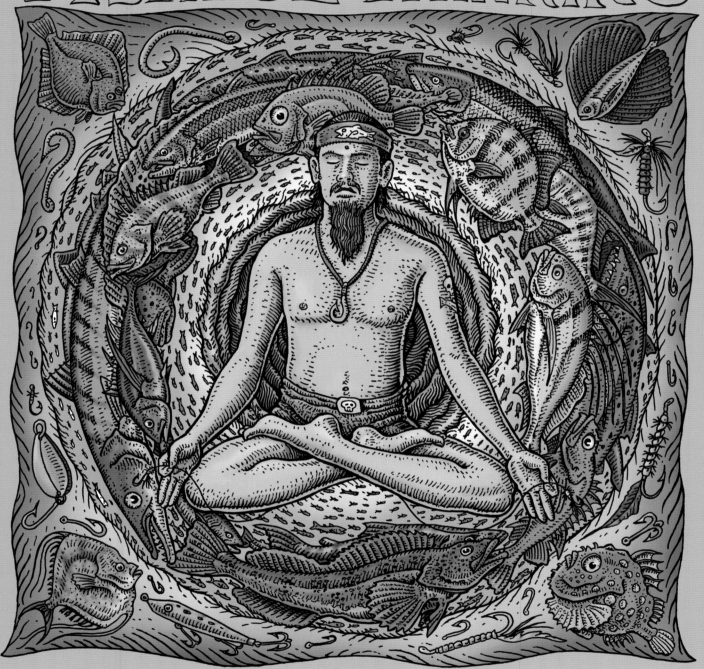

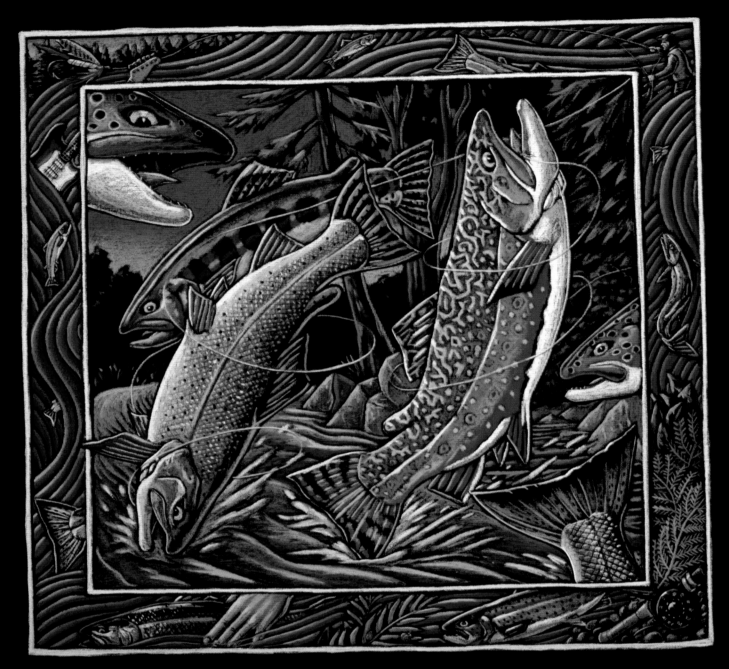

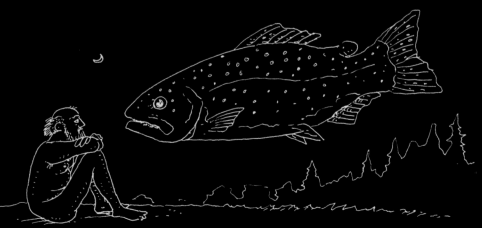

STARING DOWN THE TROUT

DOUBLE RAINBOW

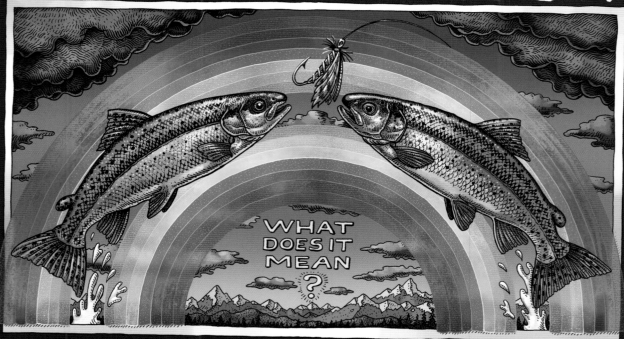

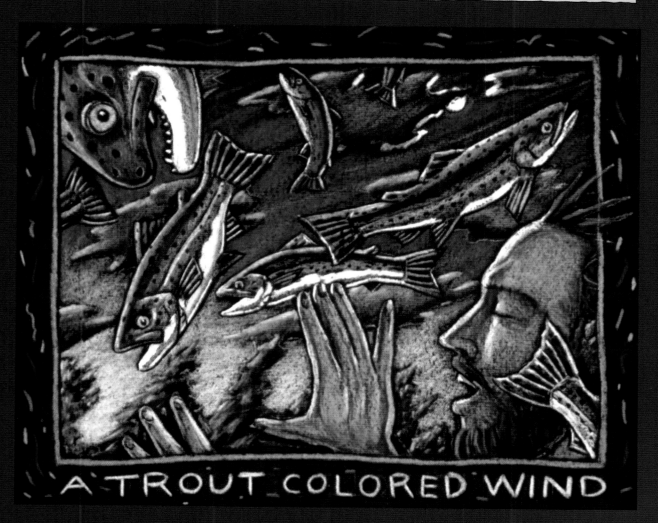

CUTTHROAT BUSINESSMEN

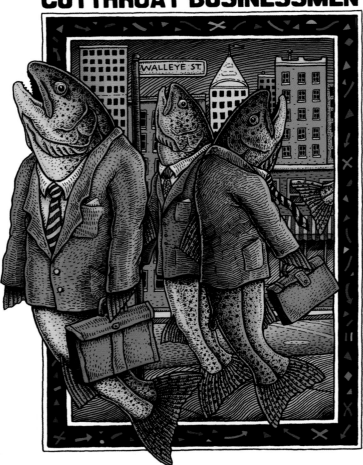

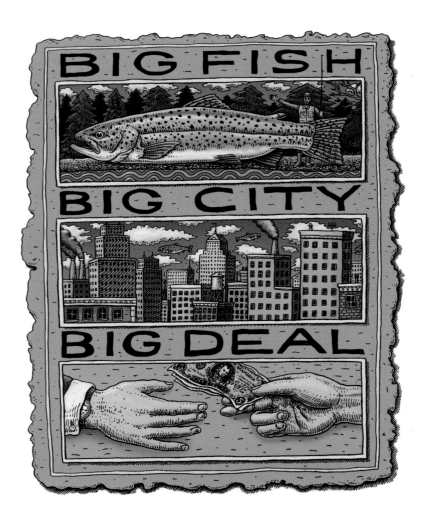

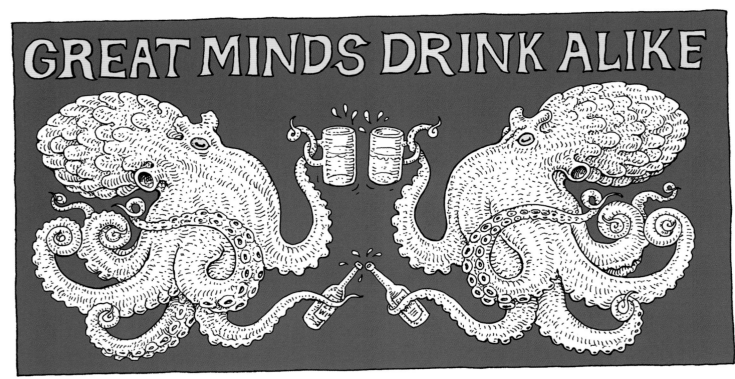

OCTOPI WALL STREET!

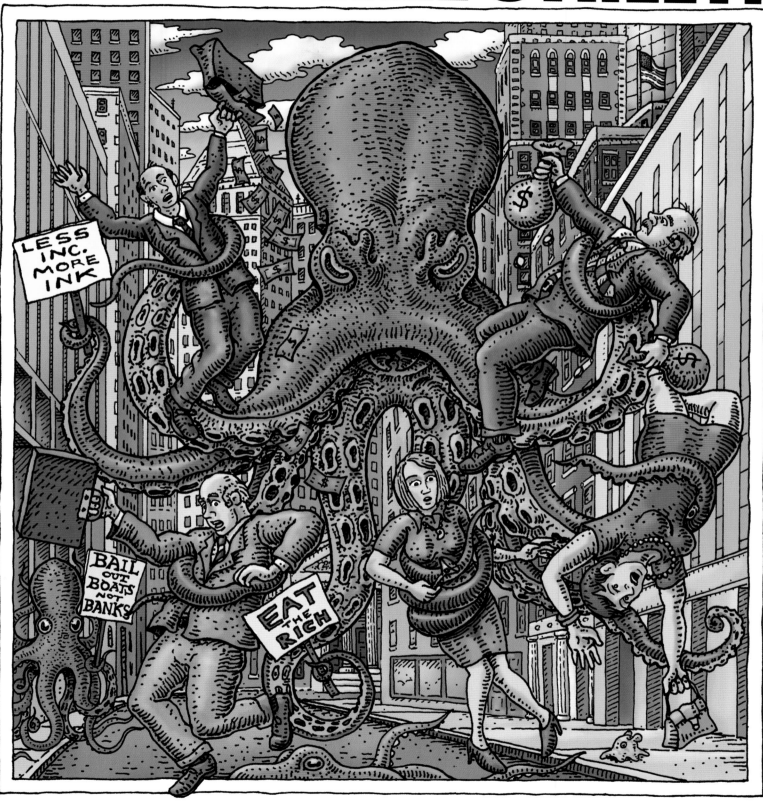

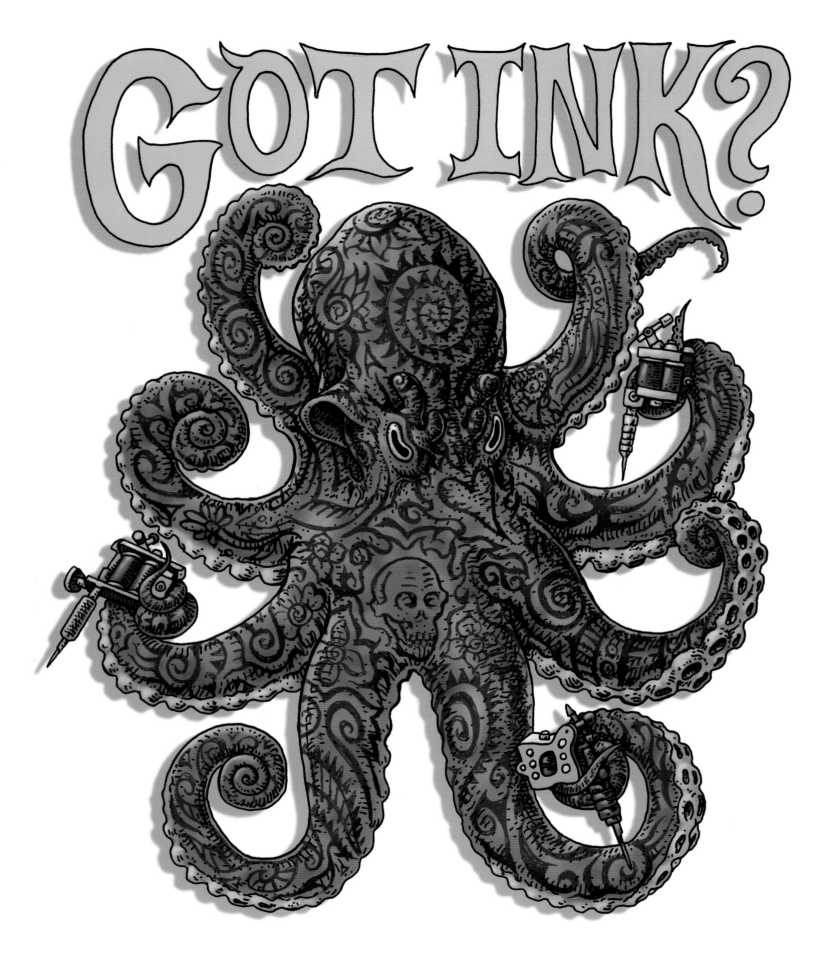

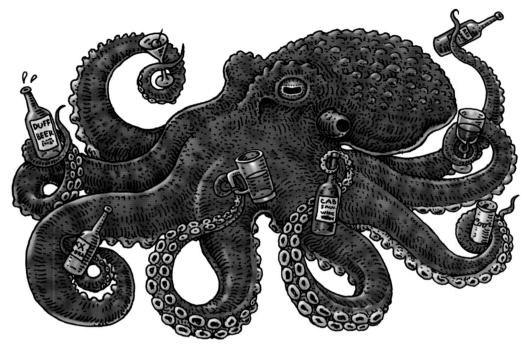

I'LL DRINK TO THAT !

SQUID
PRO
QUO

THE ID

AND THE
SQUID

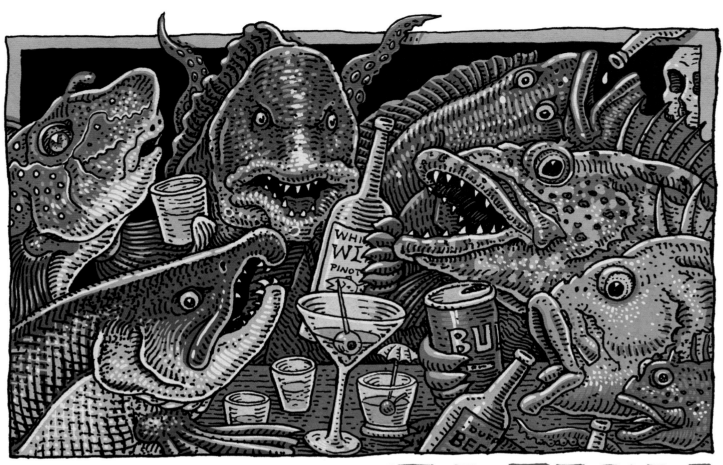

DRINK LIKE A FISH

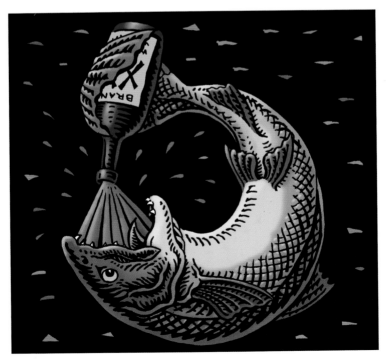

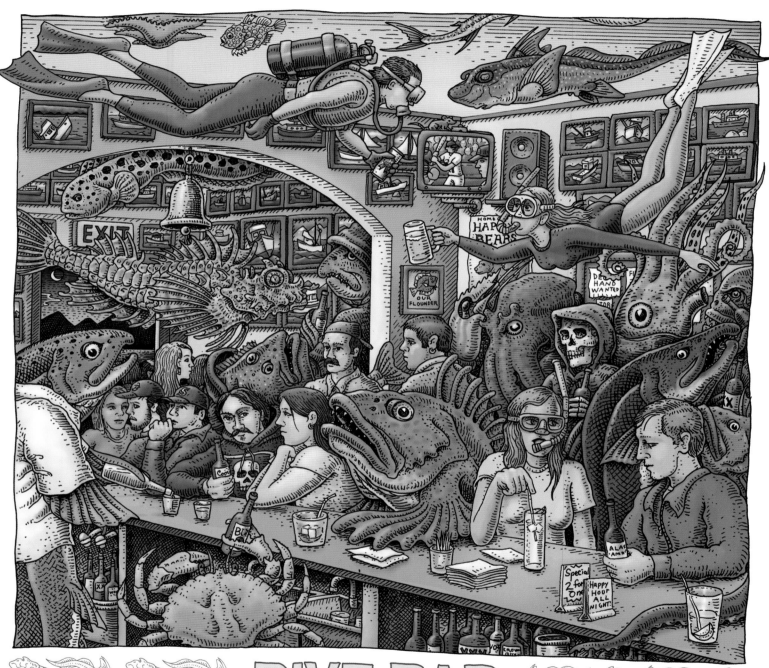

DIVE BAR

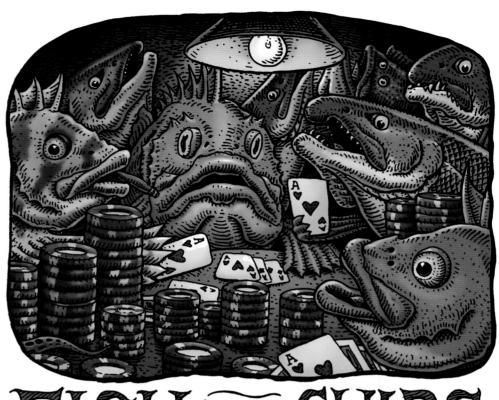

FISH AND CHIPS

HE WHO SMELT IT DEALT IT

BEEVUS AND HALIBUTT-HEAD

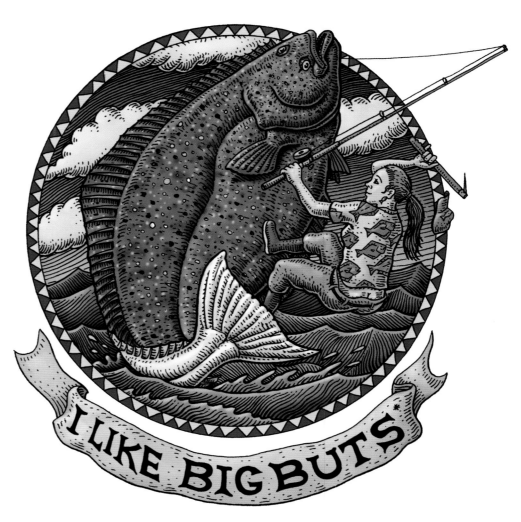

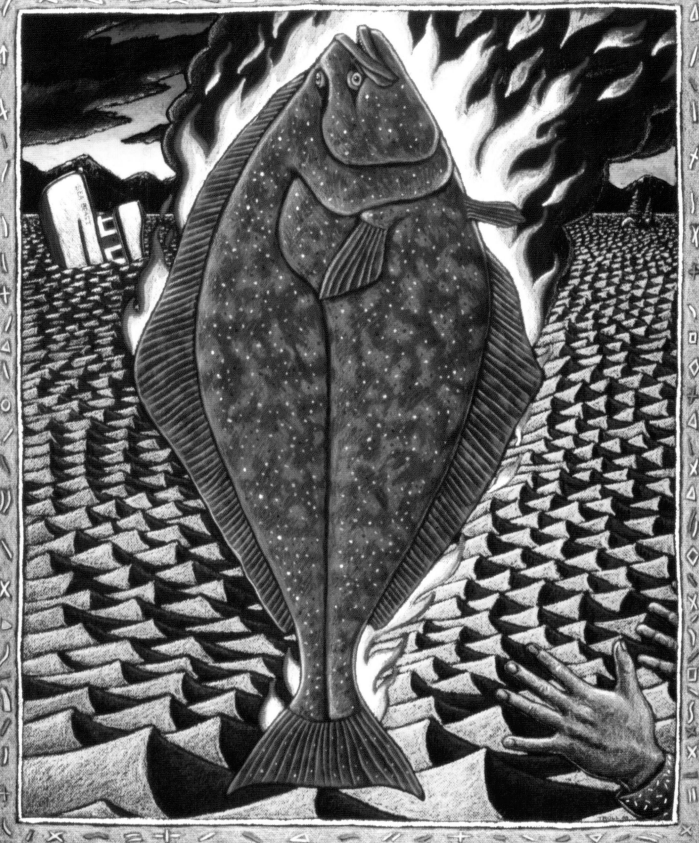

DARK NIGHT OF THE SOLE

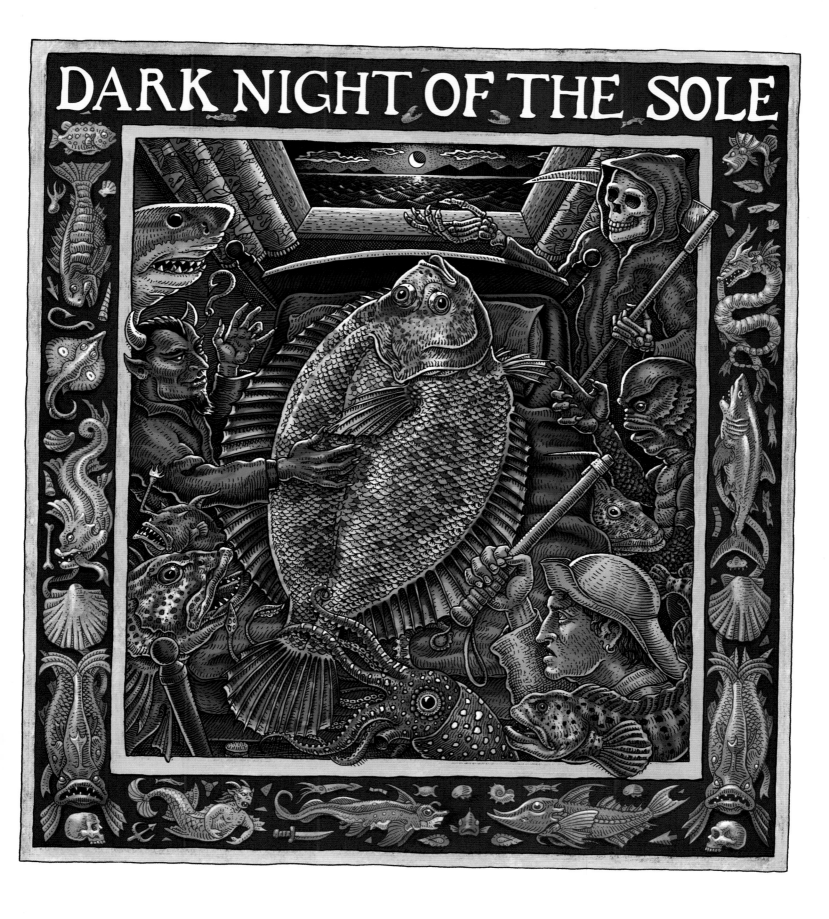

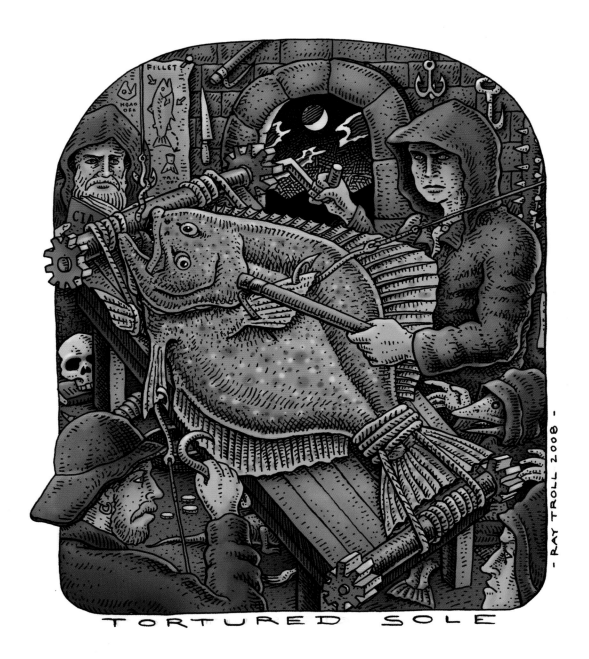

TORTURED SOLE

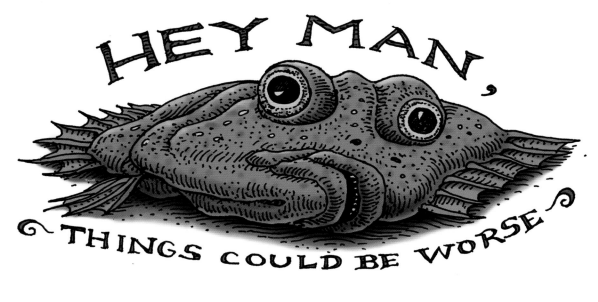

HEY MAN, THINGS COULD BE WORSE

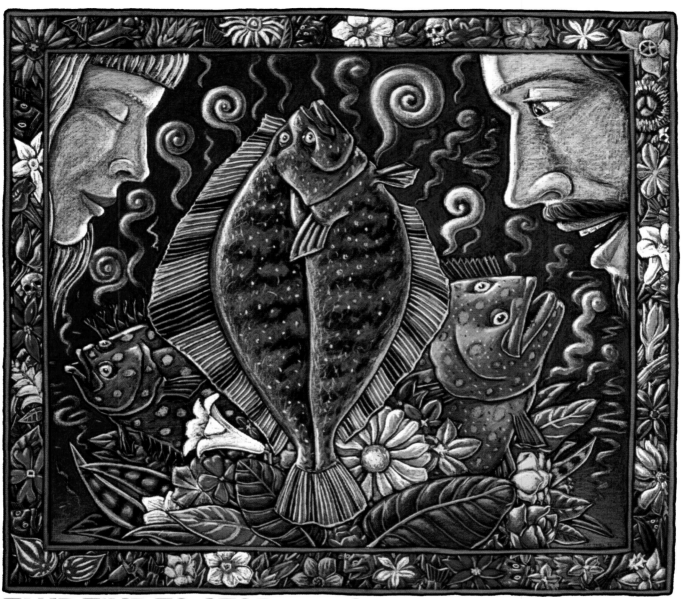

TAKE TIME TO STOP AND SMELL THE FLOUNDERS

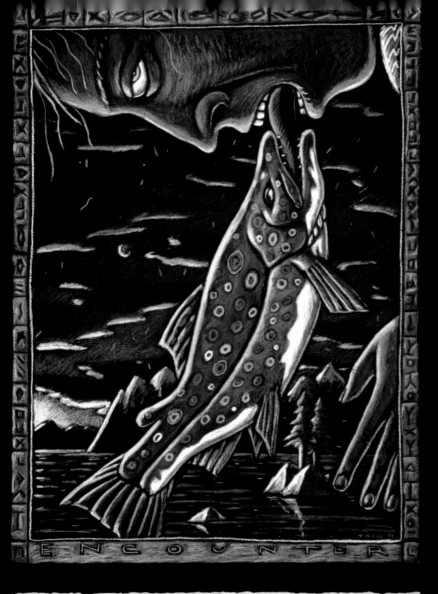

ENCOUNTER

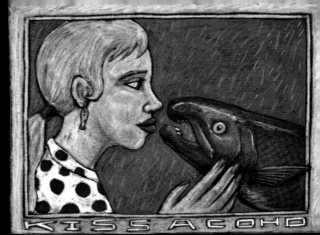

KISS A COHO

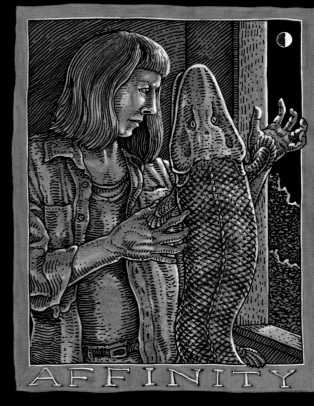

AFFINITY

LOVE AND DEATH ON T.V. R.T.

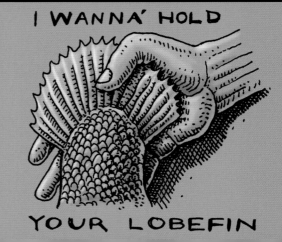

I WANNA' HOLD

YOUR LOBEFIN

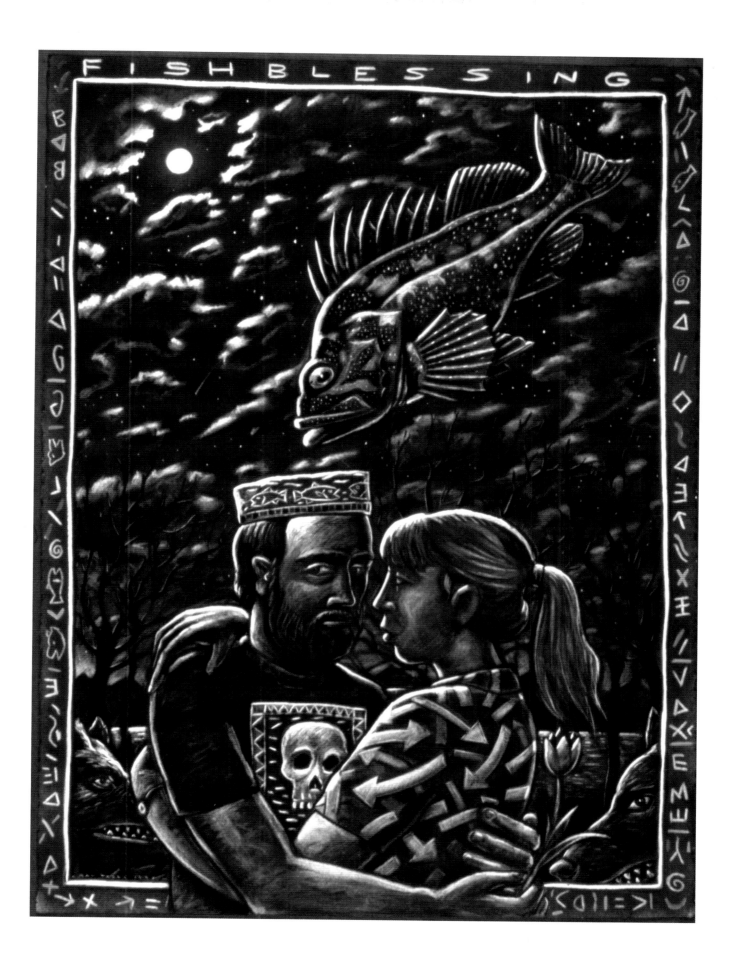

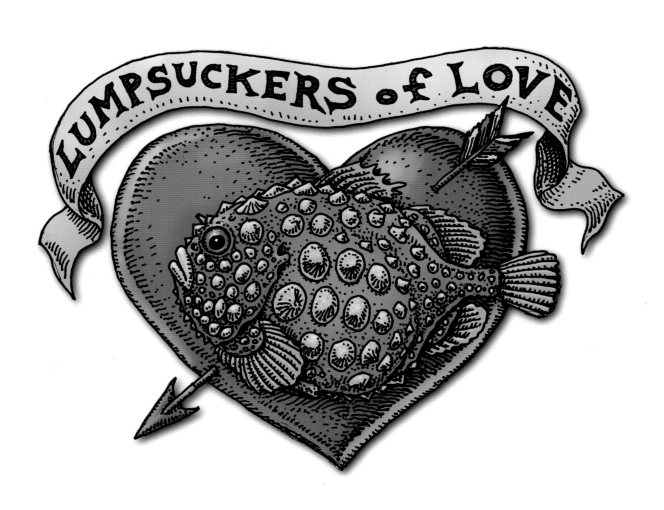

LUMPSUCKERS of LOVE

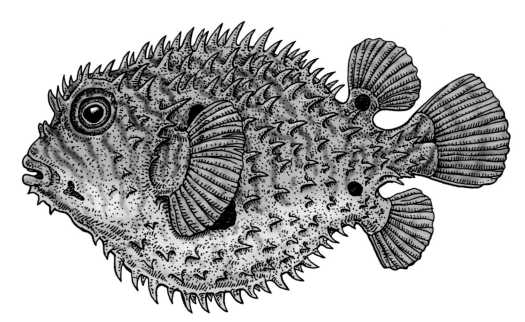

BLOW ME

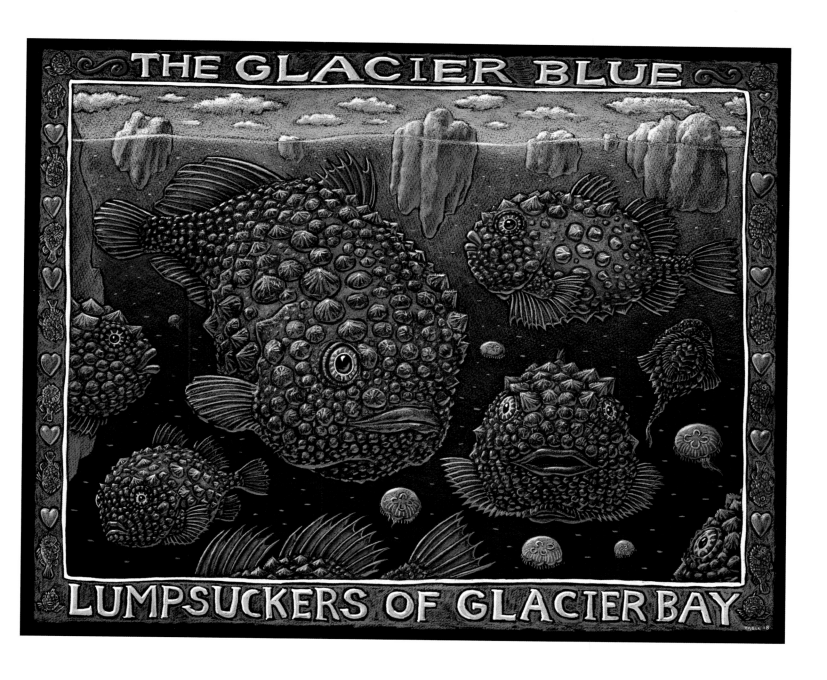

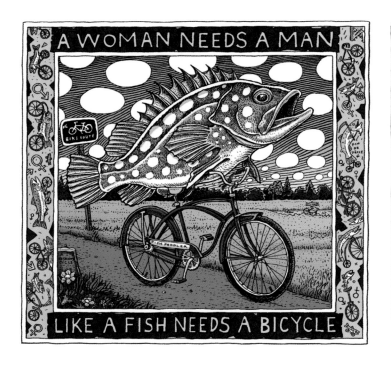

A WOMAN NEEDS A MAN
LIKE A FISH NEEDS A BICYCLE

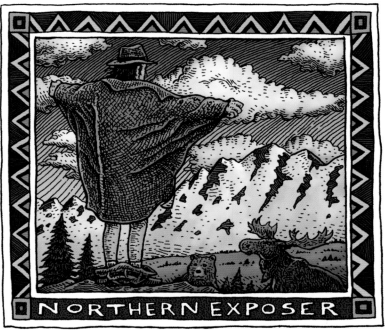

NORTHERN EXPOSER

IT'S A THIN LINE BETWEEN LOVE AND BAIT

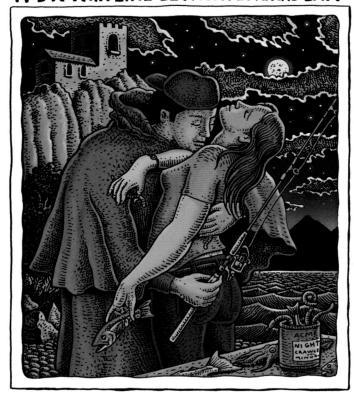

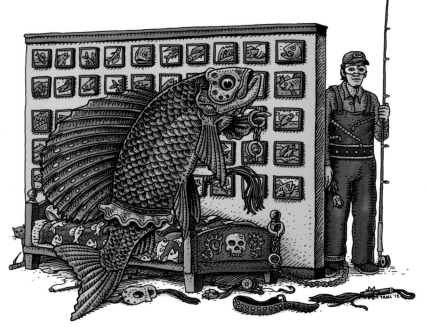

Fifty Shades of Grayling

THE COFFEE SUTRA

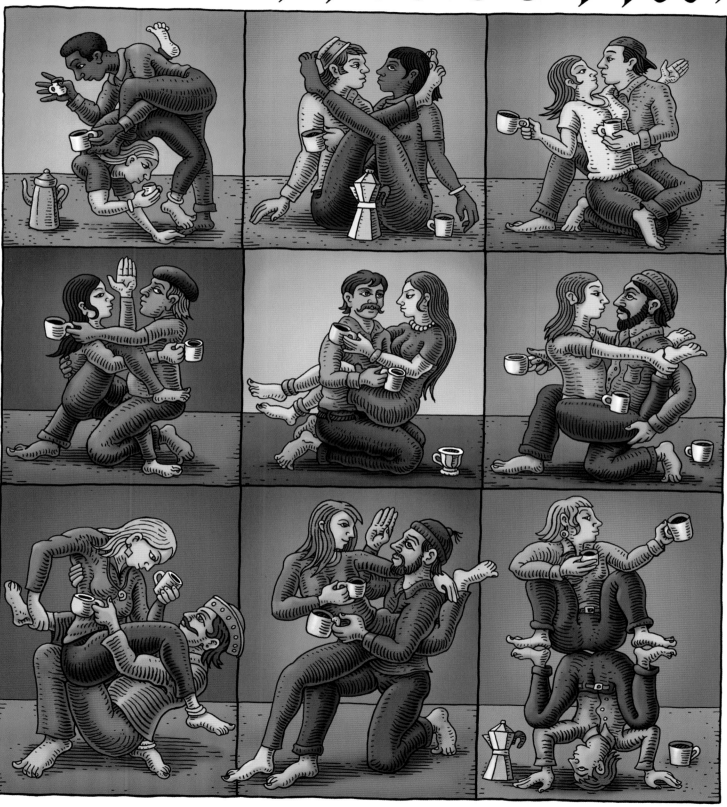

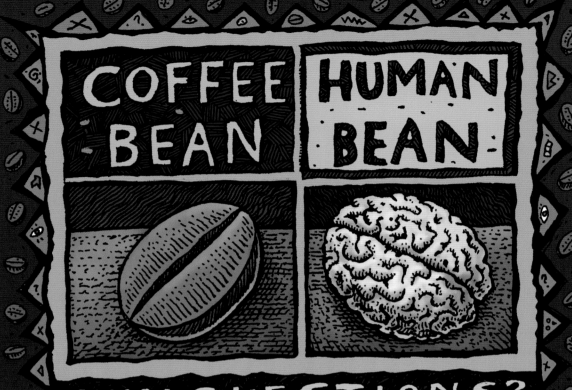

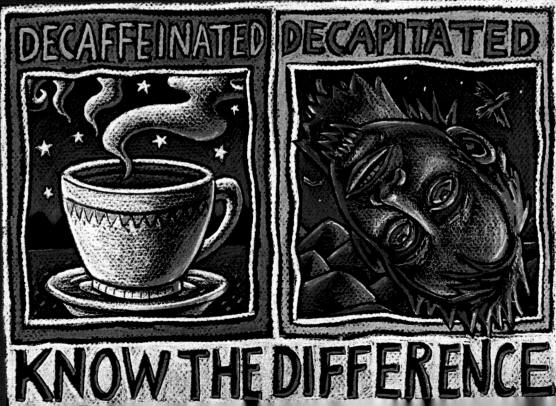

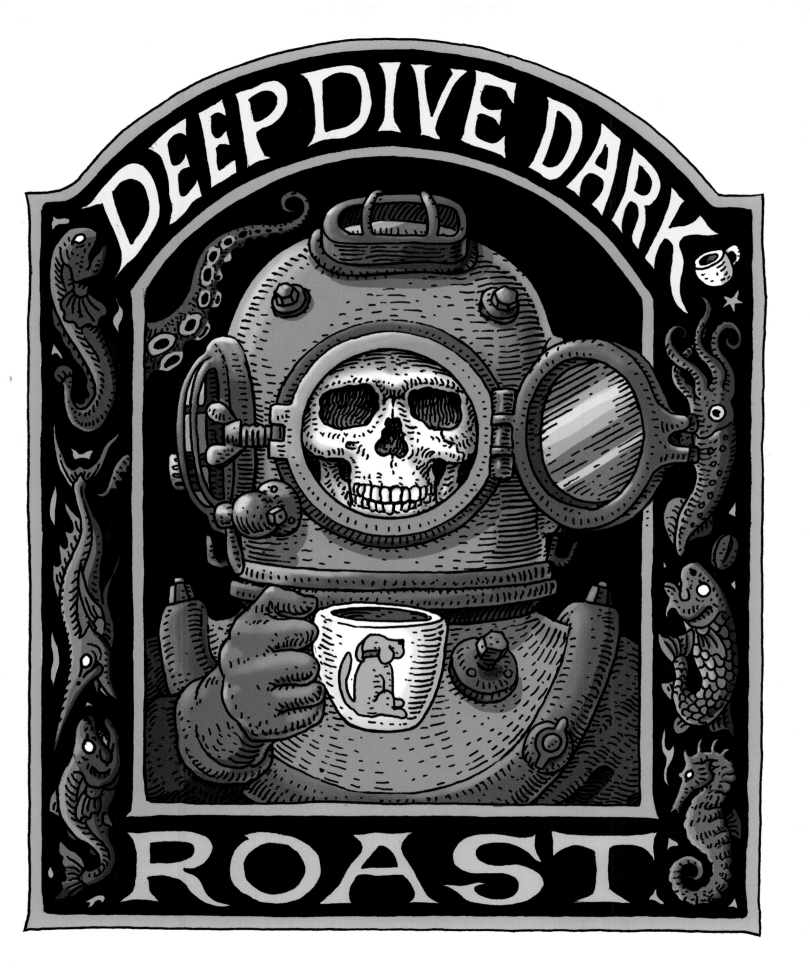

DEEP DIVE DARK ROAST

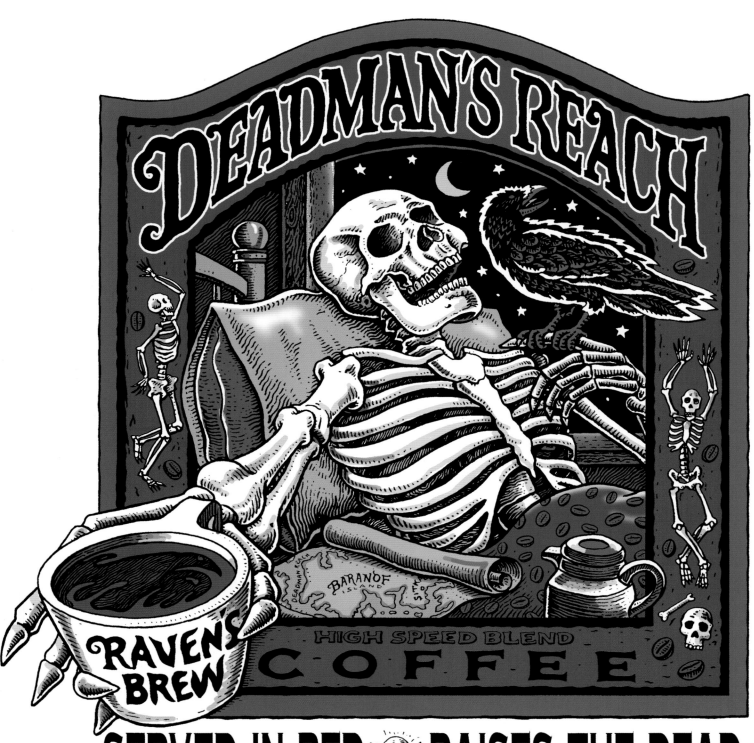

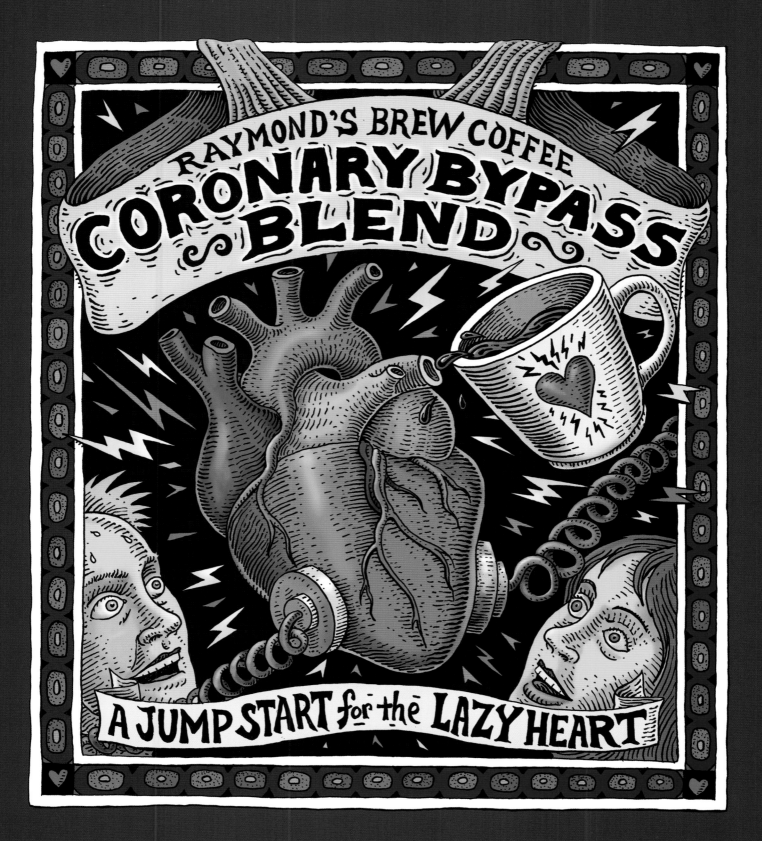

THE FAMILY THAT PREYS TOGETHER STAYS TOGETHER

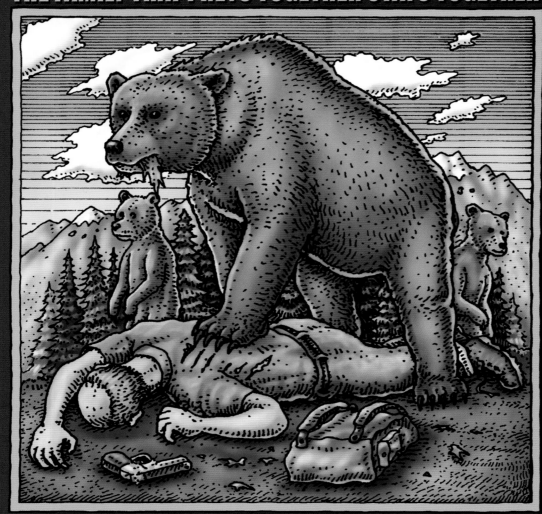

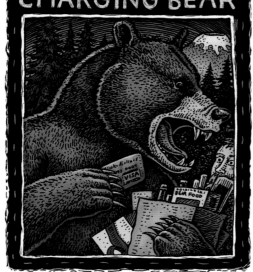

A Kodiak moment...

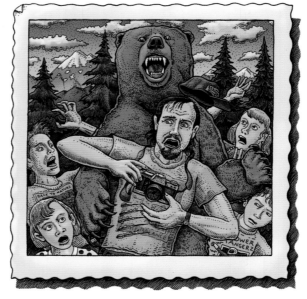

NEVER EVER GET BETWEEN ME AND MY

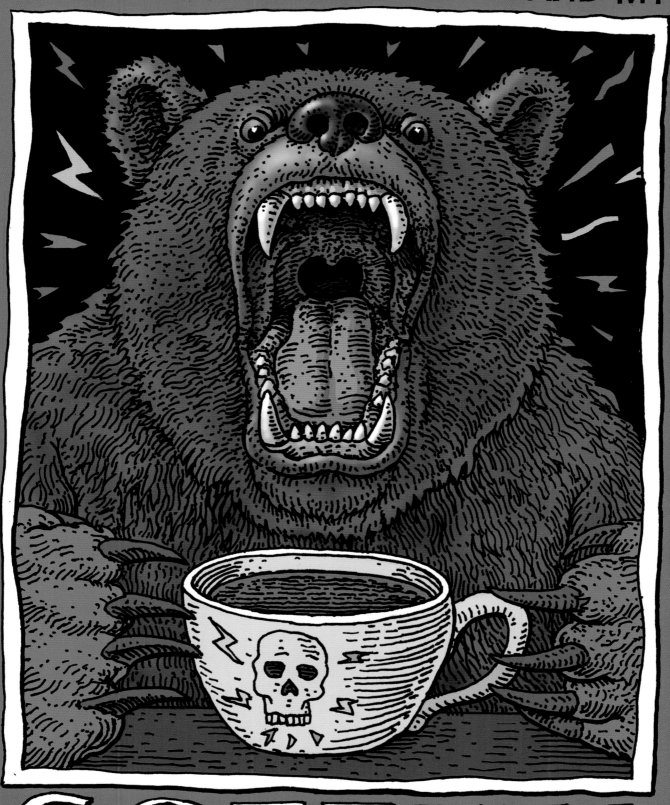

COFFEE!

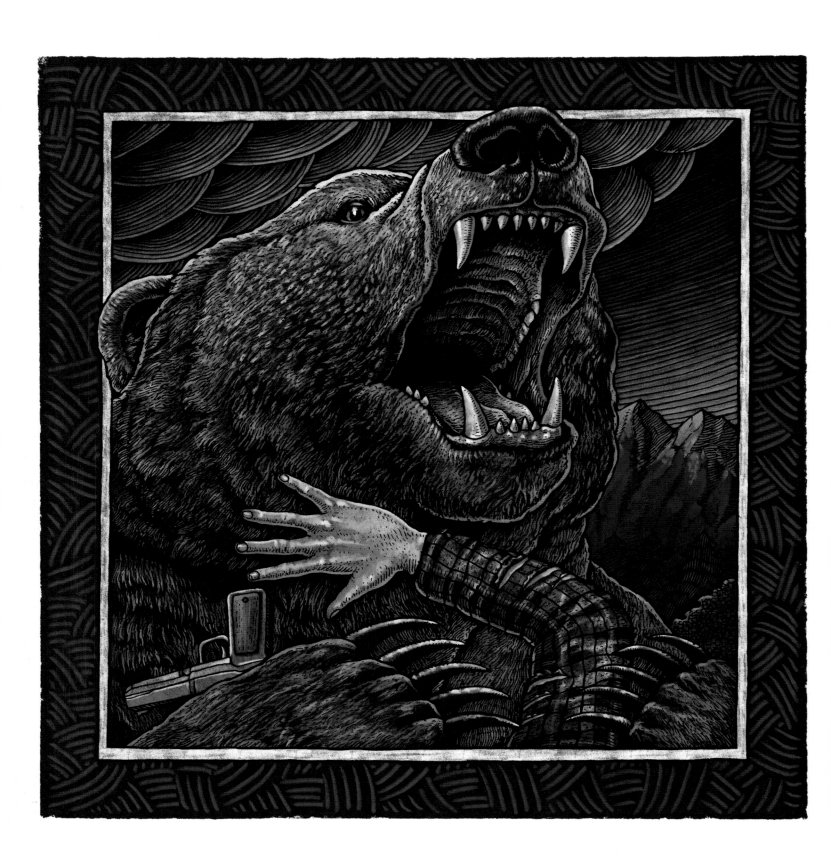

The Last Great Adventure

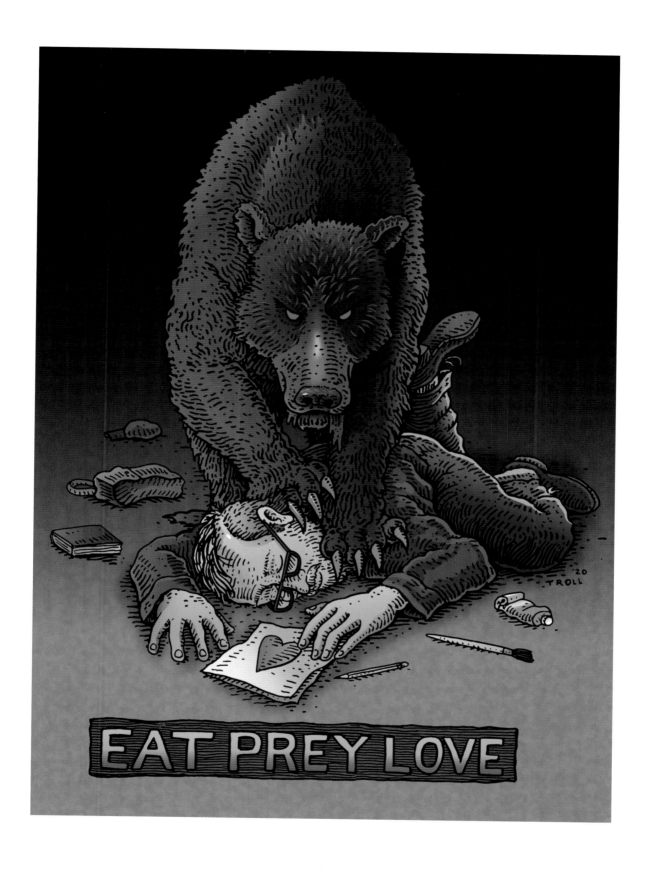

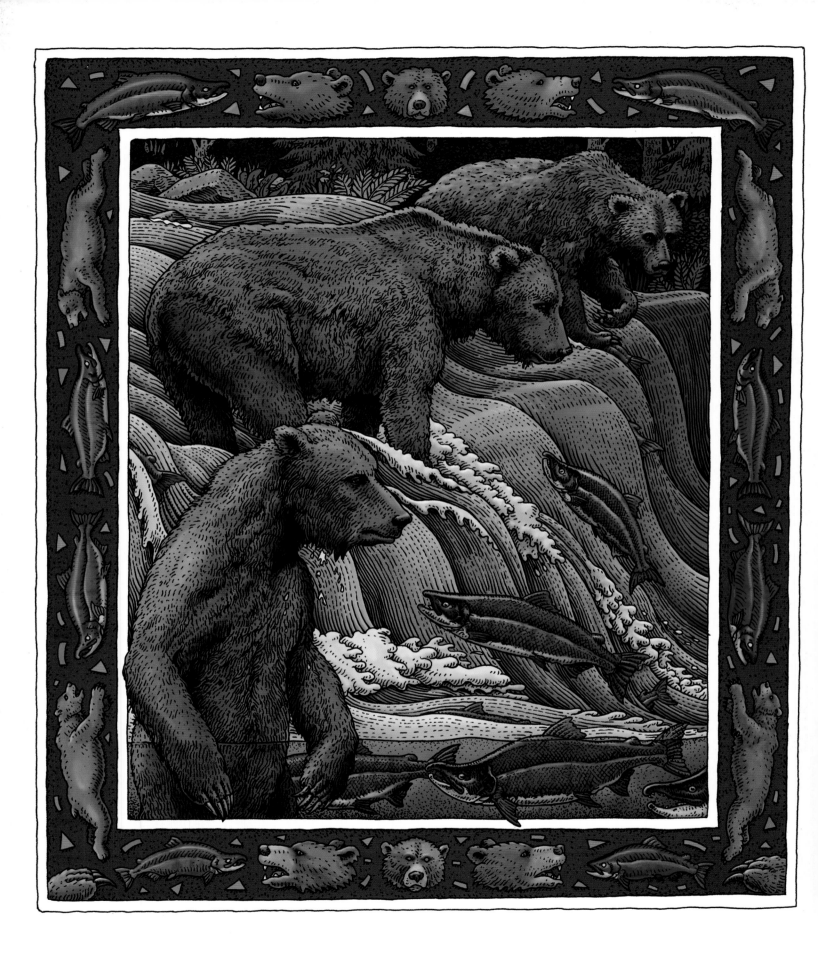

Bears of Katmai

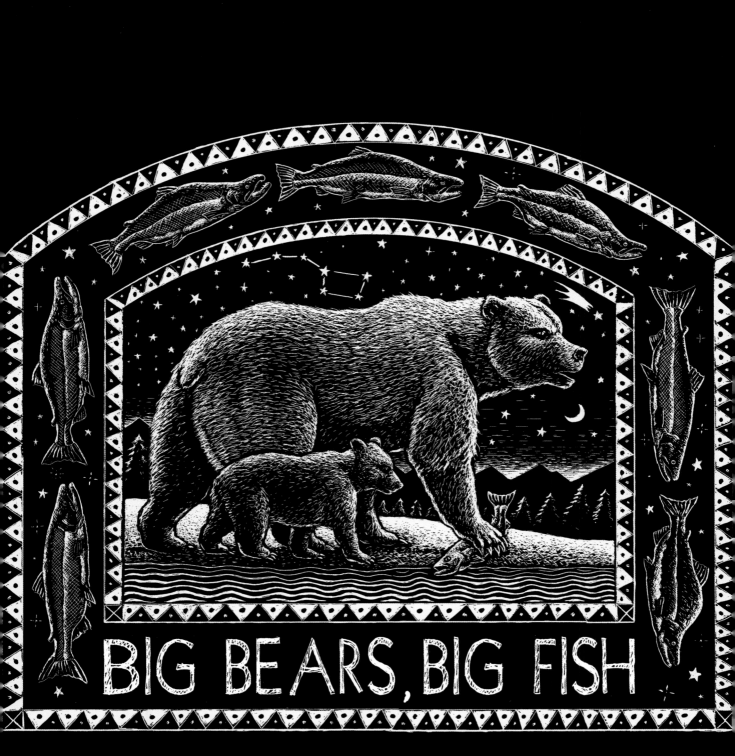

BIG BEARS, BIG FISH

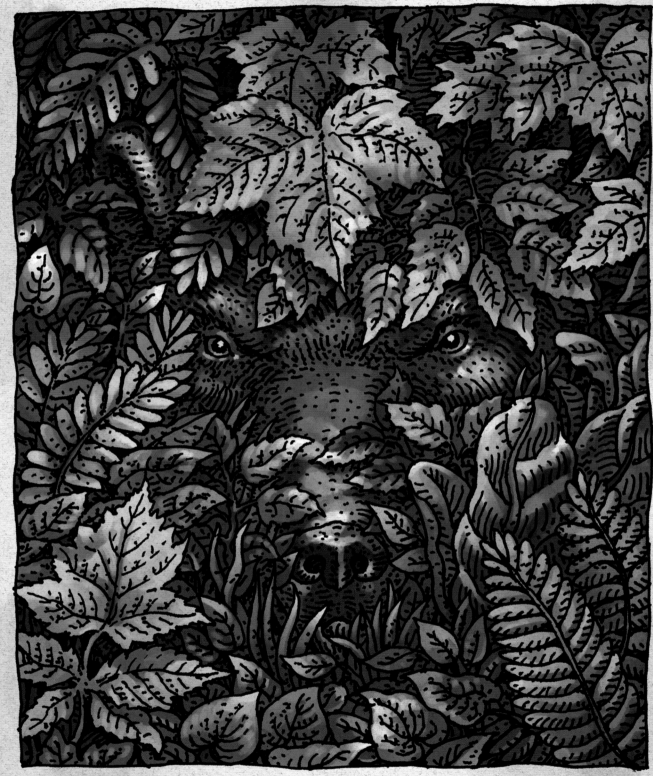

BEARLY THERE

DEVIL'S CLUB

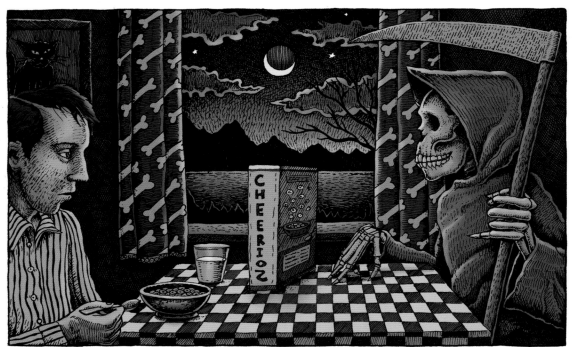

DEATH AND CHEERIO2

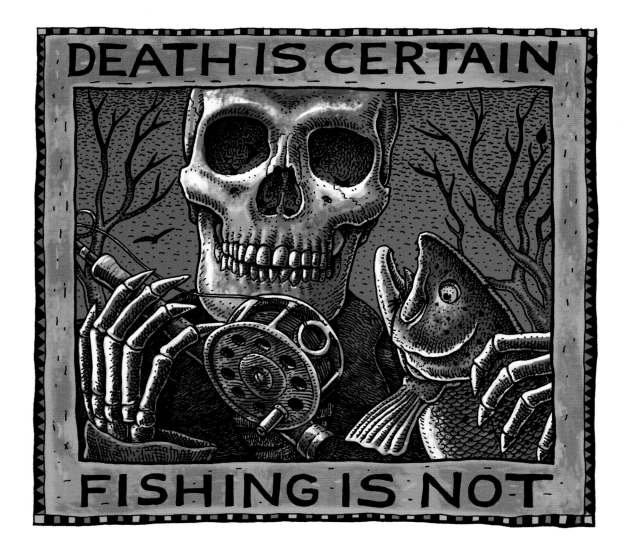

THE SEVENTH SEAL

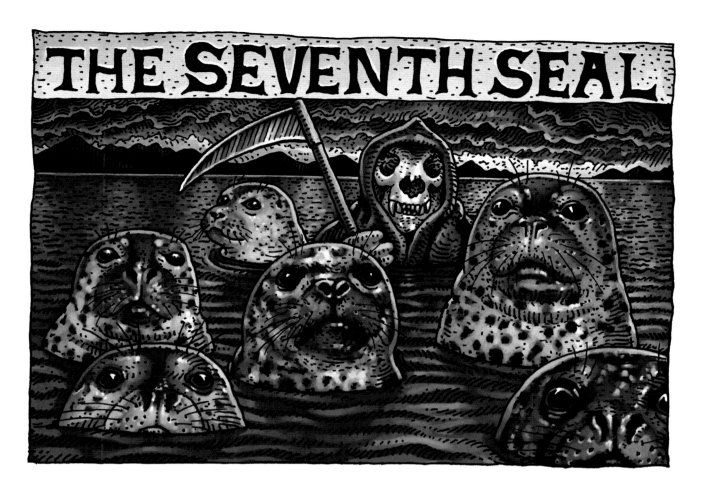

TO DREAM THE IMPOSSIBLE STREAM

DOOBIE
OR NOT
DOOBIE

WHAT WAS THE QUESTION?

Don't fear the Reefer

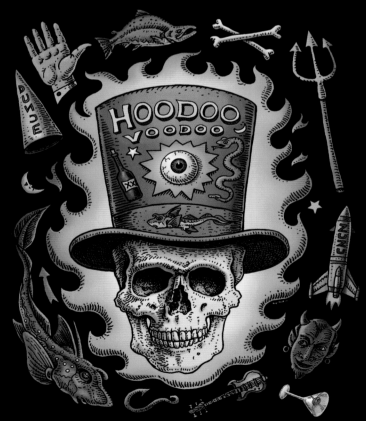

HOODOO
VOODOO

IT'S HAPPY HOUR IN HELL

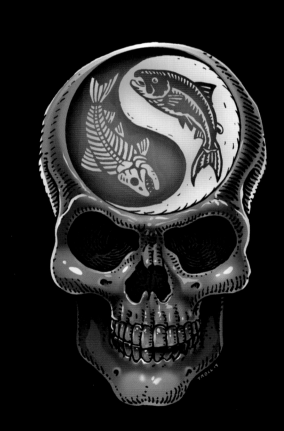

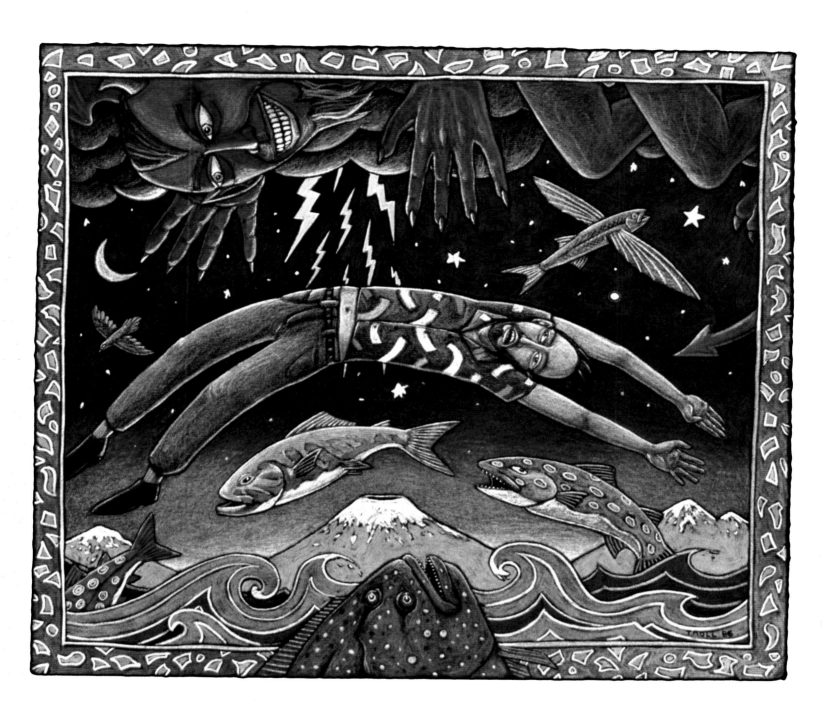

ABOVE: Between the Devil and the Deep Blue Sea *FOLLOWING SPREAD:* The Kingfisher, the Raven and the Half Moon Run

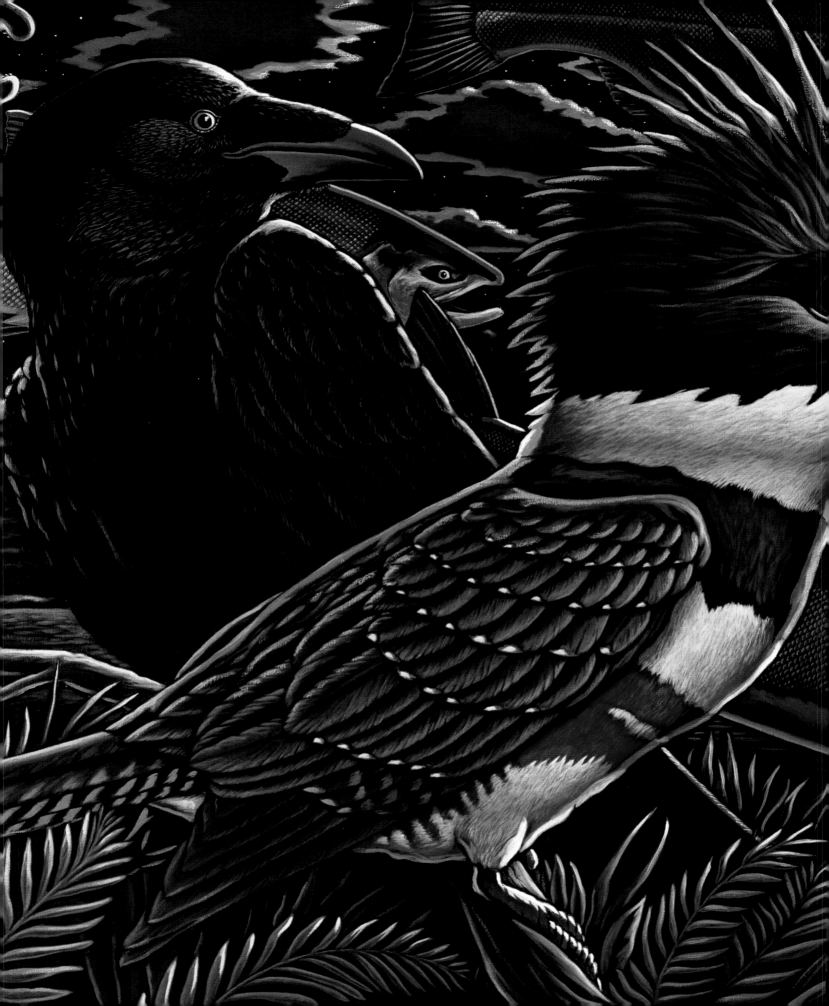

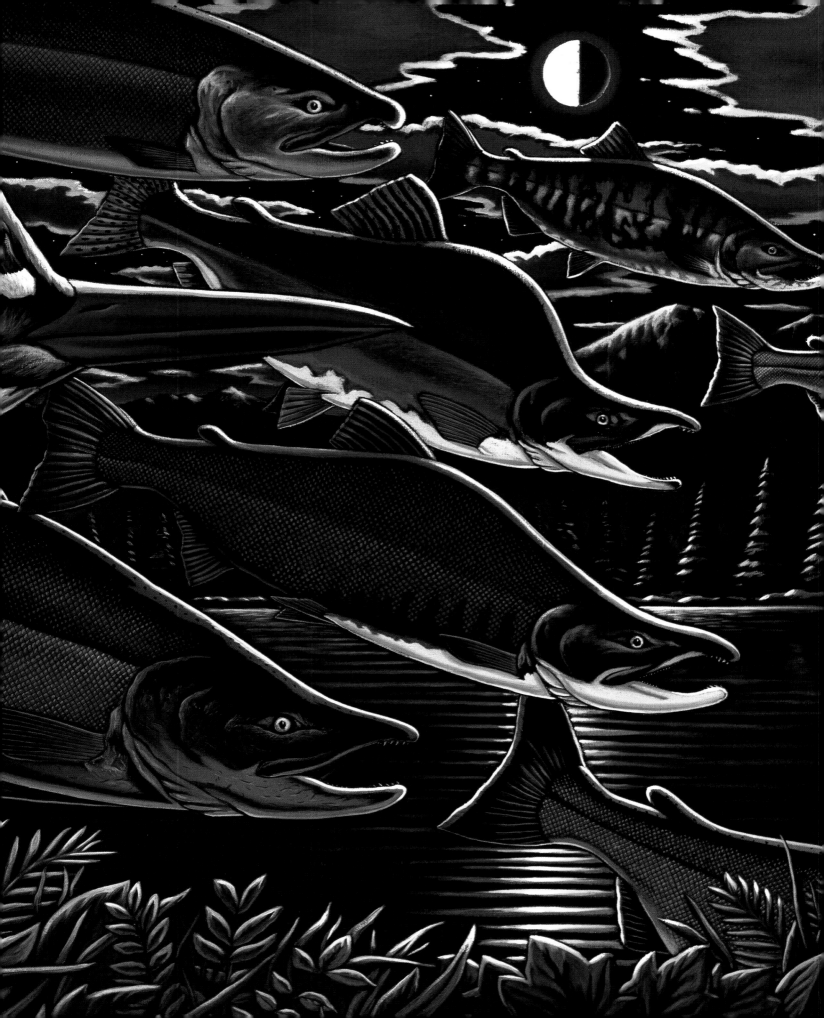

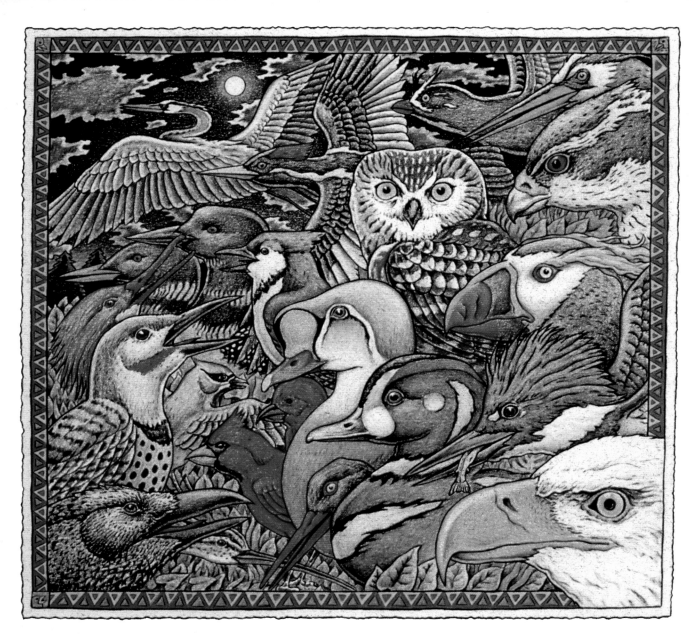

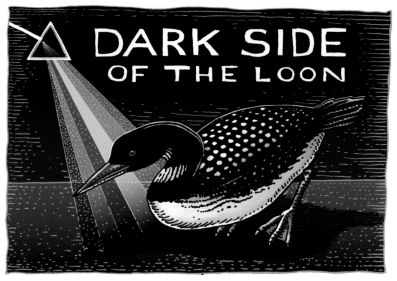

TOP: One for the Birds

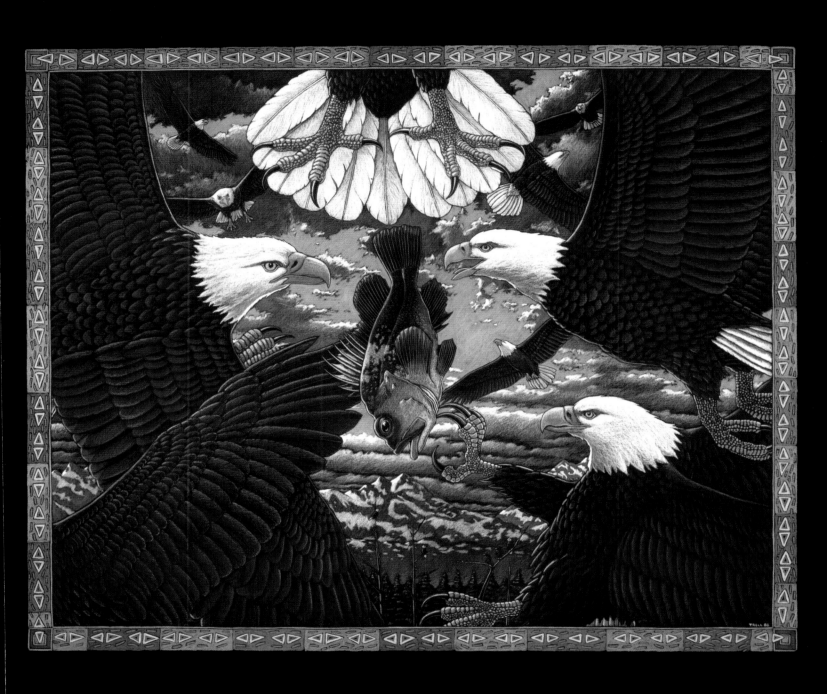

Eagle Bait

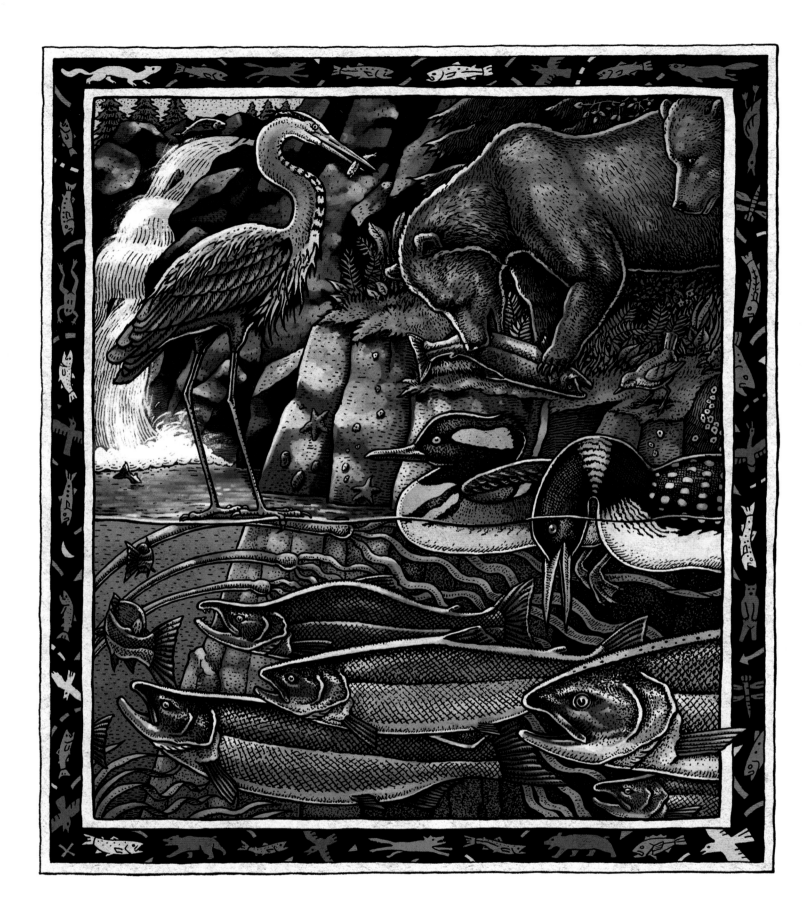

Preserve the Balance

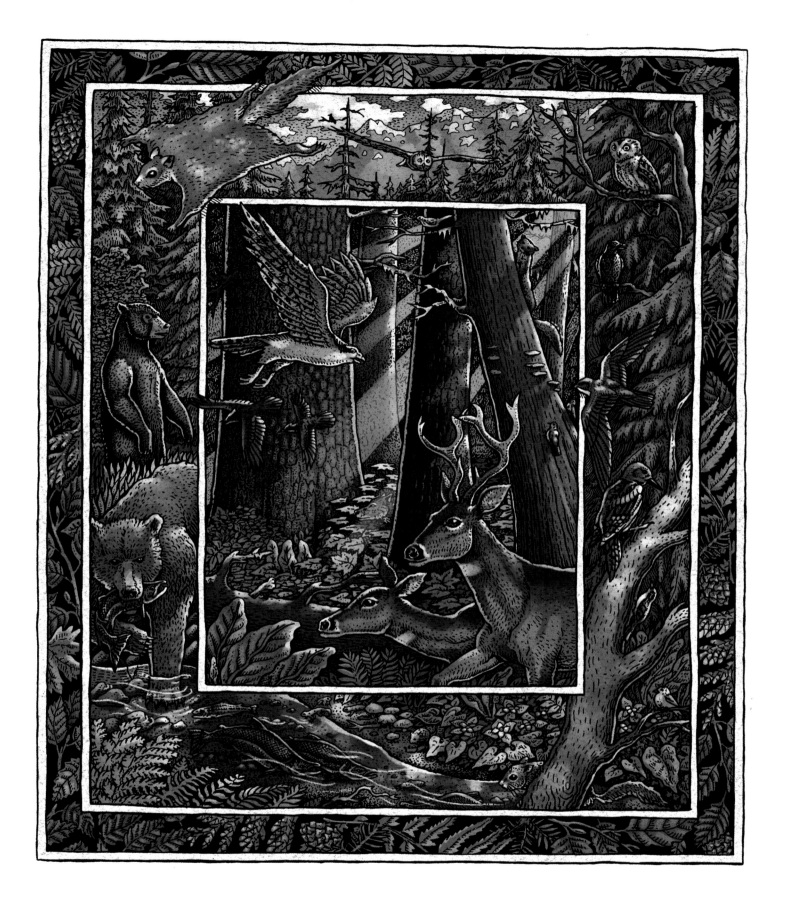

Ancient Forests Forever

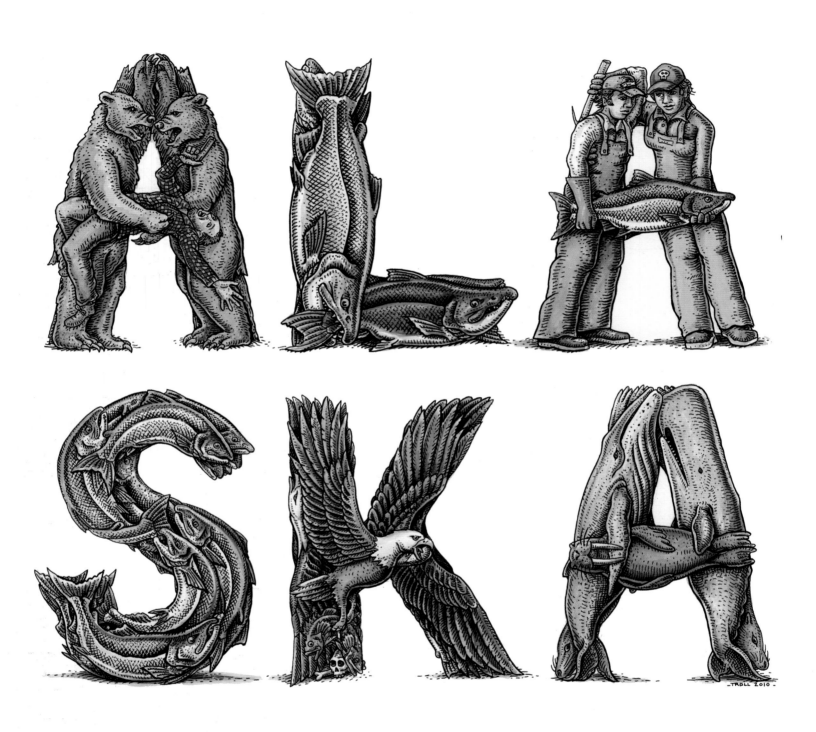

A.L.A.S.K.A.

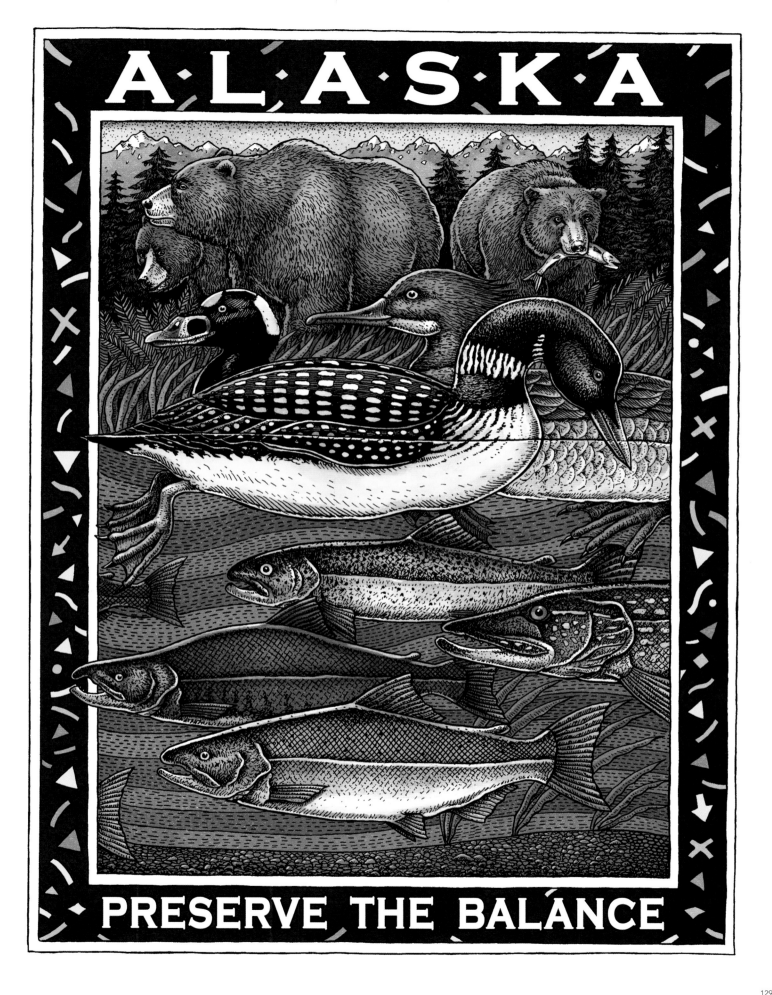

129

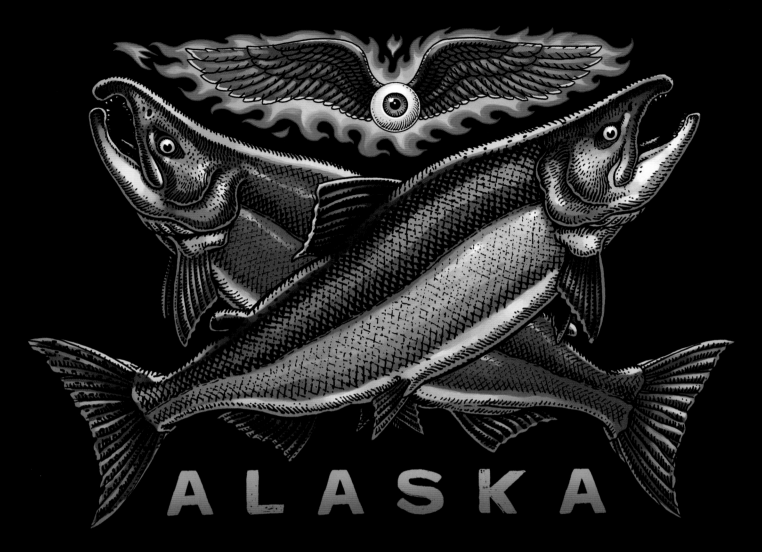

ALASKA

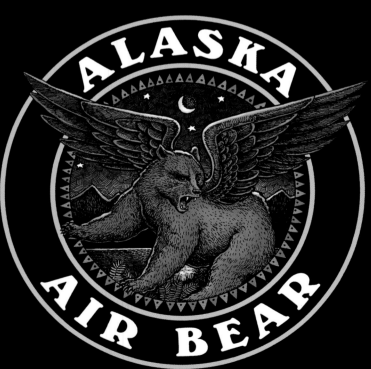

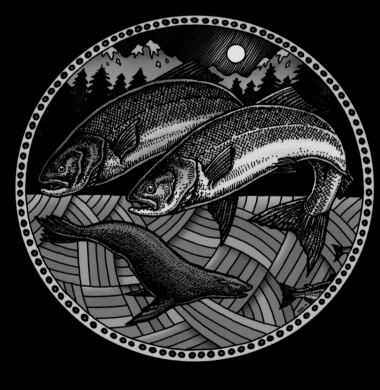

BOTTOM RIGHT: Coho Duo

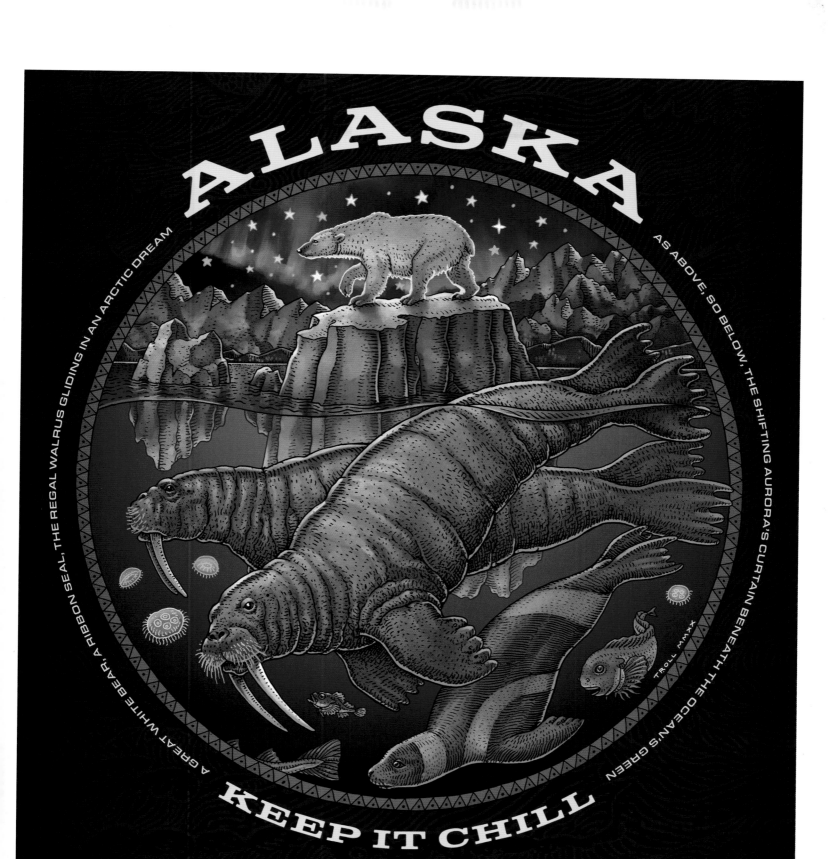

ALASKA

KEEP IT CHILL

A GREAT WHITE BEAR, A RIBBON SEAL, THE REGAL WALRUS GLIDING IN AN ARCTIC DREAM

AS ABOVE, SO BELOW, THE SHIFTING AURORA'S CURTAIN BENEATH THE OCEAN'S GREEN

TROLL MMXX

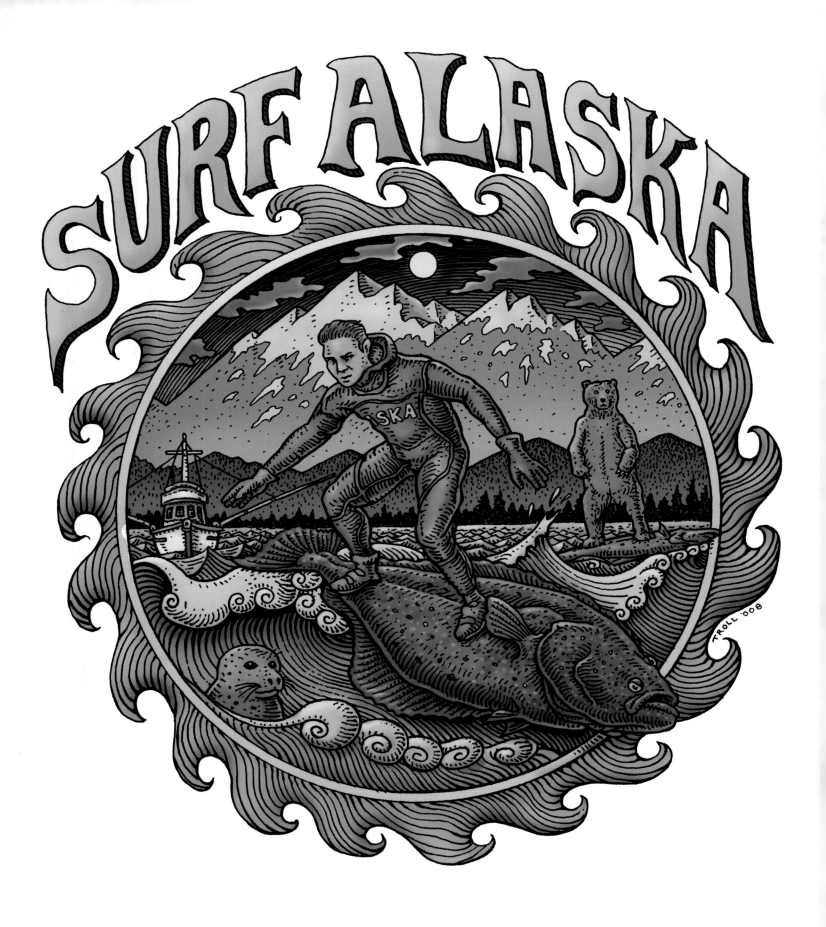

OPPOSITE PAGE: Spike the UAS Humpback

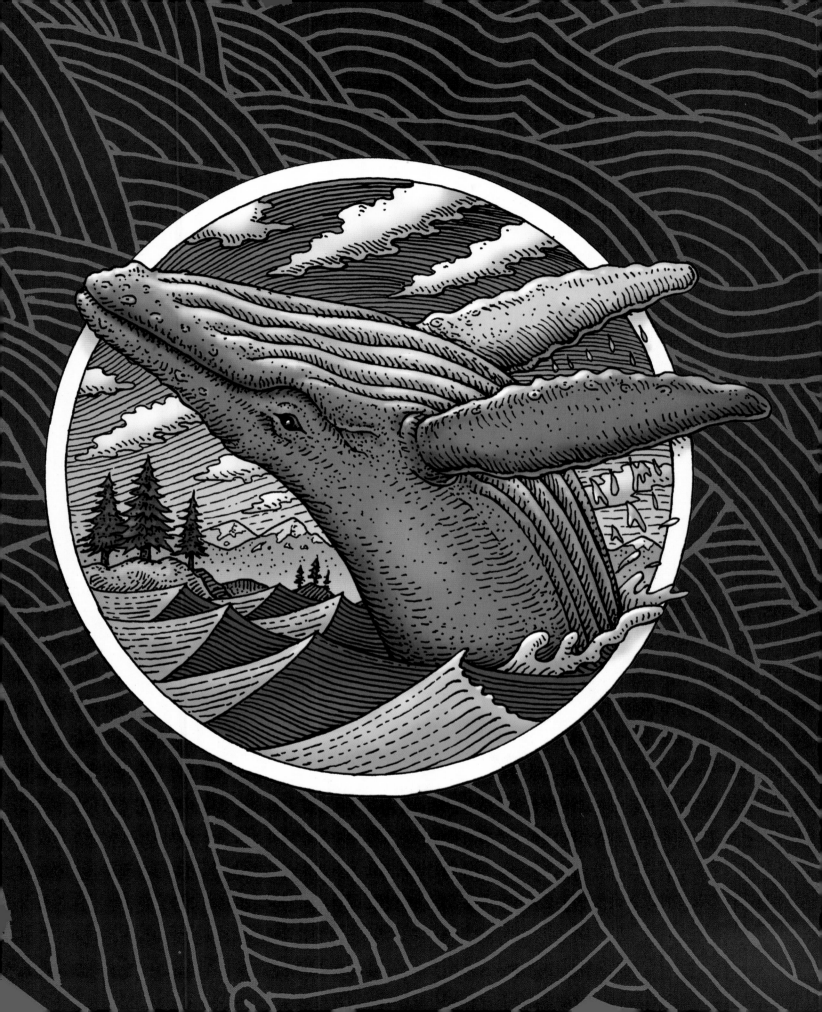

A WHALE OF A TIME

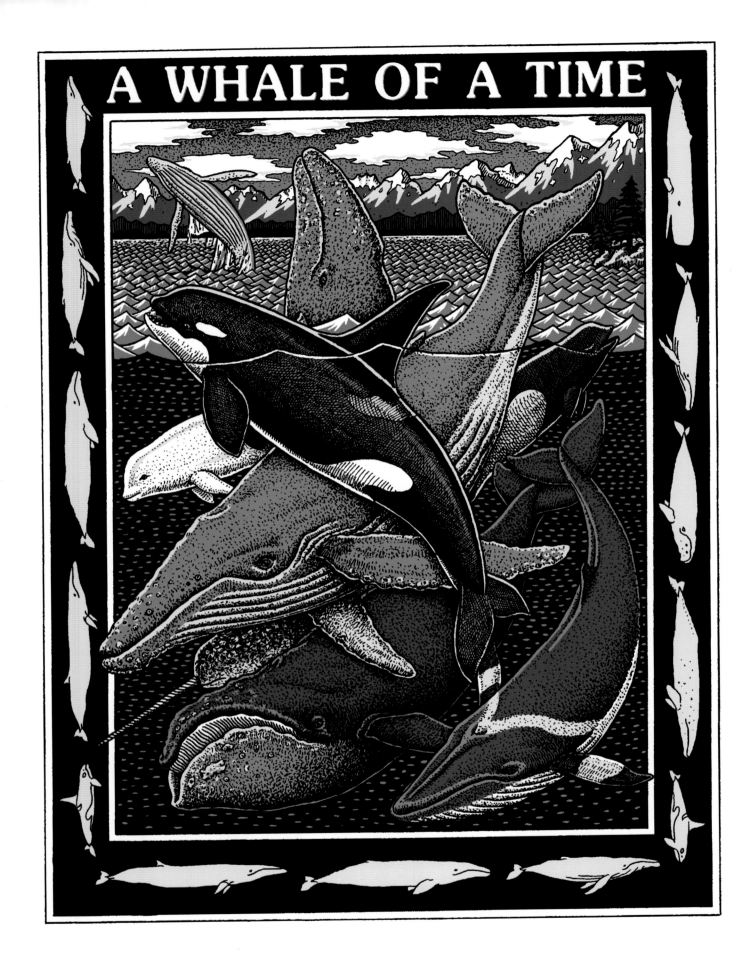

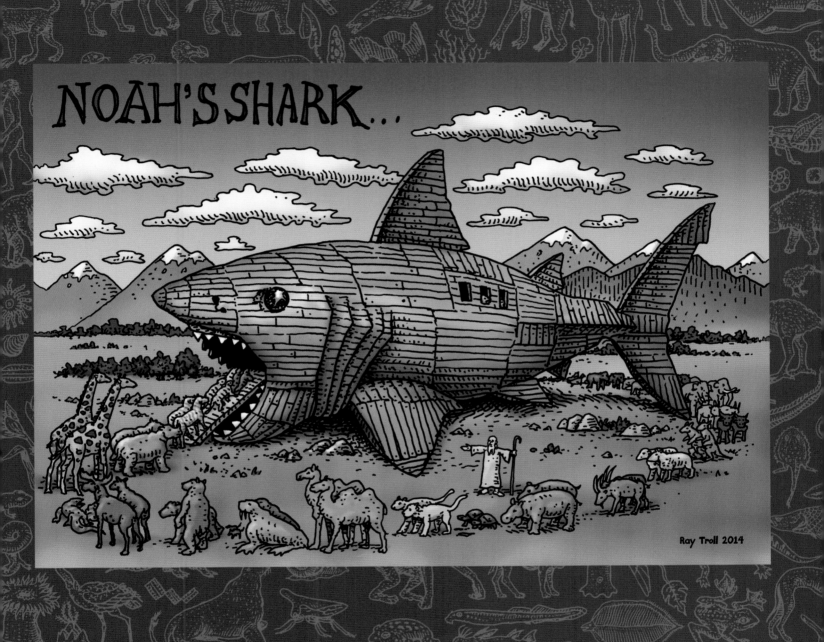

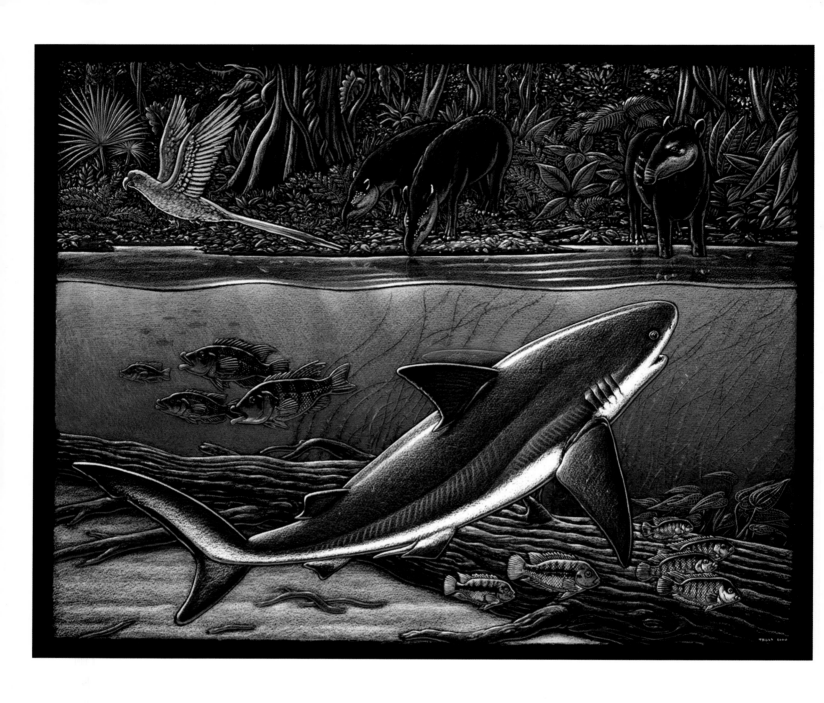

'B' is for Bull Shark

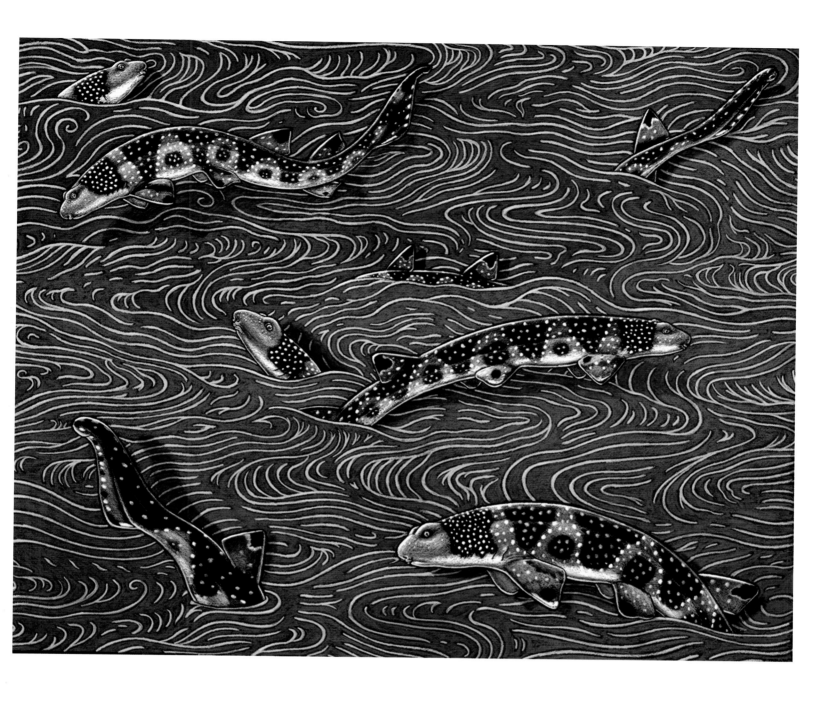

ABOVE: 'V' is for Varied Carpet Shark FOLLOWING SPREAD: Sharks, Skates and Ratfish of Alaska

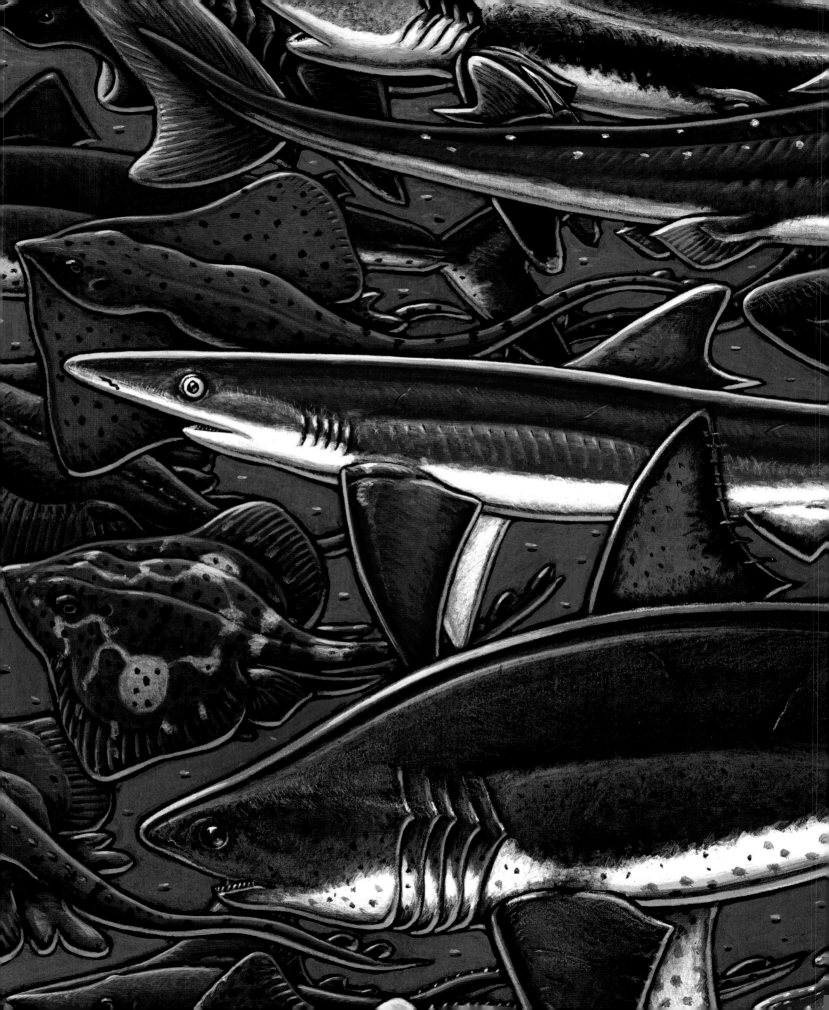

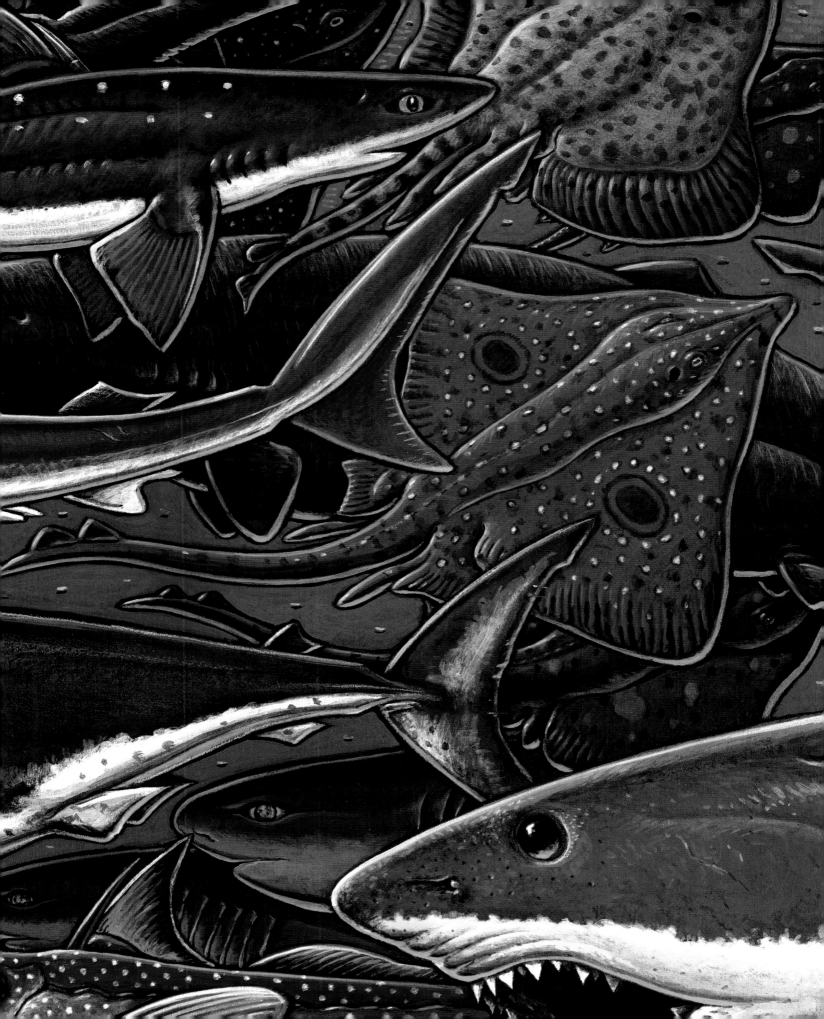

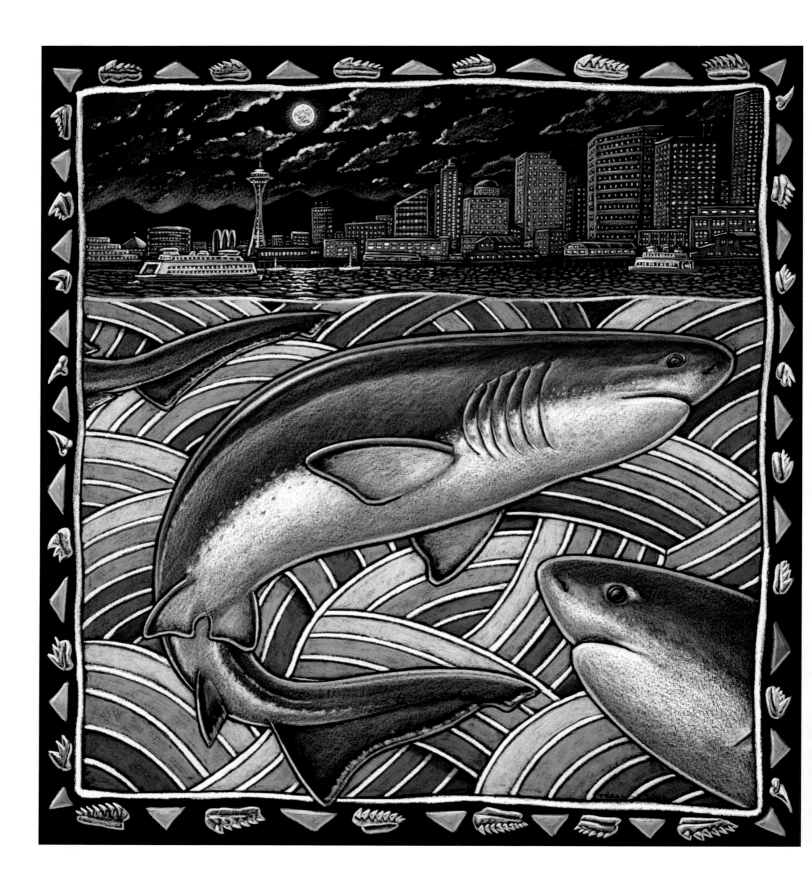

Six and the City

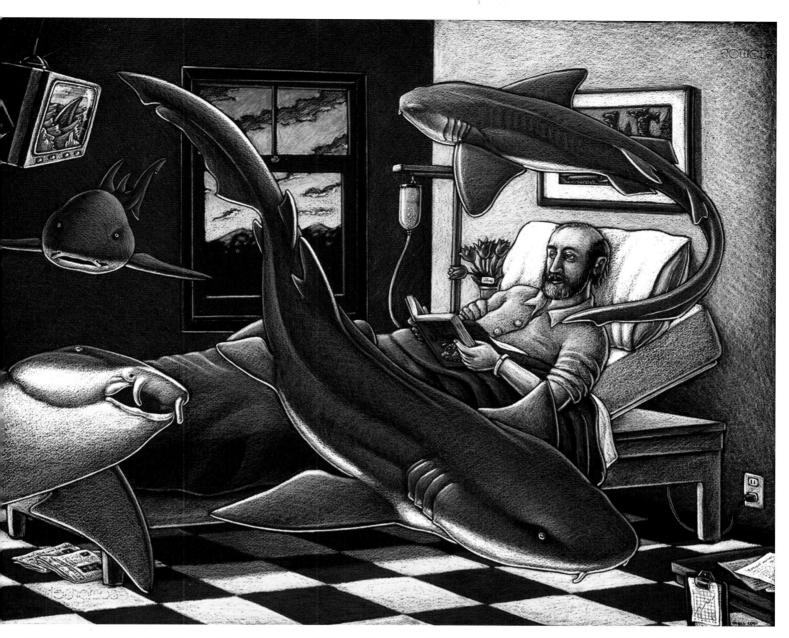

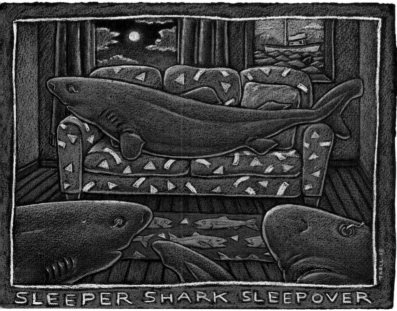

SLEEPER SHARK SLEEPOVER

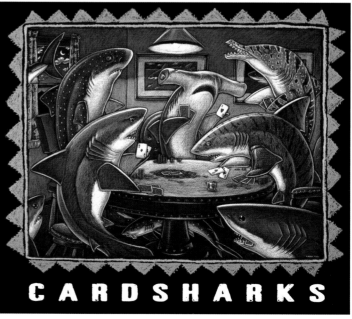

CARDSHARKS

TOP: 'N' is for Nurse Shark

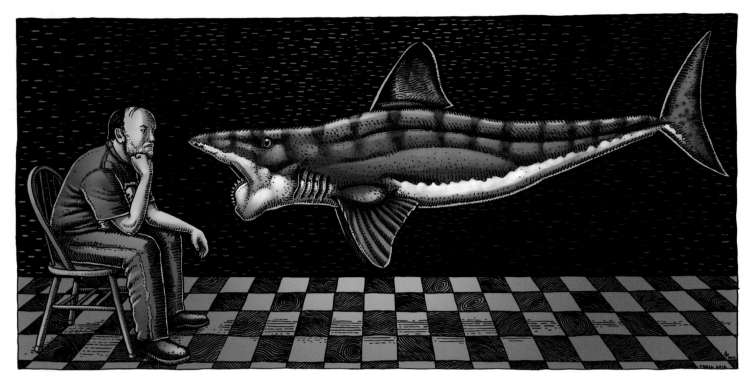

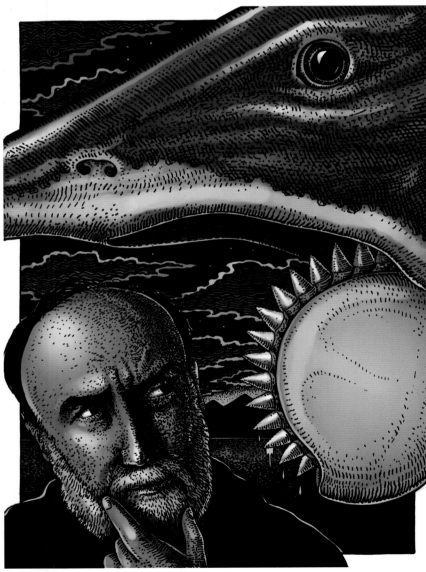

TOP: A Man, a Shark and 20 Years *BOTTOM:* Raymond and the Shark *OPPOSITE PAGE:* Karpinsky's Lament

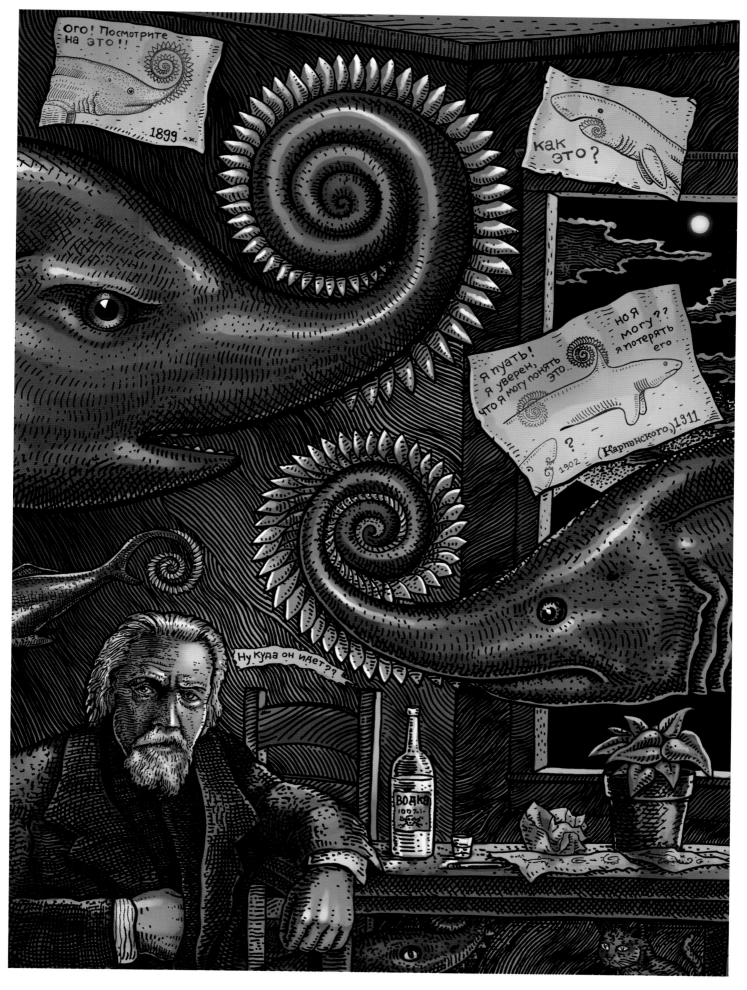

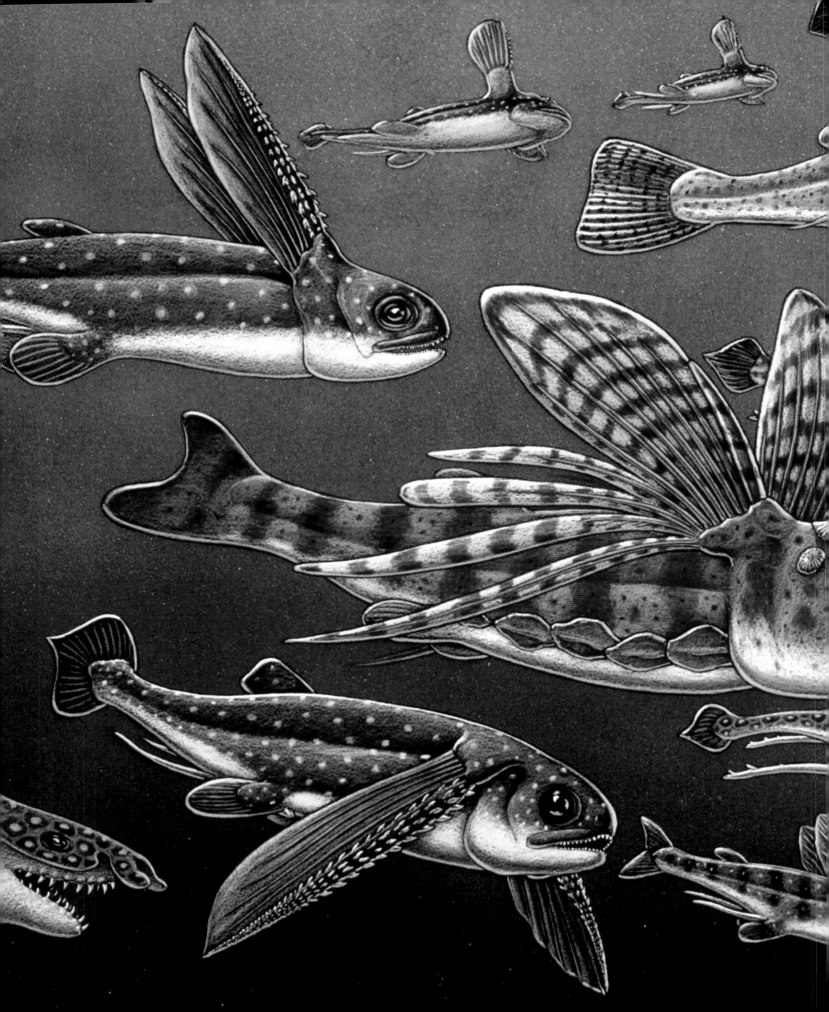

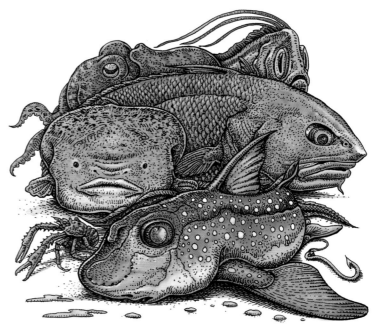

LEFT: 'I' is for Iniopterygians *RIGHT*: Ugliest Catch

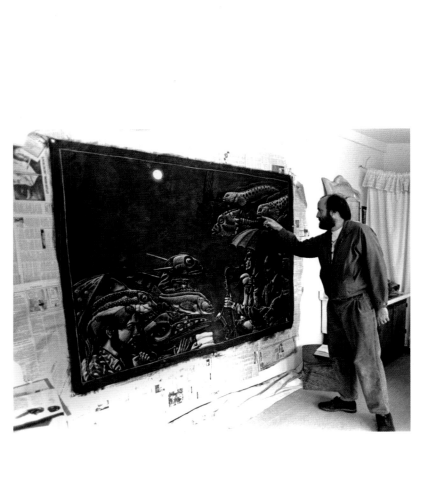

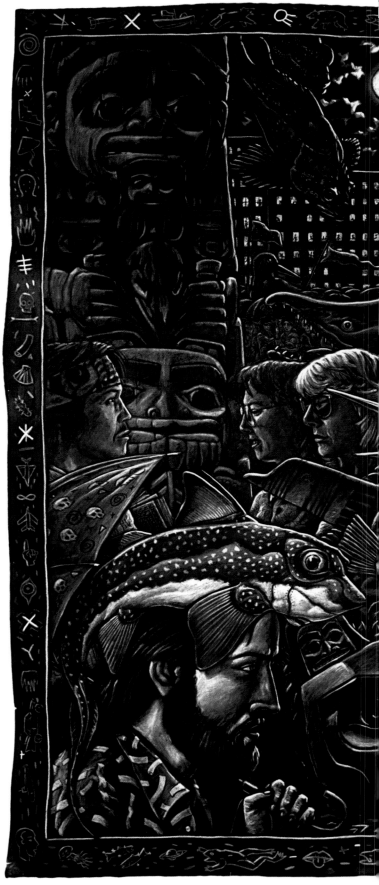

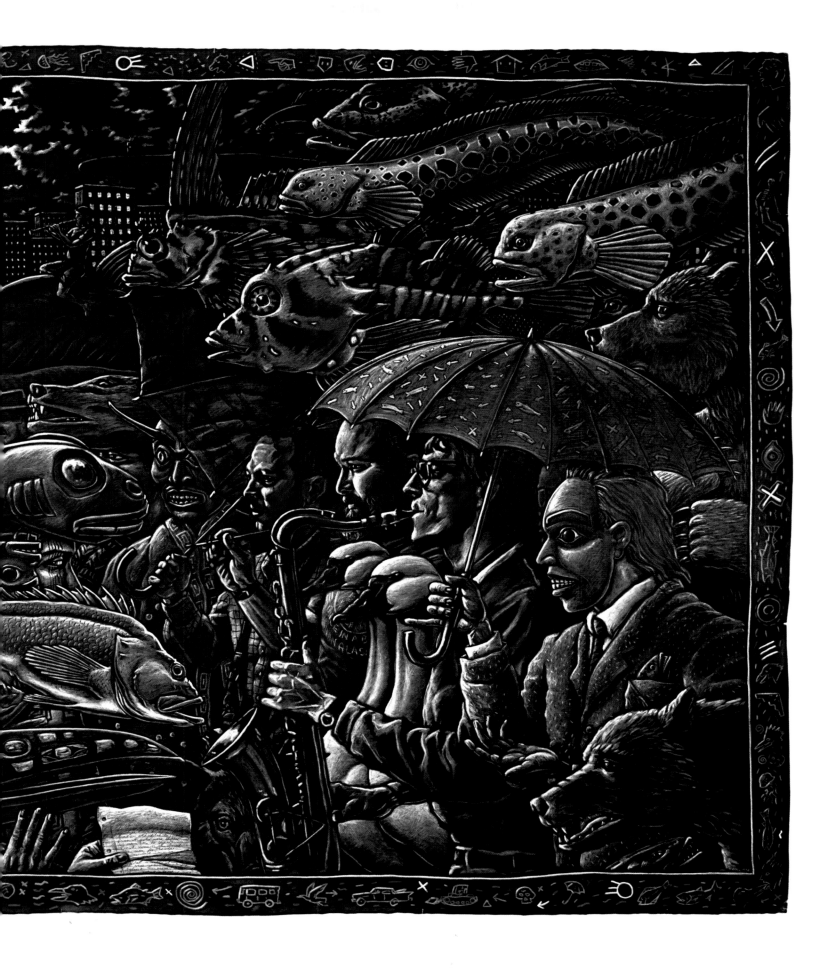

Rain on the Parade

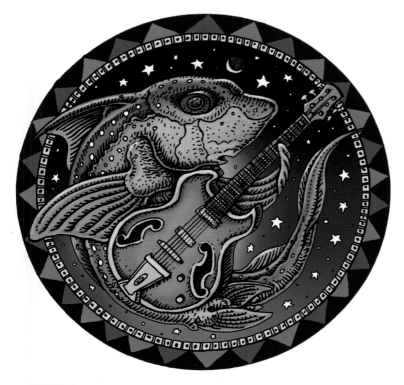

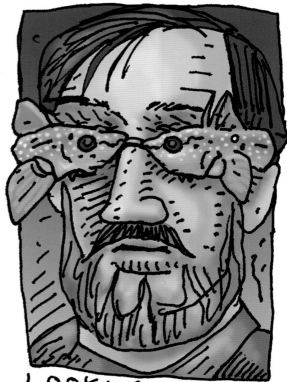

LOOKING AT THE WORLD THROUGH RATFISH COLORED GLASSES

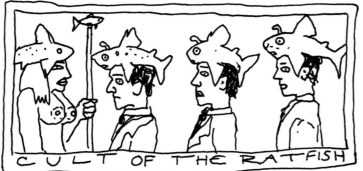

CULT OF THE RATFISH

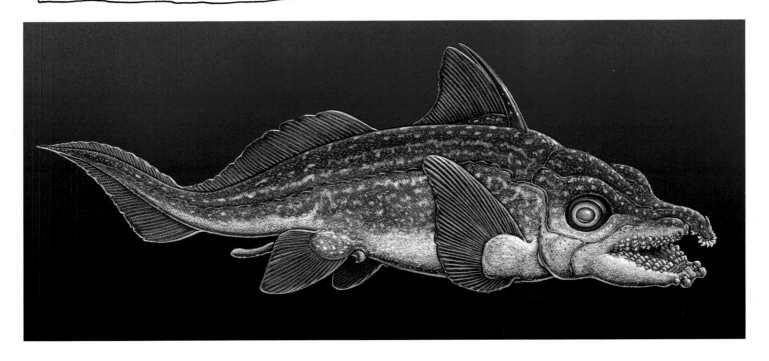

TOP LEFT: Ratfish Wranglers Logo *BOTTOM:* Helodus Reconstruction

FEAR NOT THE PALE RATFISH

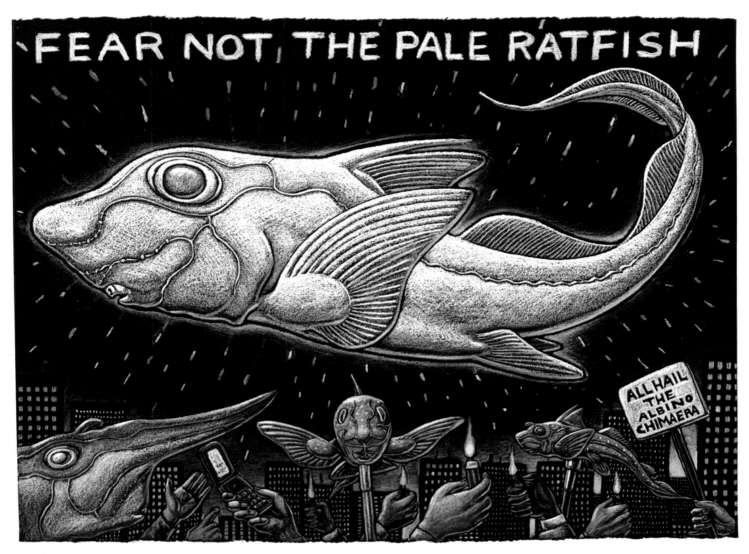

ALL HAIL THE ALBINO CHIMAERA

RATFISH WAITING PATIENTLY FOR SEATTLE TO GO AWAY.

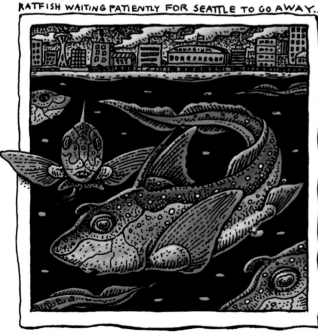

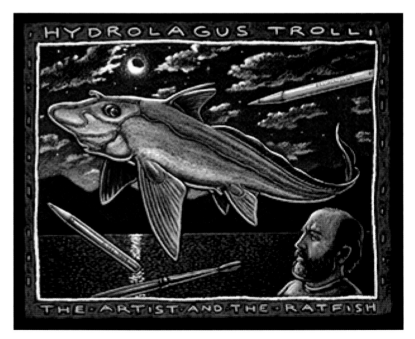

HYDROLAGUS TROLLI

THE·ARTIST·AND·THE·RATFISH

RATFISH RULE

Let me tell you a little story 'bout a fishy friend of mine
Dating back 300 million years in time
Goatfish, Spookfish, chimaera et tu
Strictly my opinion but the ratfish rule!

Hydrolagus colliei the water rabbit king
Comin' from the water with his eyes blue green
Shining like a Navajo, meck a leck a hiney ho
Nasty little claspers say my boy is set and good to go

Down 20 fathoms, he got lovin' on his head
Rub him just the wrong way , yer gonna be dead
One fish, two fish, dead fish, blue
I wish you was a ratfish too
One fish, two fish, dead fish, blue
I wish you was a ratfish too
One fish, two fish, dead fish, blue
I wish you'all were ratfish too

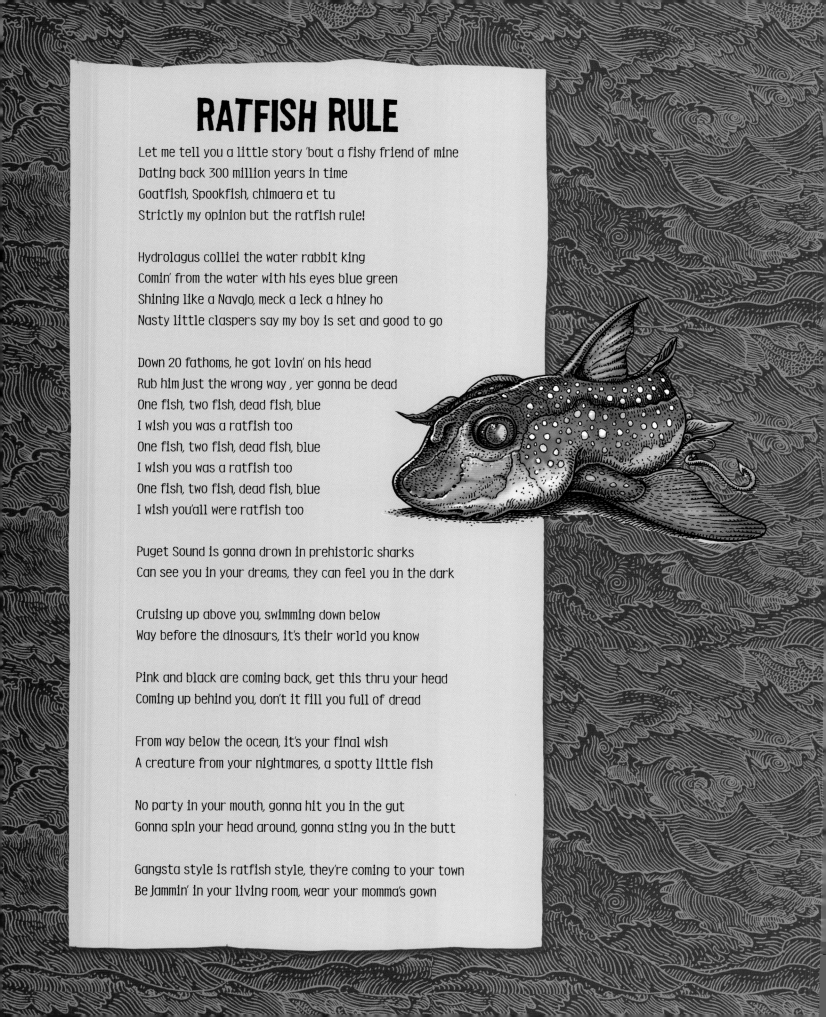

Puget Sound is gonna drown in prehistoric sharks
Can see you in your dreams, they can feel you in the dark

Cruising up above you, swimming down below
Way before the dinosaurs, it's their world you know

Pink and black are coming back, get this thru your head
Coming up behind you, don't it fill you full of dread

From way below the ocean, it's your final wish
A creature from your nightmares, a spotty little fish

No party in your mouth, gonna hit you in the gut
Gonna spin your head around, gonna sting you in the butt

Gangsta style is ratfish style, they're coming to your town
Be jammin' in your living room, wear your momma's gown

From the very moment you first catch a ratfish you know there's something different about this fish. It looks like nothing else in the sea. Indeed it truly is like a visitor from another world, another planet. The Devonian planet to be precise, because ratfish first evolved over 300 million years ago, way, way back in time, and they have changed very little since those ancient Paleozoic days. Ratfish are living fossils, my friends.

There are about 50 species on our watery planet today, some growing to about five feet in length, although most are around two feet.

They are also known as chimaeras, the name of the mythical Greek monster made of many beasts. Other common names are ghost sharks, spookfish, and elephantfish.

The Alaskan species is the spotted ratfish, Hydrolagus colliei. Hydro meaning "water" and lagus meaning "rabbit." So yeah, it's a water rabbit too. The mouth looks just like a rabbit's buckteeth. Their tails resemble a rat's, hence the common name.

Most people don't like ratfish, but I'm here to tell you, you should love 'em. Their eyes are fantastically cool—big, shimmering globs of shiny turquoise.

The males sport a pair of bizarre clasping organs for doing what comes naturally at 20 fathoms below. Ratfish, just like their shark cousins, must have physical contact to make more little ratfish. However, unlike the beastly male sharks that must bite and hold on to their lady friends, the gentlemanly ratfish will use a "grabbing" device on top of its head, called a tenaculum, to ever so gently hold the female's pectoral fin while he uses one

of his two pelvic claspers to fertilize her. Oh my.

Watch out for their poisonous dorsal fin spines, brothers and sisters. If it pokes you, you'll be in for a world of hurt.

Their body looks like it's covered with stitches. Sorta' like a science experiment gone very wrong. Those stitch lines are actually covered with electrical sensors, used to detect their prey. That's right—a ratfish can feel you when you walk into the room. Because your muscles, your beating heart, the blood pumping in your veins, are all making electricity. And a ratfish can "see" that electricity. Oh yeah.

Ratfish are taking over the world again, friends. Their numbers are on the increase. As the ever more popular sports fish are eliminated from the ecosystem, the ratfish moves in. They are now the dominant biomass in Puget Sound in front of Seattle.

But we should not fear their return. This world has long been theirs and they are waiting, waiting for us all to just go away.

From deep, deep time to our time. All hail the ratfish.

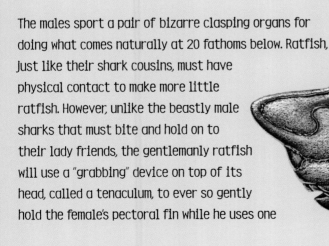

Lyrics by Ray Troll and Russell Wodehouse

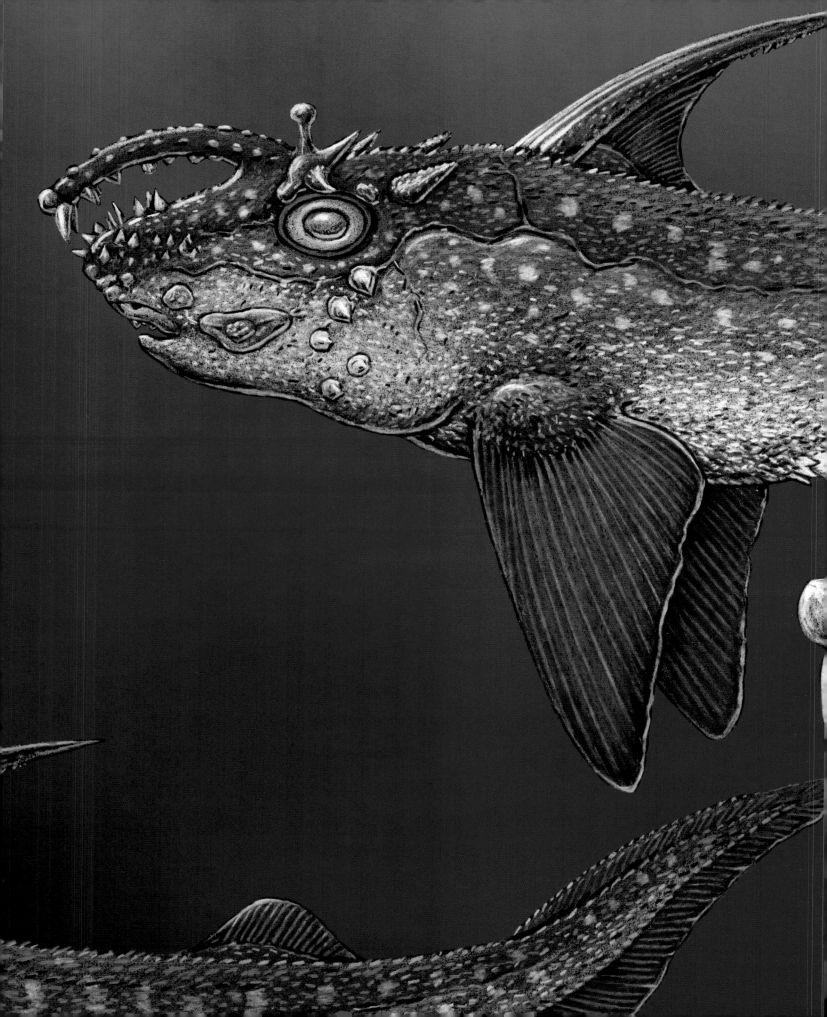

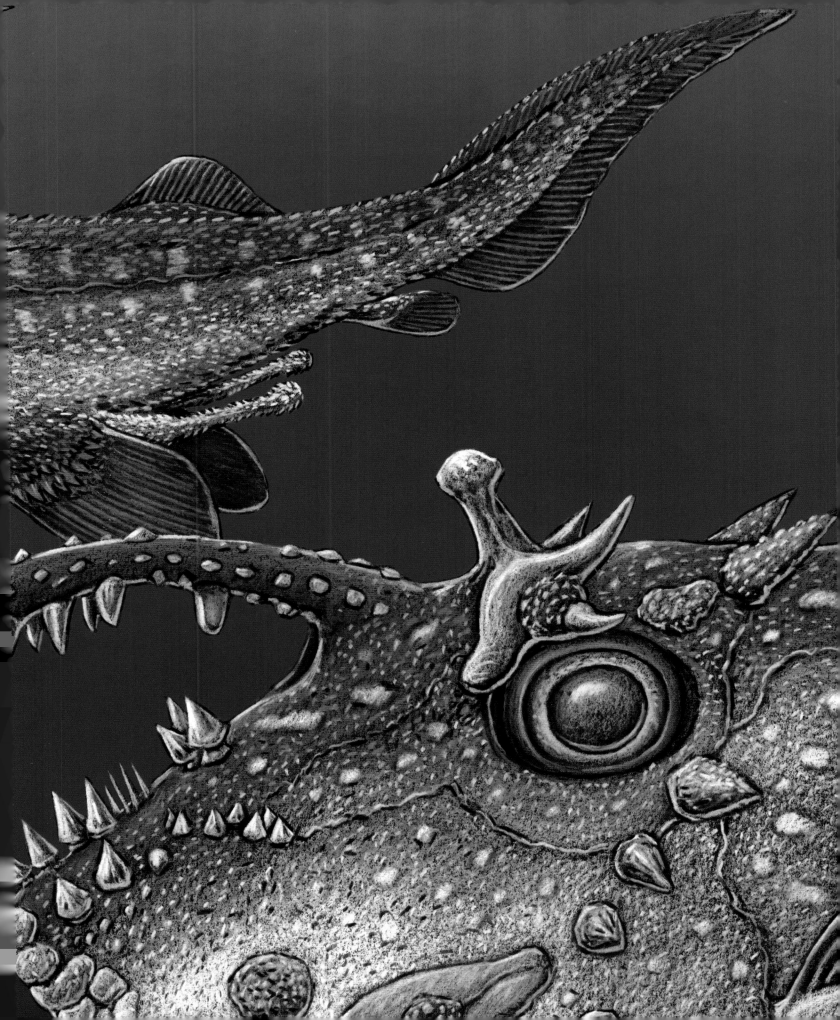

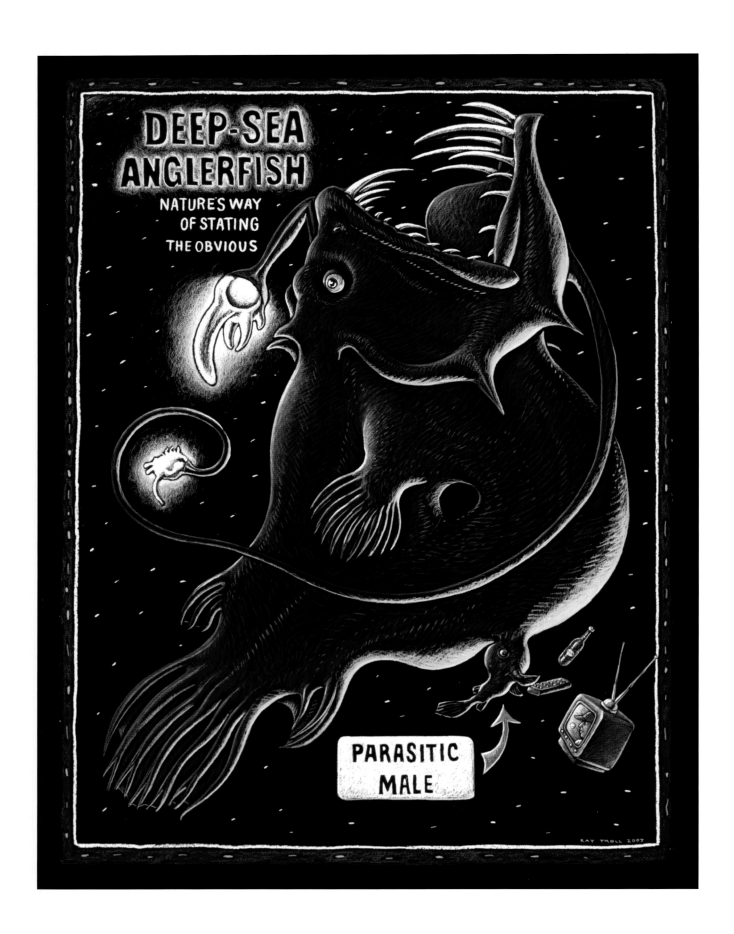

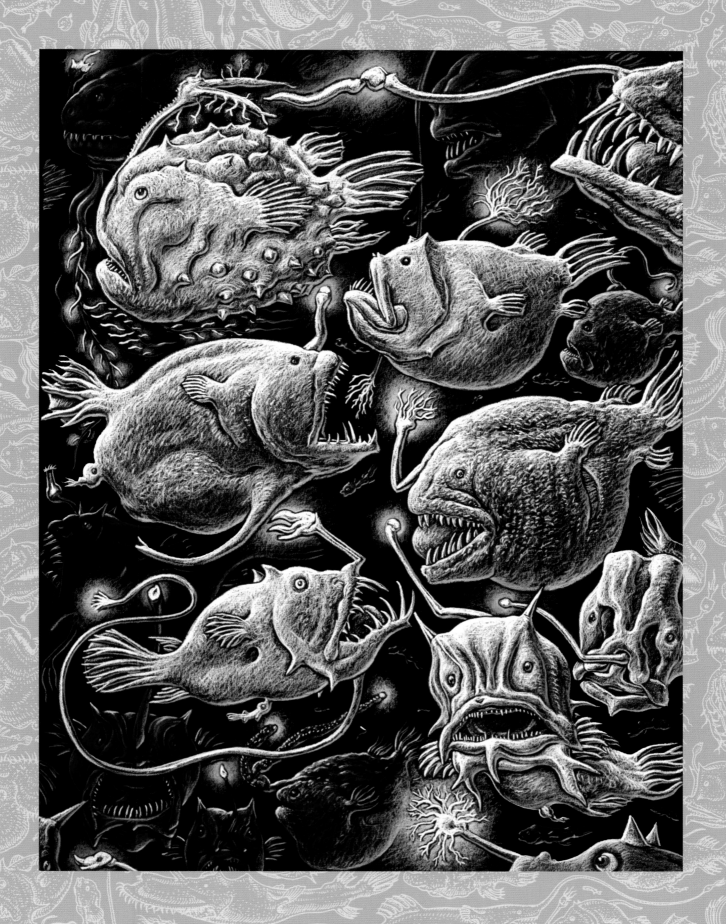

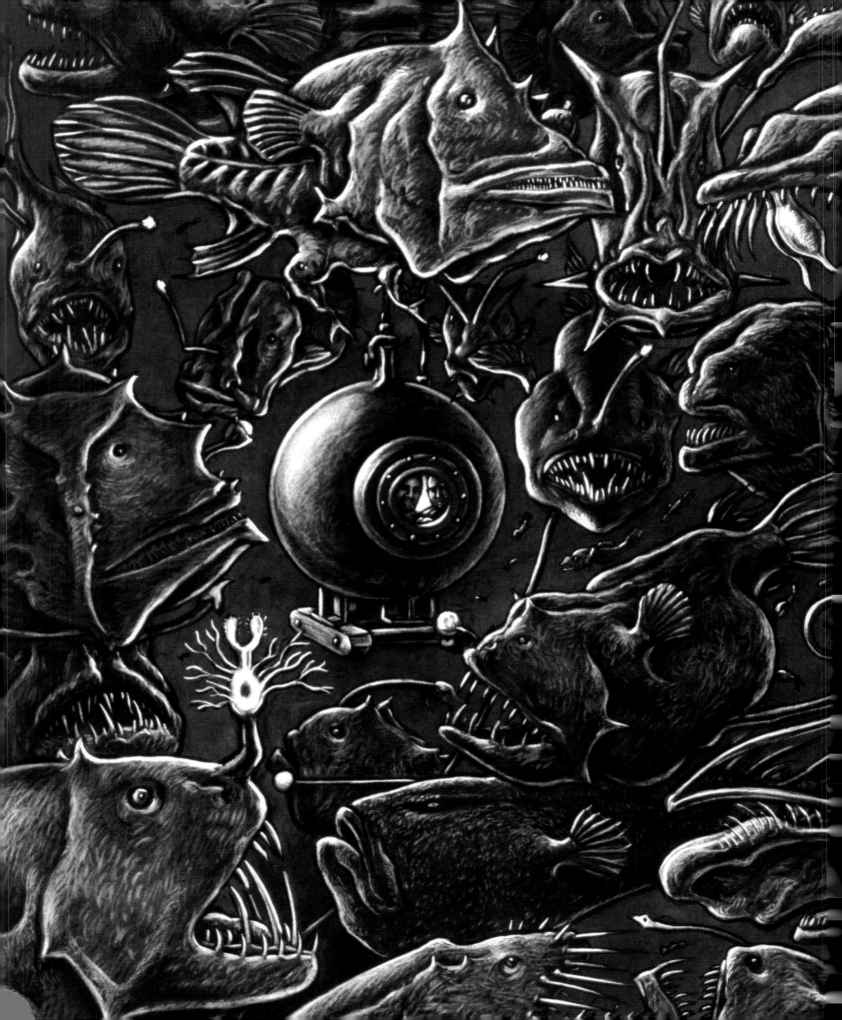

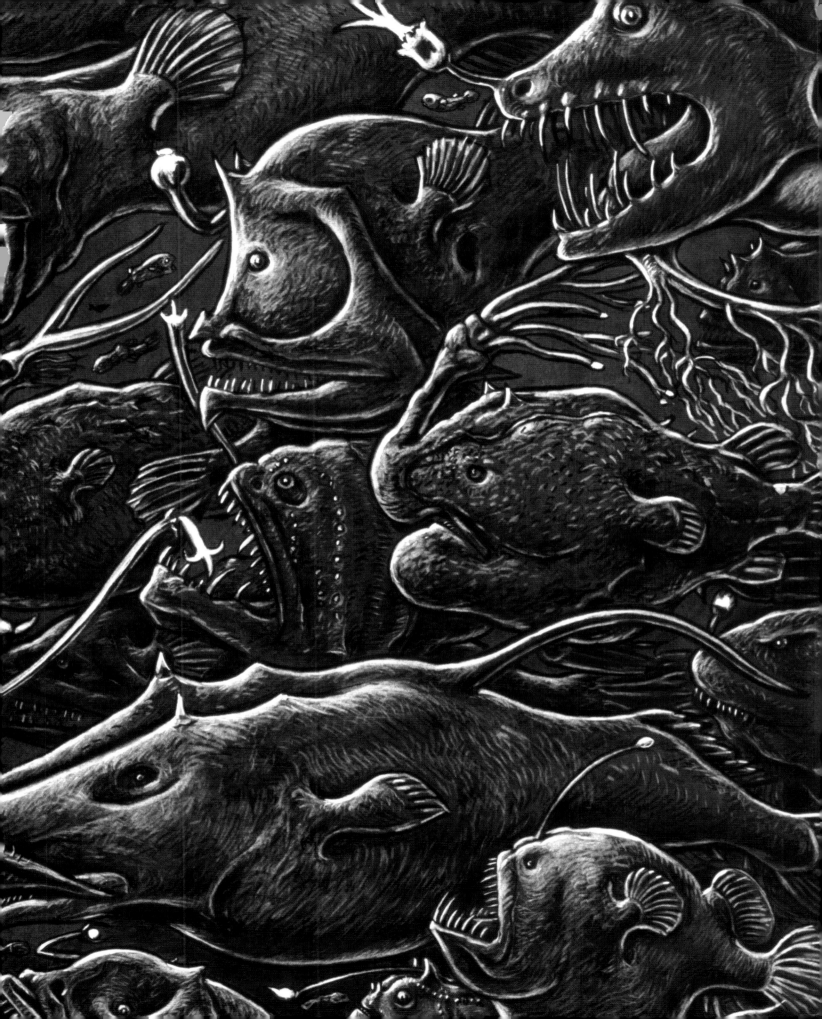

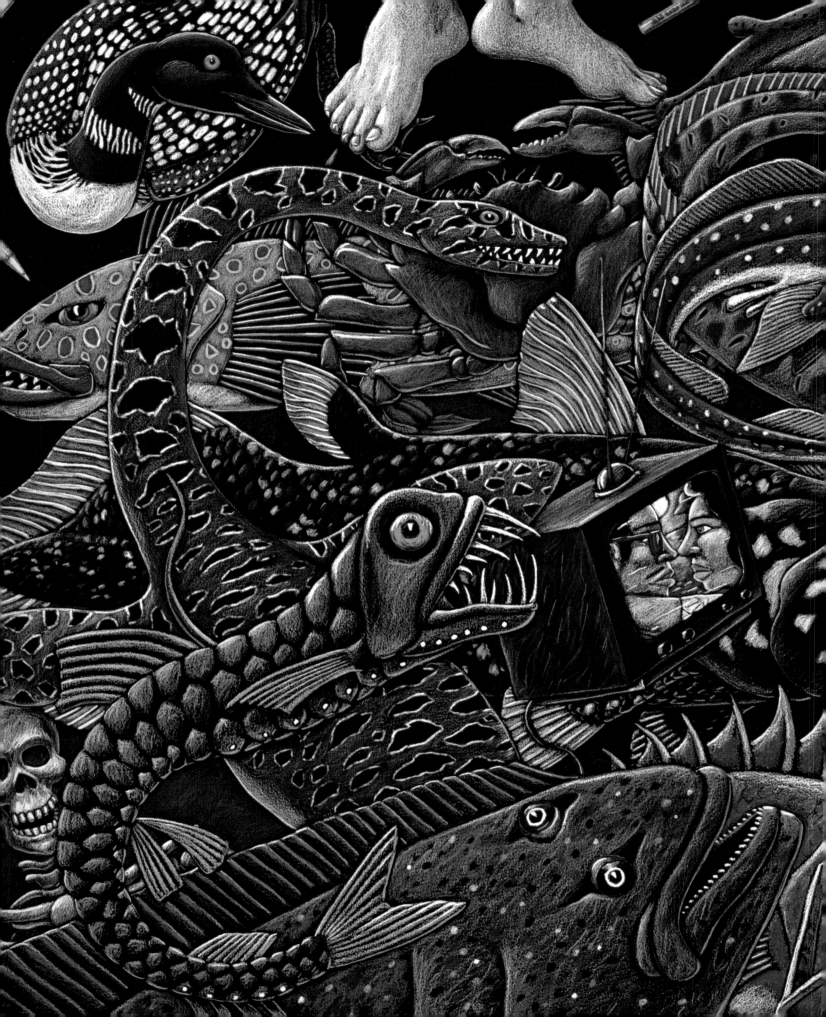

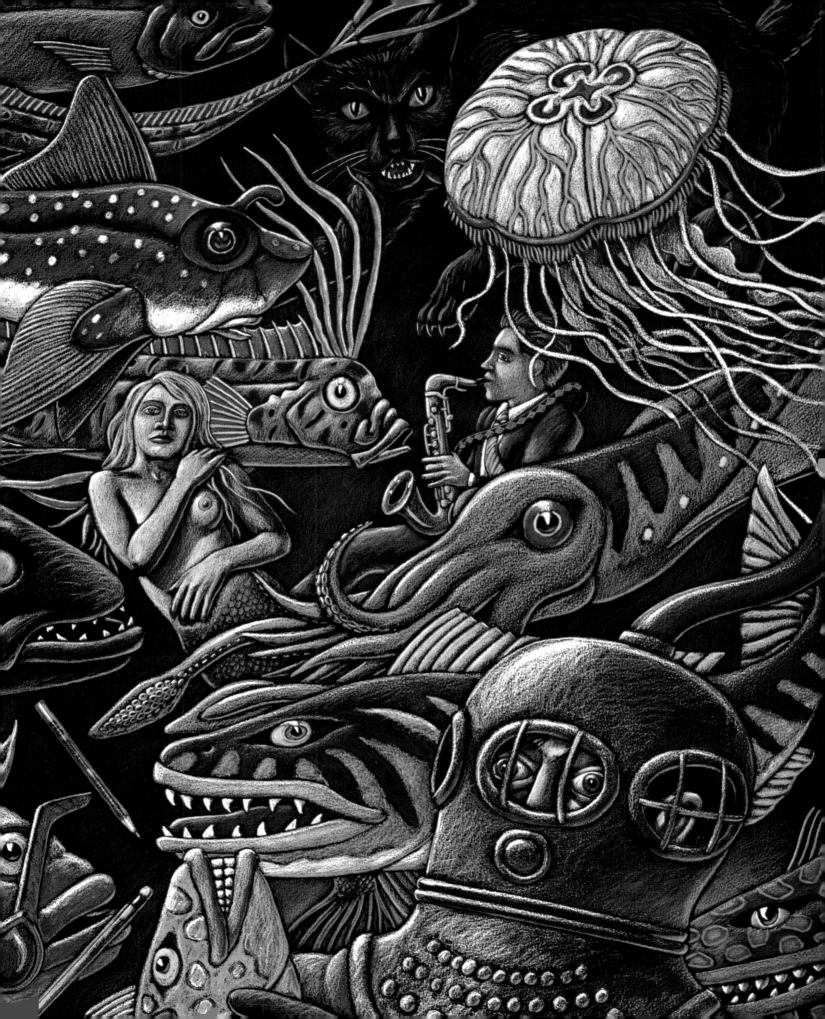

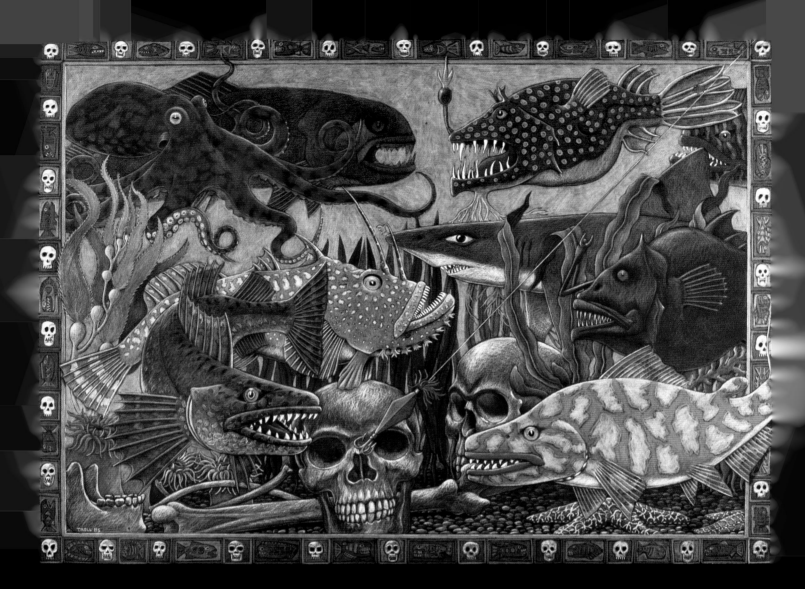

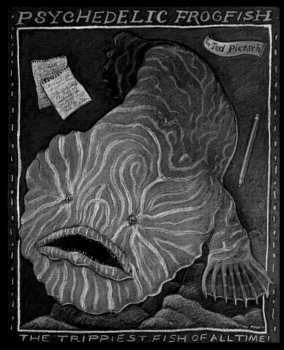

PSYCHEDELIC FROGFISH

by Ted Pietsch

THE TRIPPIEST FISH OF ALL TIME!

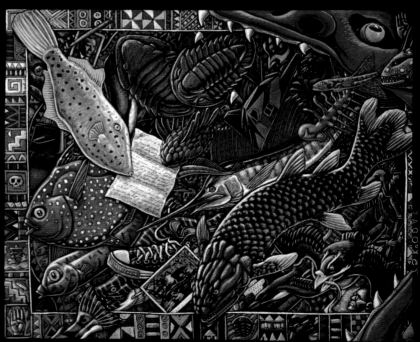

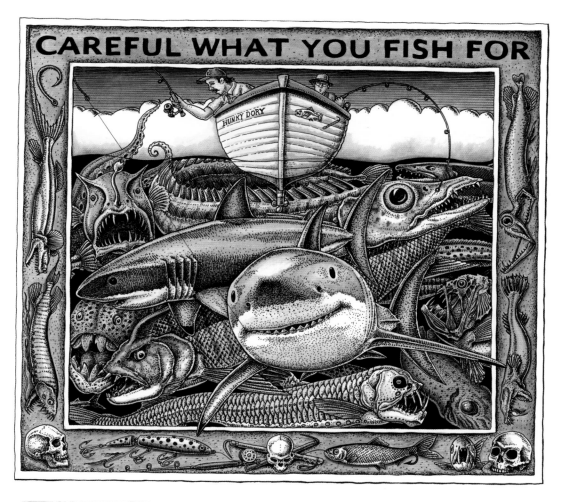

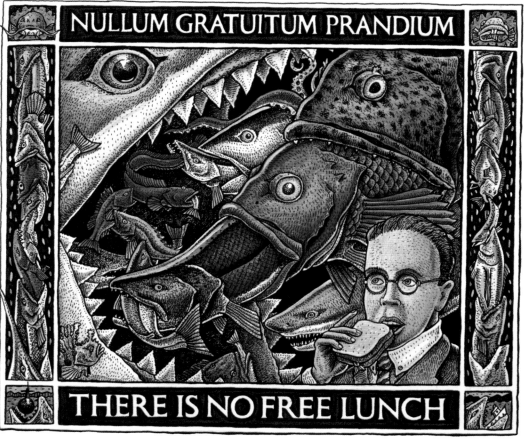

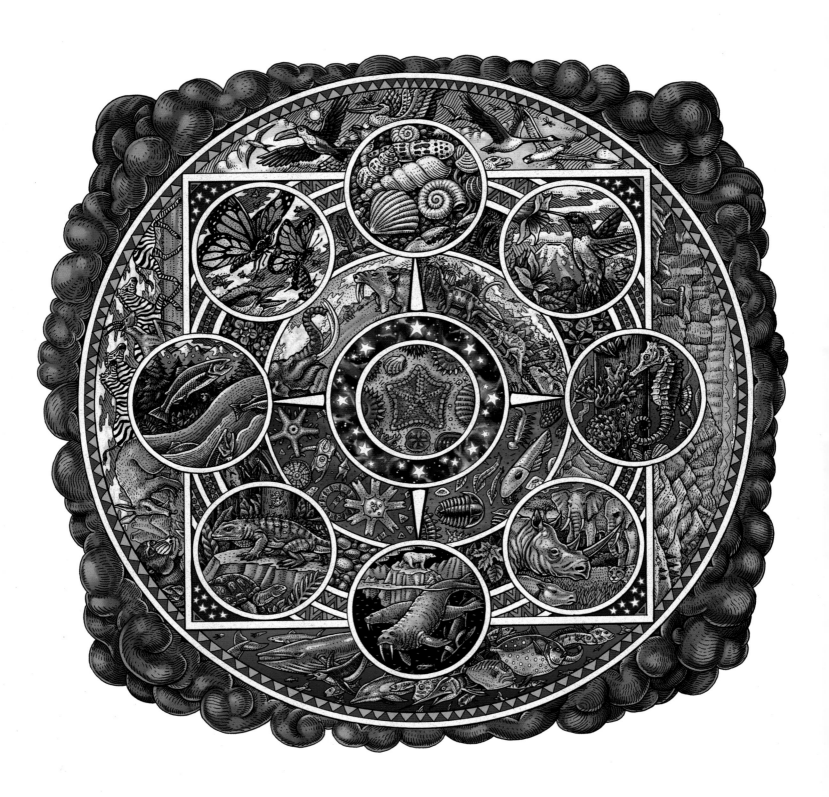

Between the Tide Pool and the Stars

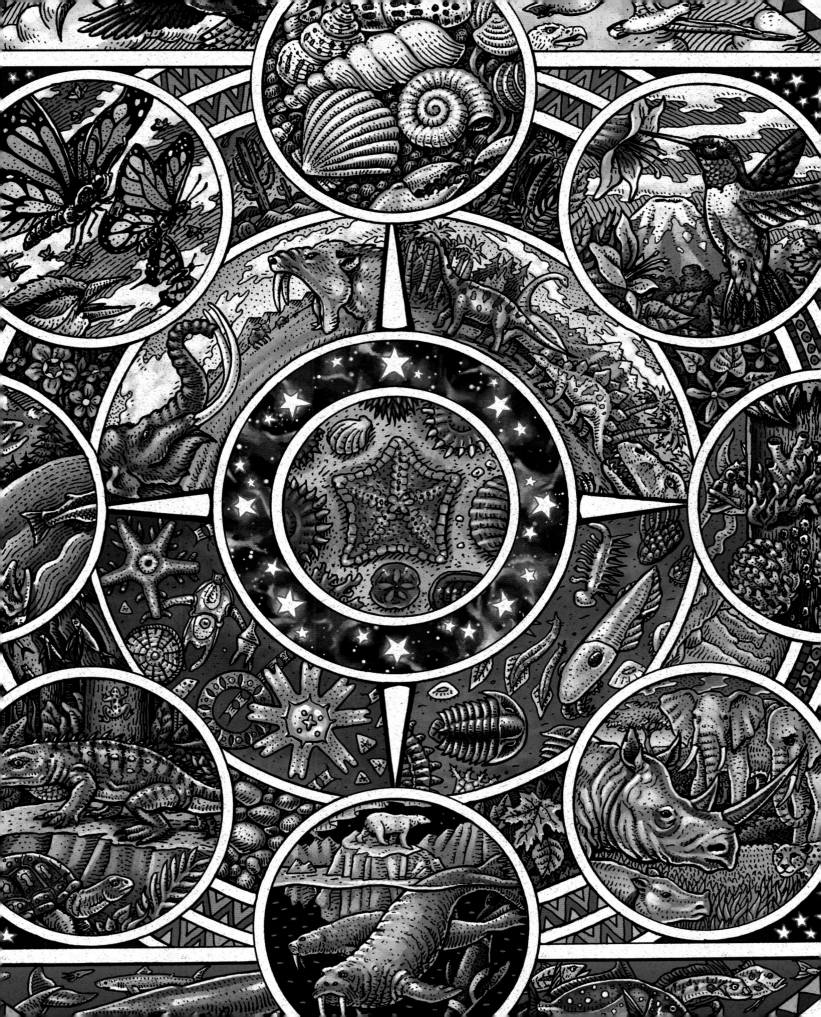

AND YOU MAY ASK YOURSELF

HOW DID I GET HERE ?

OPPOSITE PAGE: Ages of Rocks

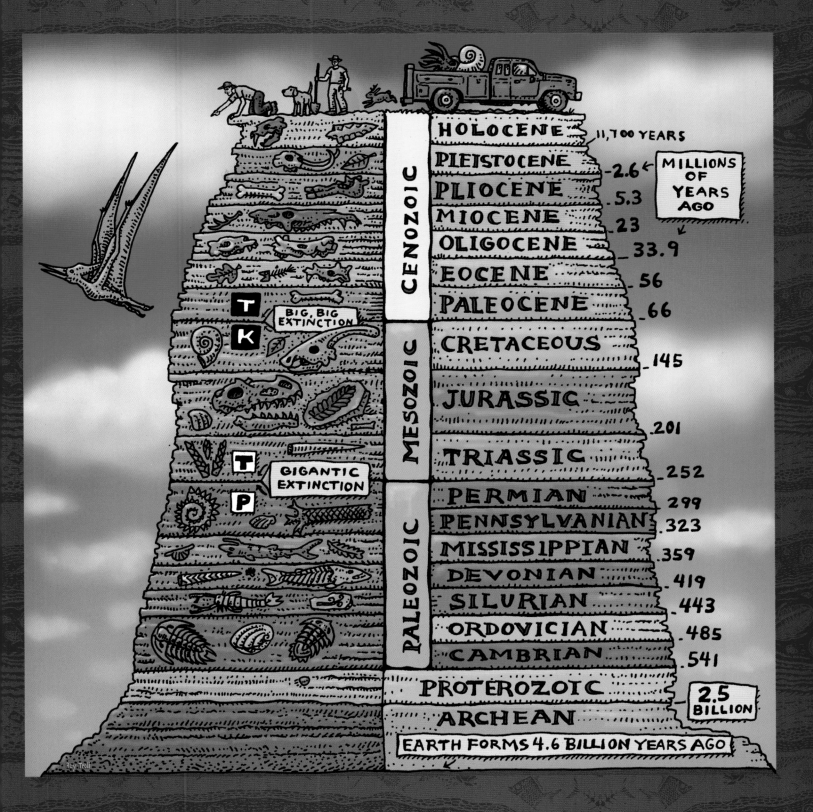

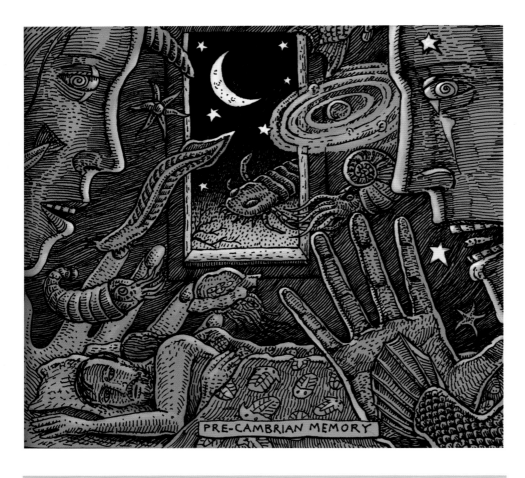

PRE-CAMBRIAN MEMORY

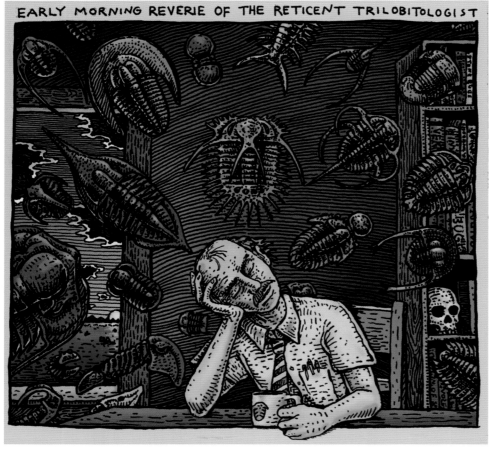

EARLY MORNING REVERIE OF THE RETICENT TRILOBITOLOGIST

TRILOBIKE

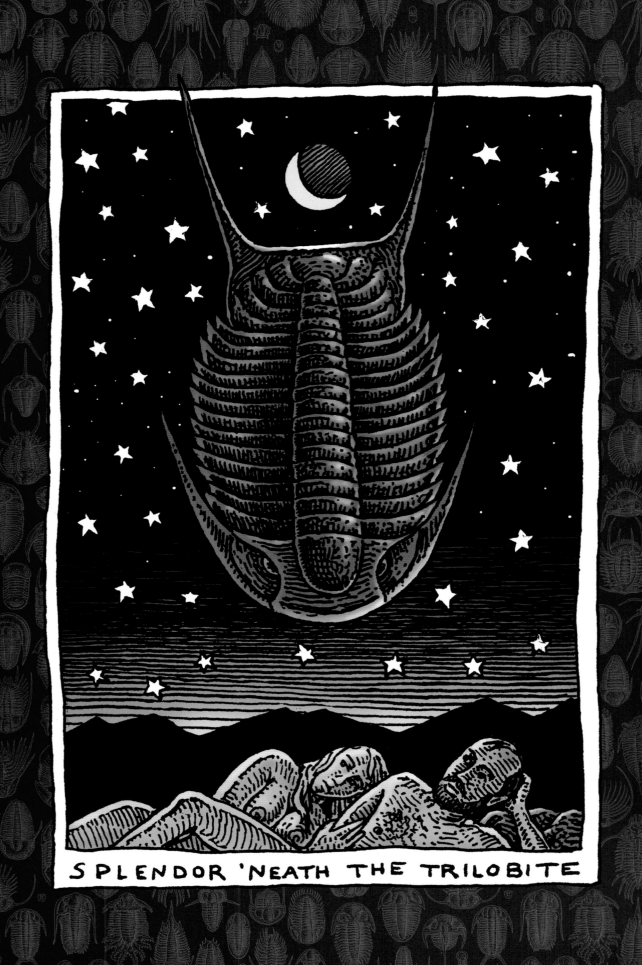

SPLENDOR 'NEATH THE TRILOBITE

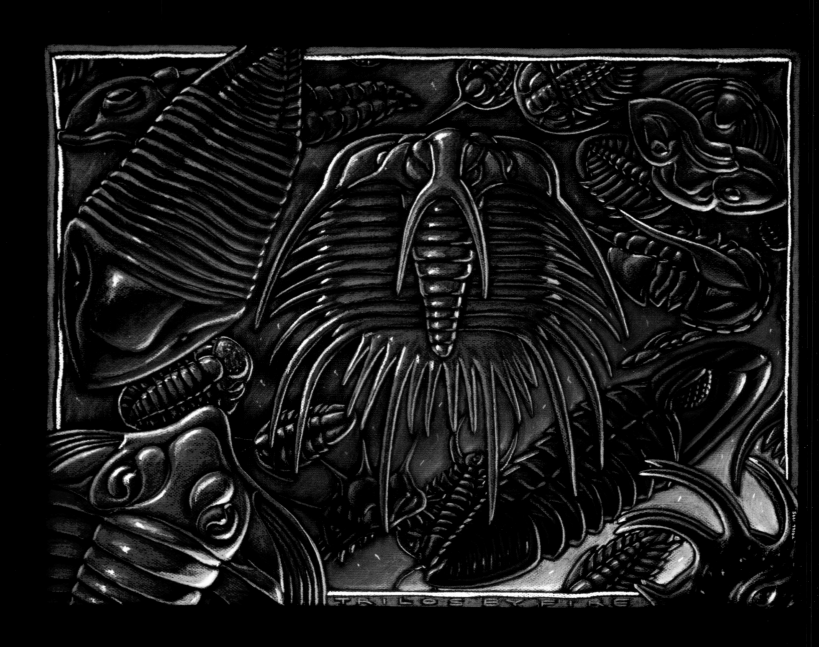

Trilos by Fire

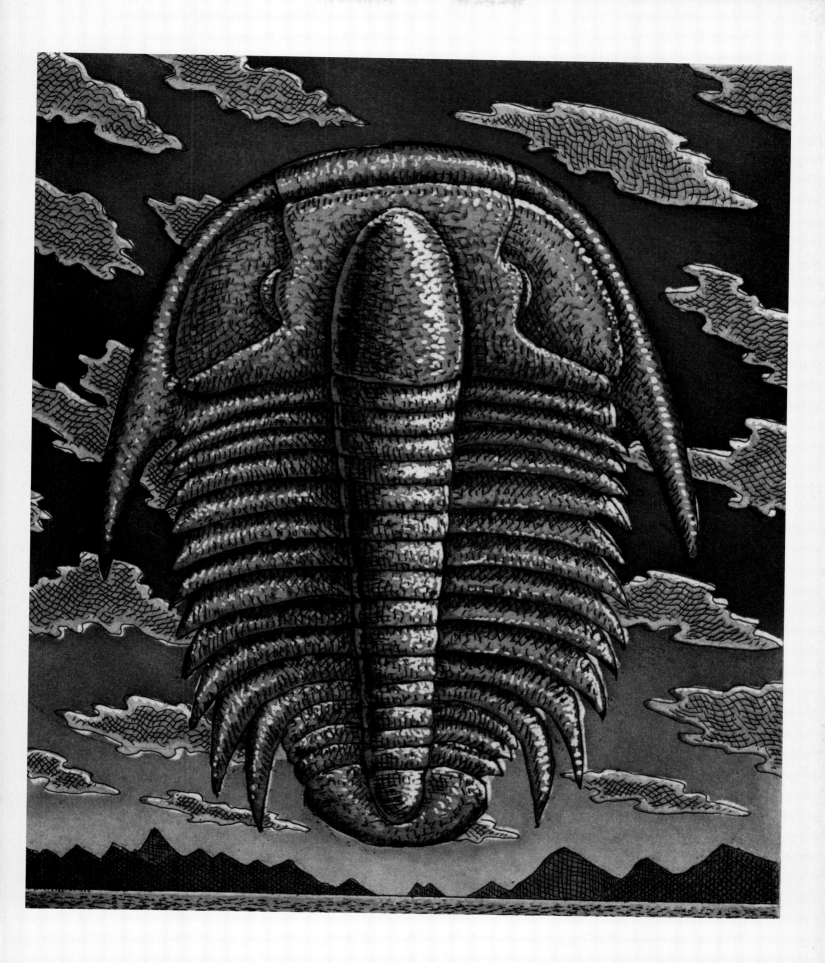

Trilobite Etching

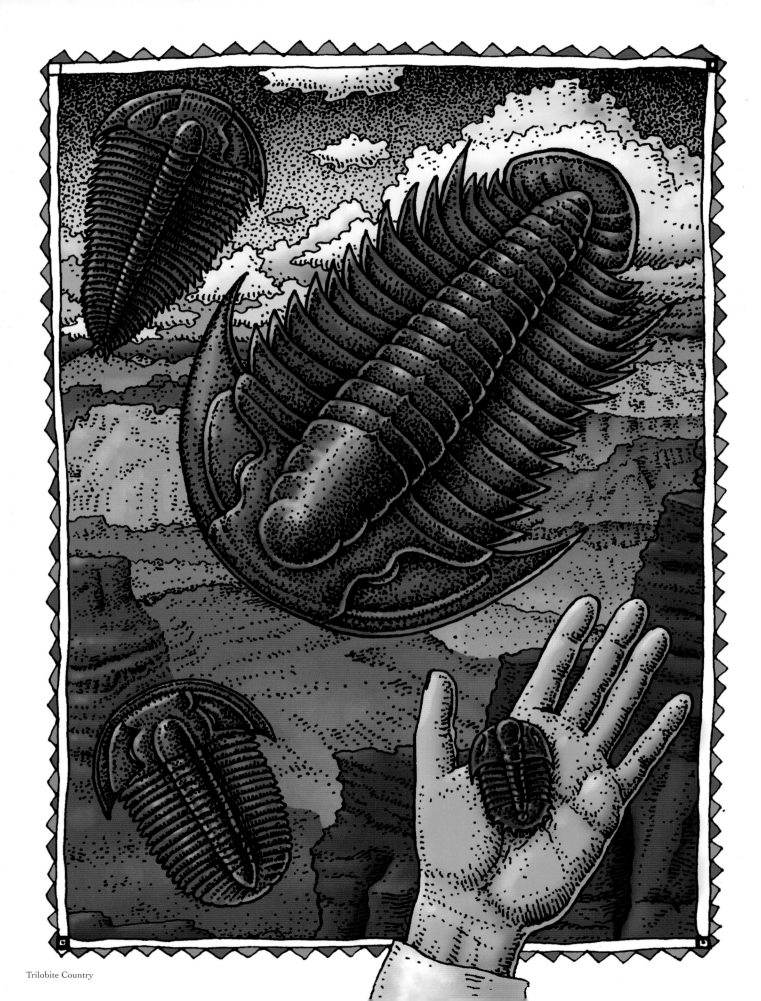

Trilobite Country

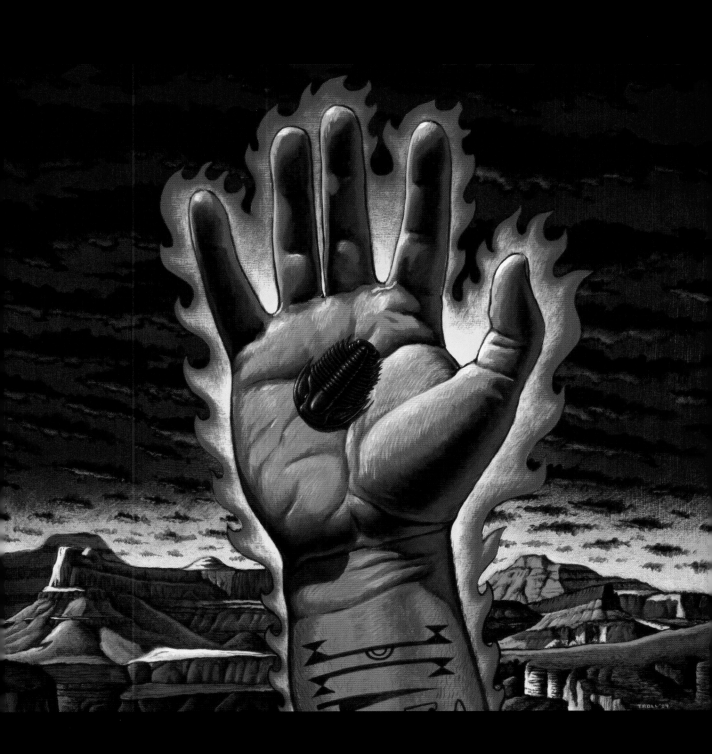

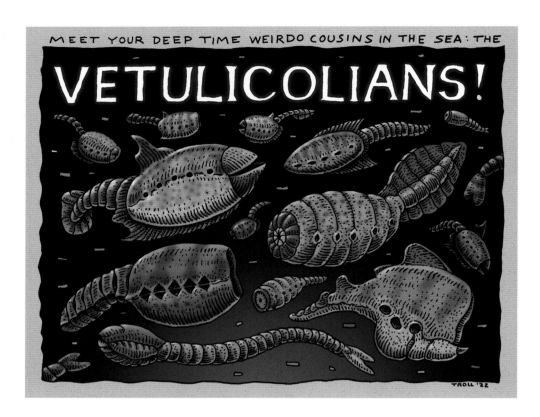

MEET YOUR DEEP TIME WEIRDO COUSINS IN THE SEA: THE

VETULICOLIANS!

TROLL '22

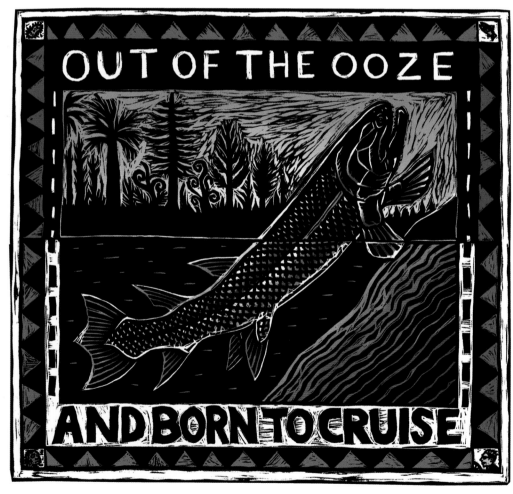

OUT OF THE OOZE

AND BORN TO CRUISE

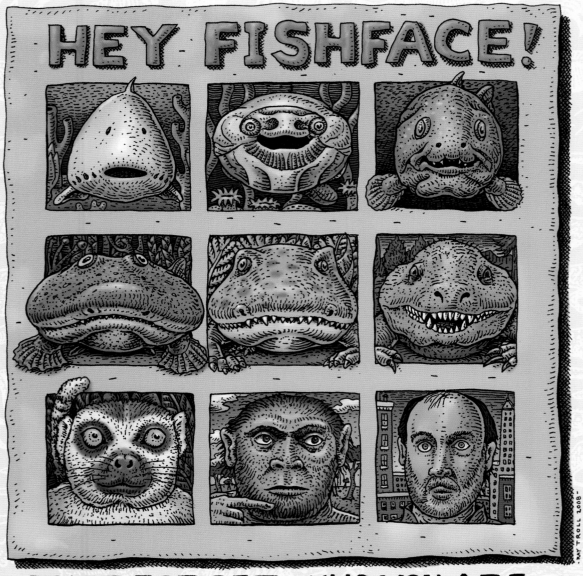

HEY FISHFACE!

DON'T FORGET WHO YOU ARE

Hey Fishface
I know who you are
Hey Fishface
You ain't no superstar
Hey Fishface
Did you forget who you are?

You're a lobefin just like me

Just another vertebrate
getting in the way
Just another vertebrate
with nothin' to say
Just another vertebrate
getting through the day

You're a lobefin just like me

Big-brained monkey
you do it all wrong
Keep mucking up this place
it won't take long
Your time on this earth
will be gone gone gone...

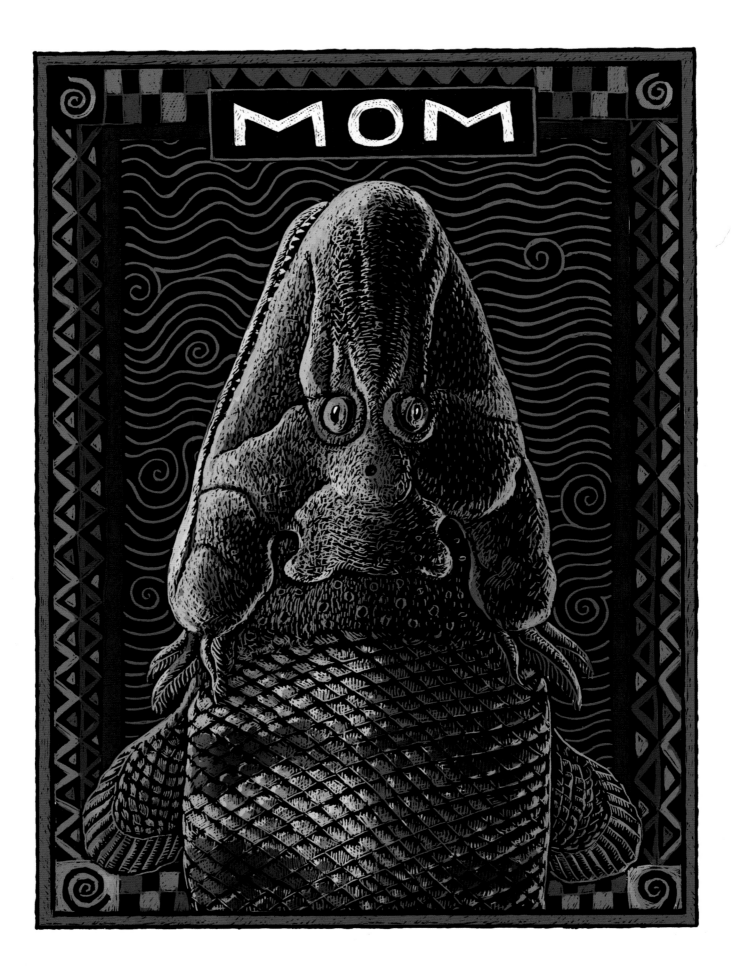

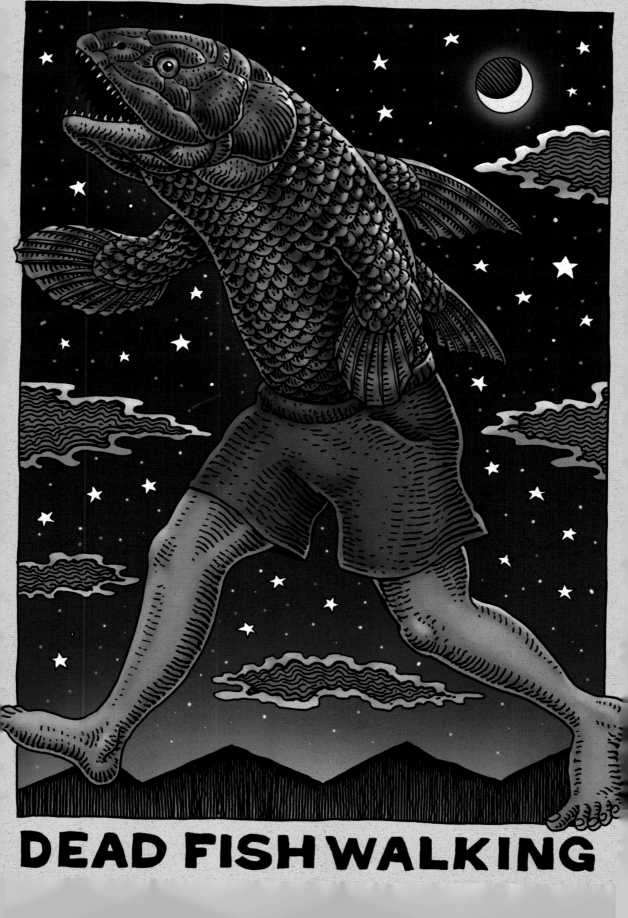

DEAD FISH WALKING

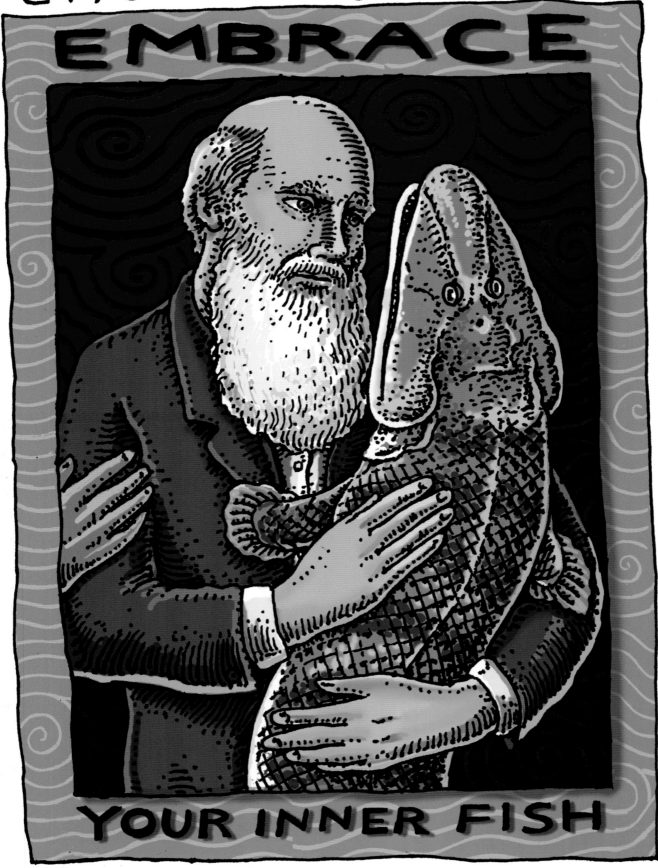

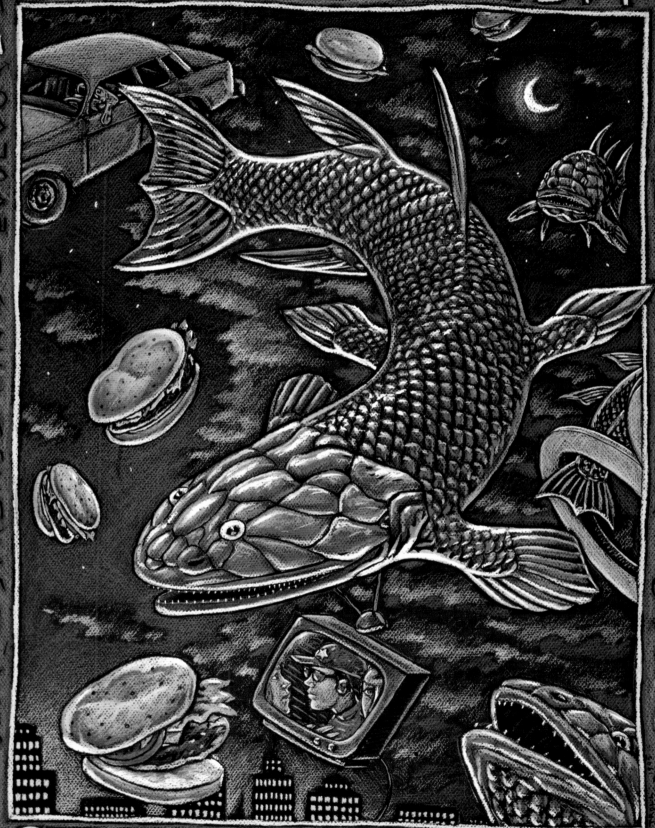

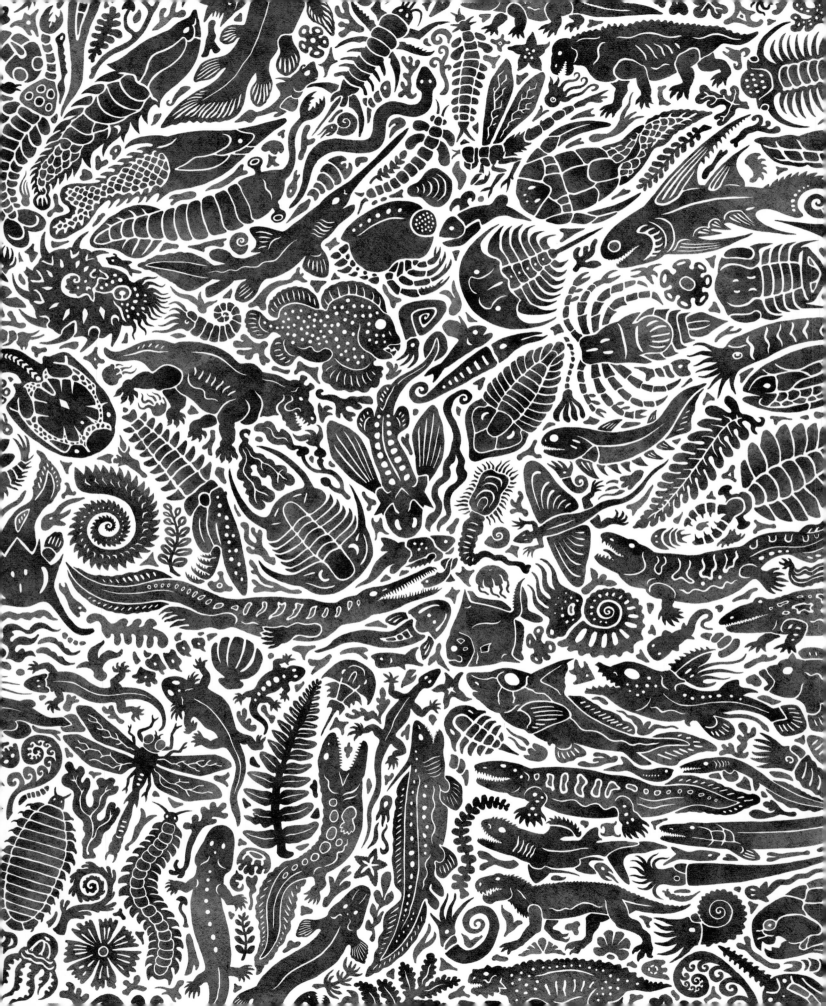

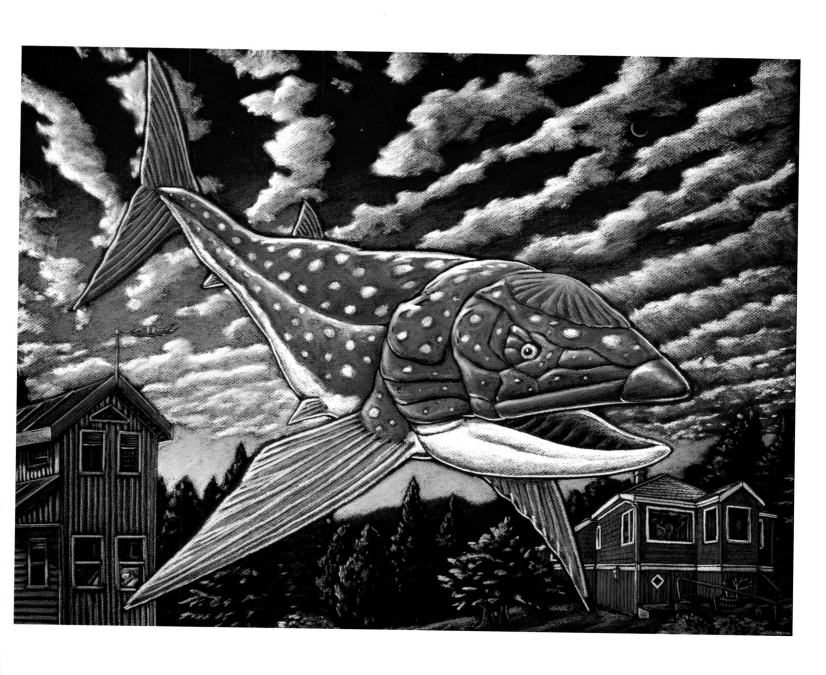

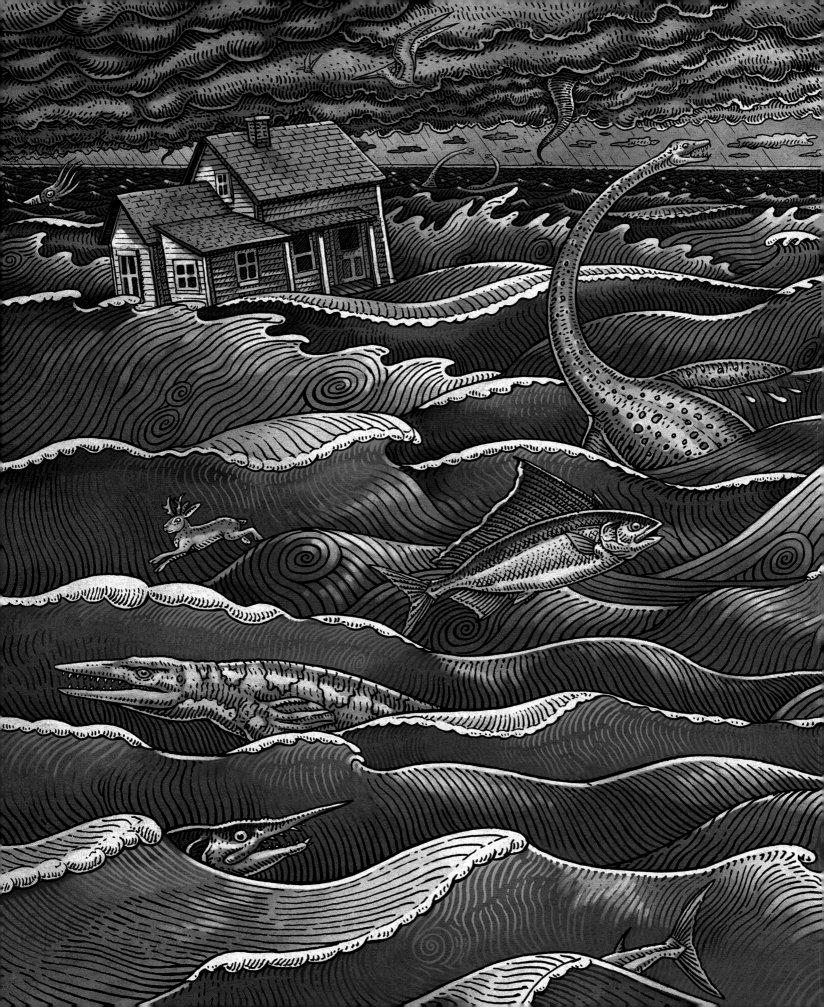

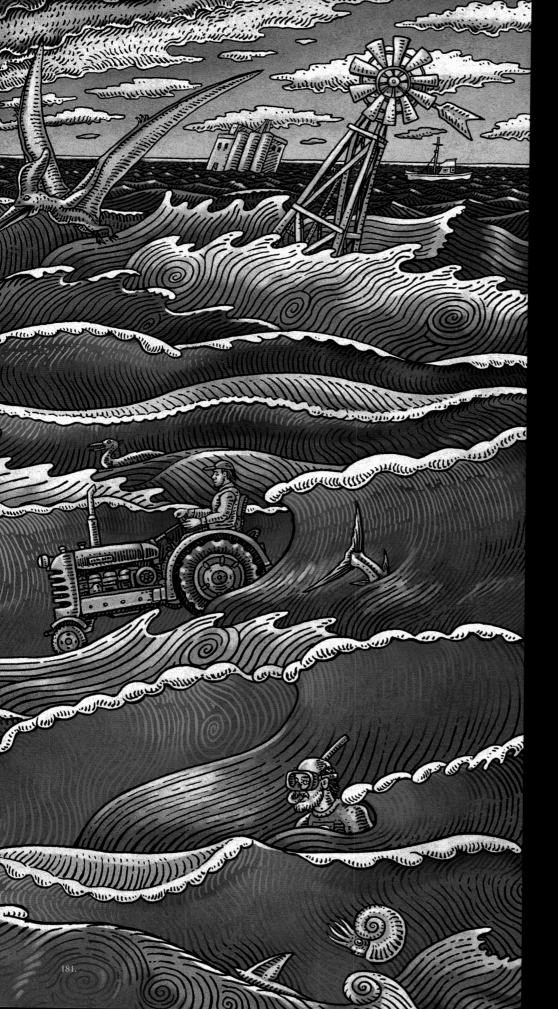

Prairie Ocean

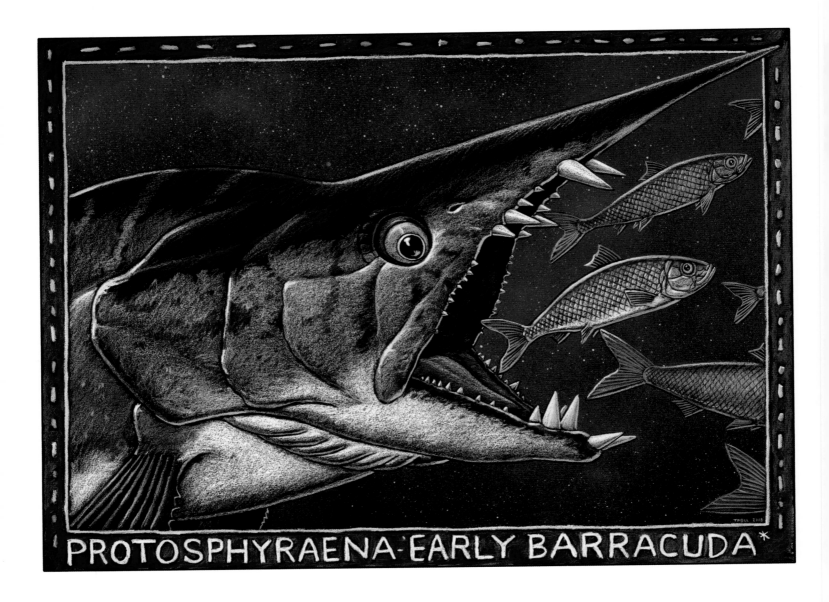

PROTOSPHYRAENA·EARLY BARRACUDA*

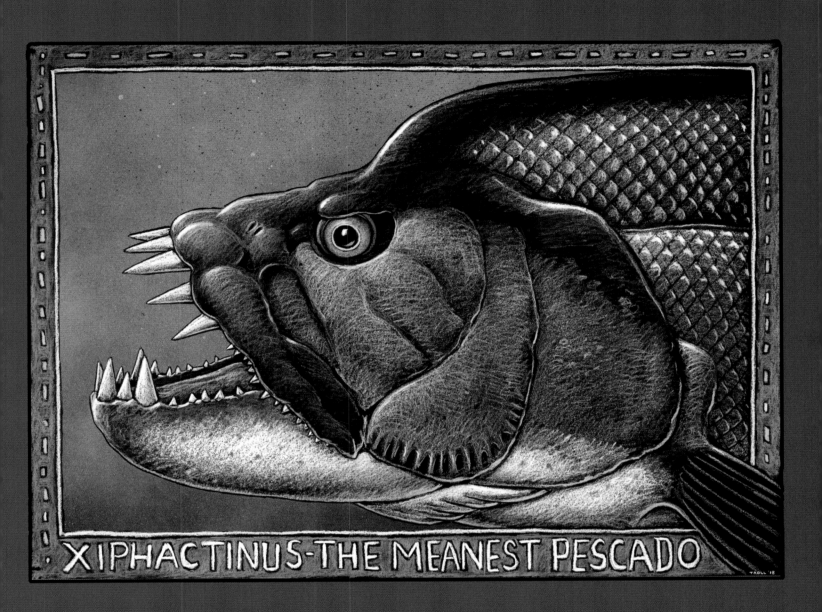

XIPHACTINUS·THE MEANEST PESCADO

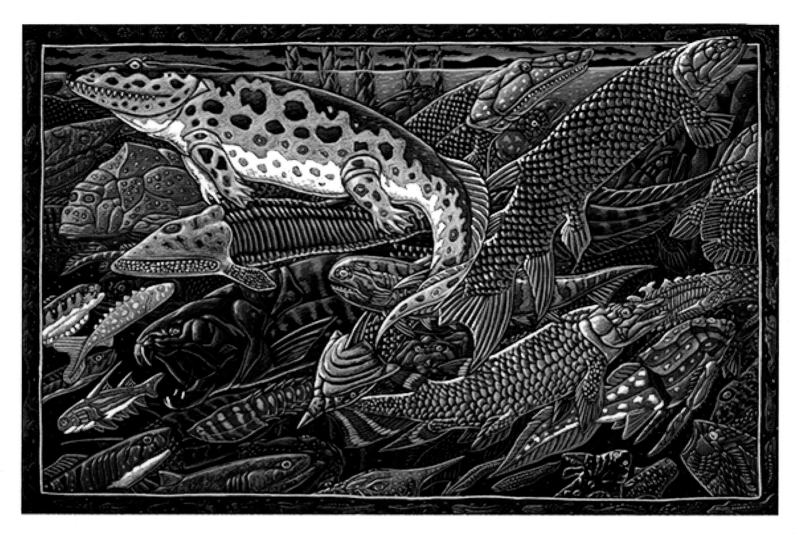

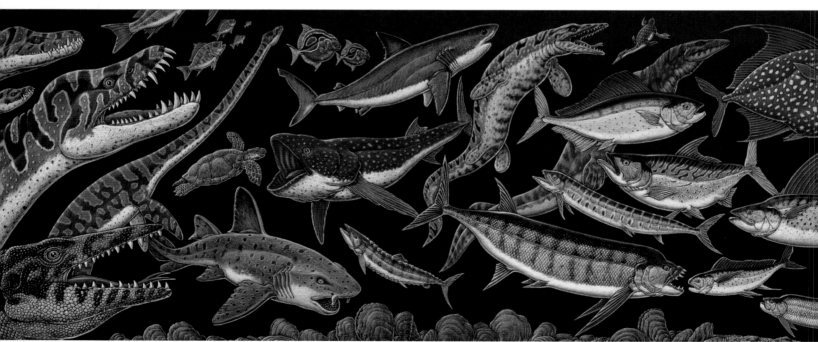

TOP: Devonian D-Day *BOTTOM SPREAD PIECE:* Kansas Ocean Life

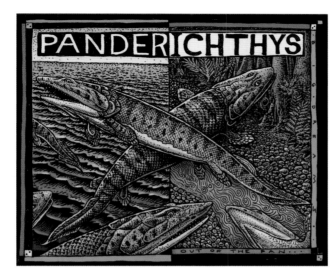

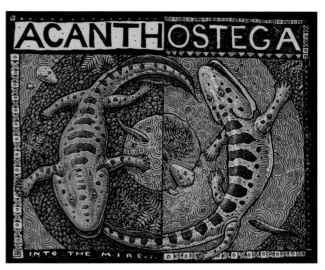

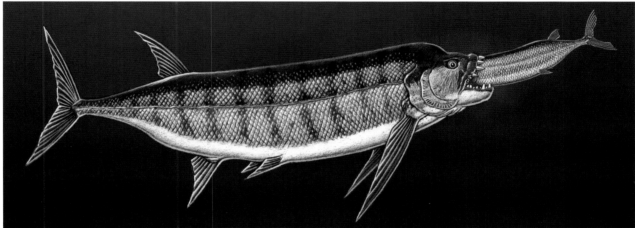

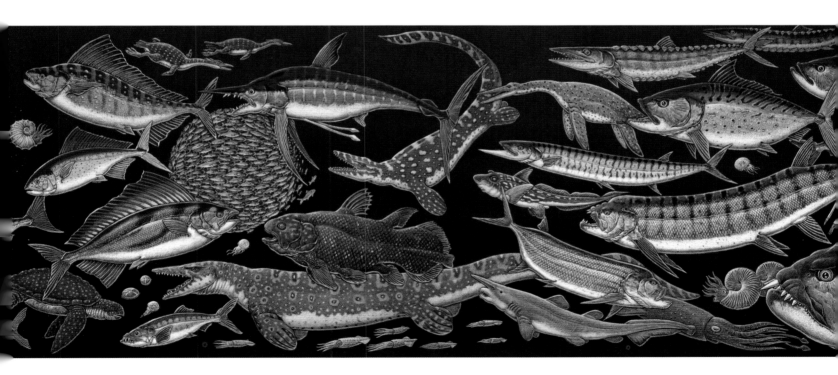

MIDDLE: A Fossilized Lesson in Gluttony *FOLLOWING SPREAD:* Not in Kansas Anymore

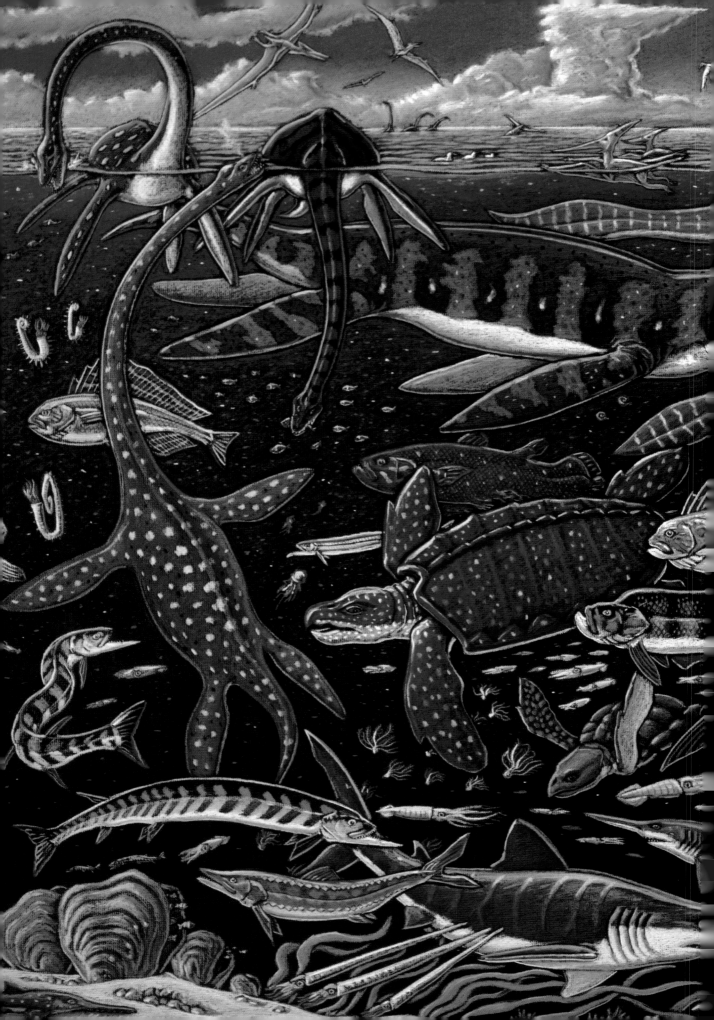

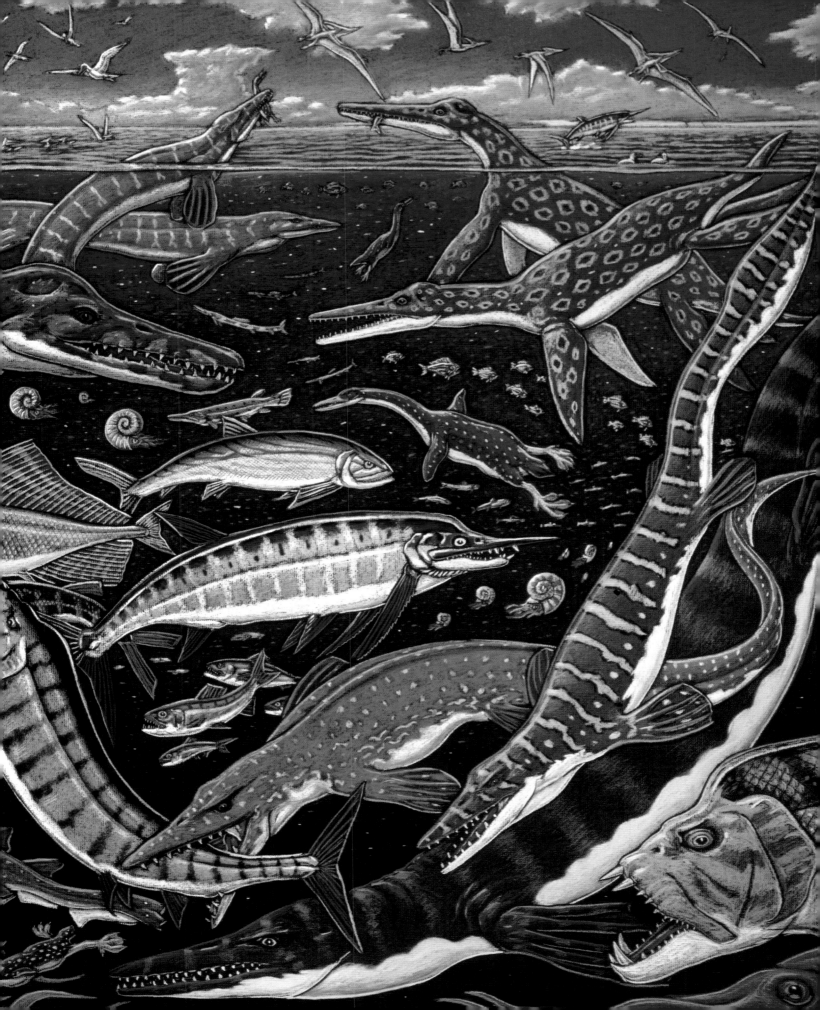

IT'S NEVER TOO LATE TO

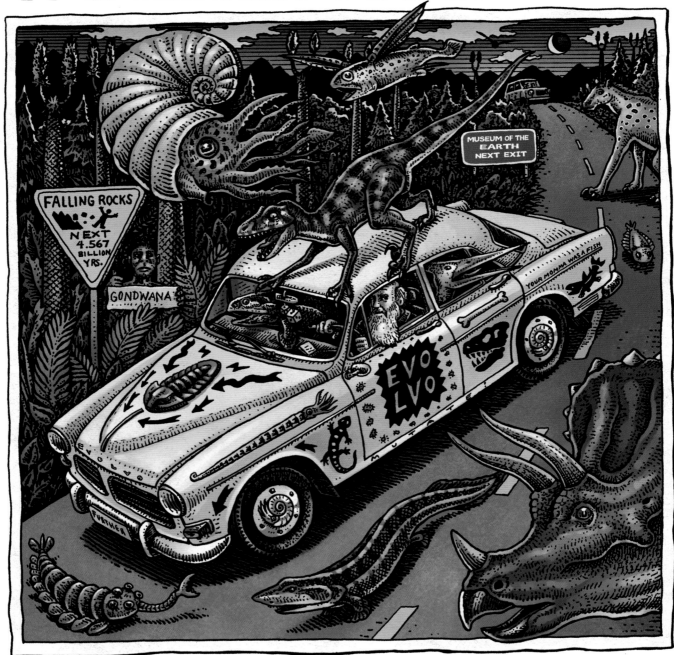

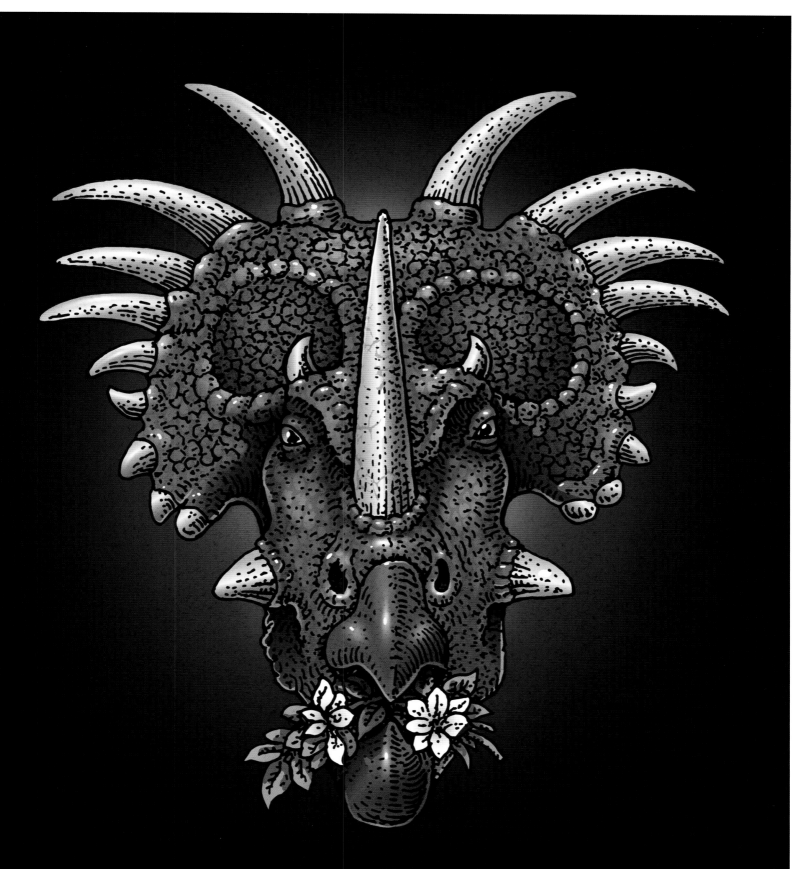

"DINOSAURS INVENTED FLOWERS"

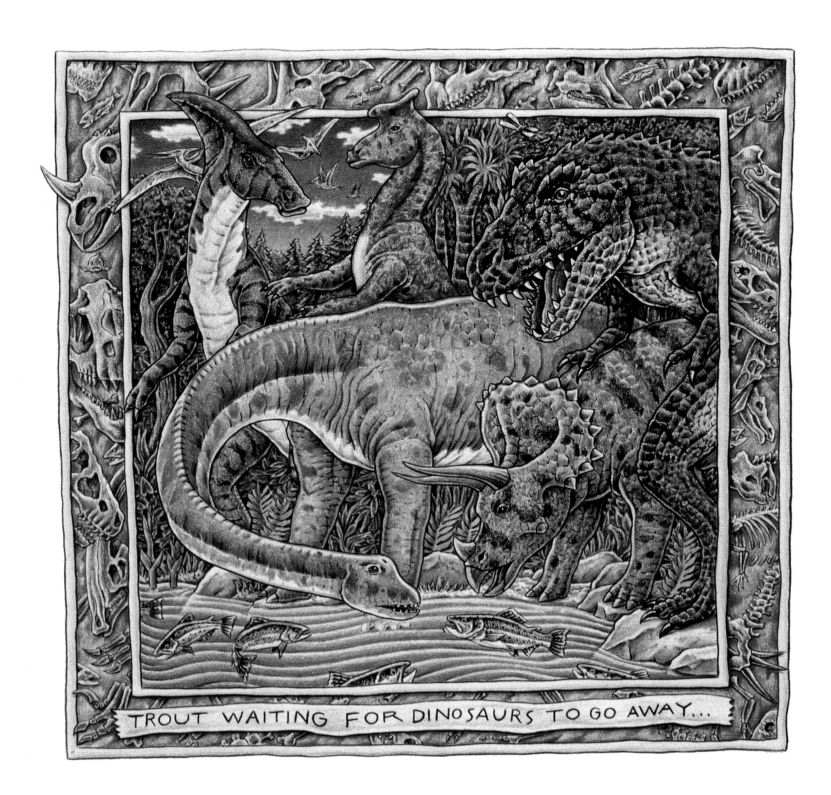

TROUT WAITING FOR DINOSAURS TO GO AWAY...

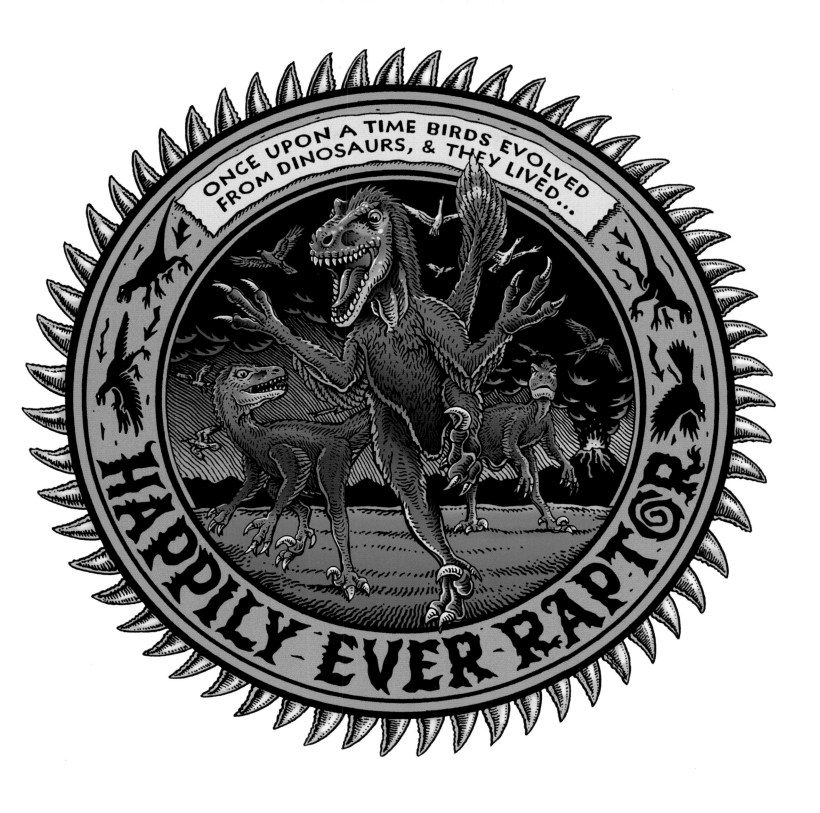

ONCE UPON A TIME BIRDS EVOLVED FROM DINOSAURS, & THEY LIVED...

HAPPILY·EVER·RAPTOR

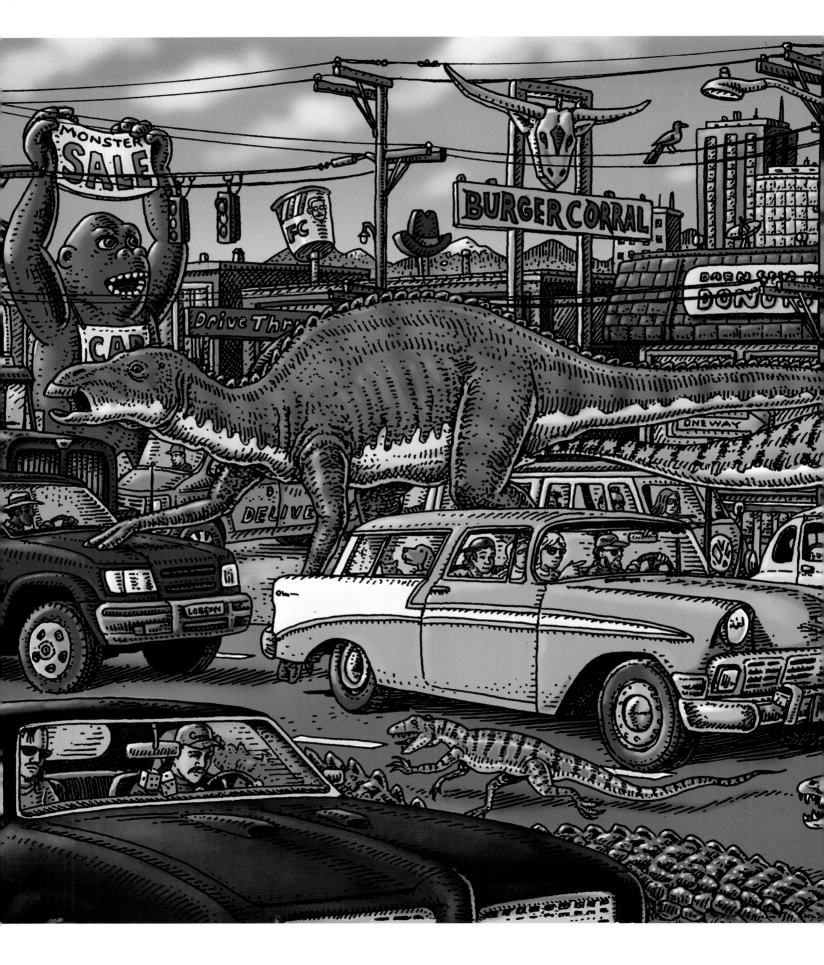

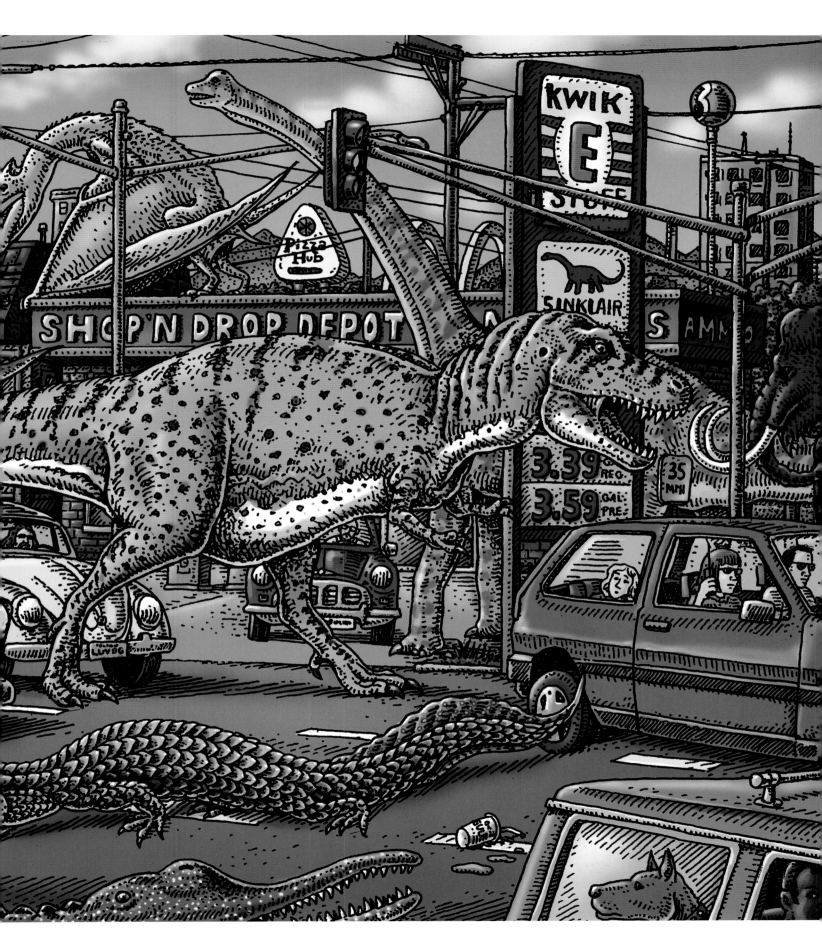

Suburban Rex

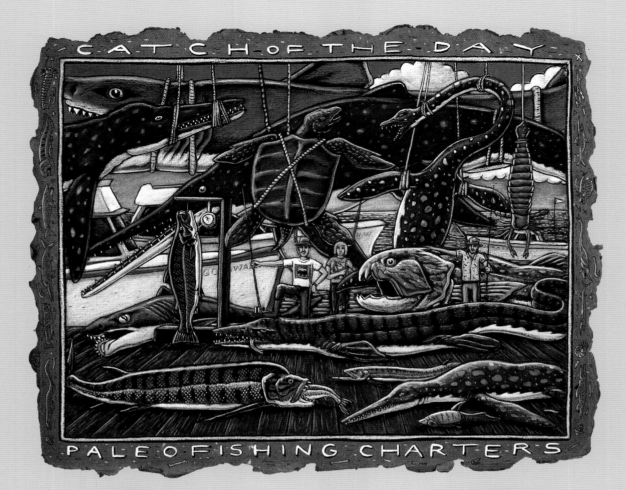

CATCH OF THE DAY

PALEO FISHING CHARTERS

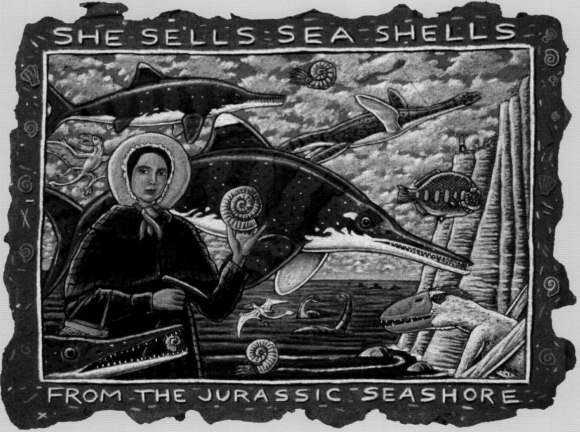

SHE SELLS SEA SHELLS

FROM THE JURASSIC SEASHORE

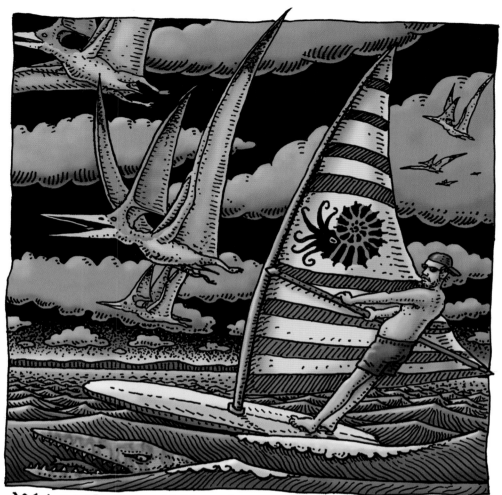

WINDSURFIN' THE NIOBRARA

UINTATHERIUM WITH GAR ON NOSE

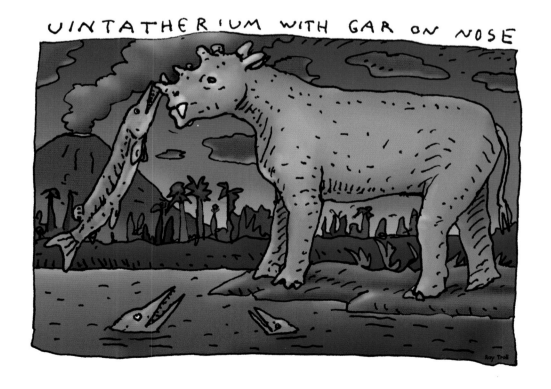

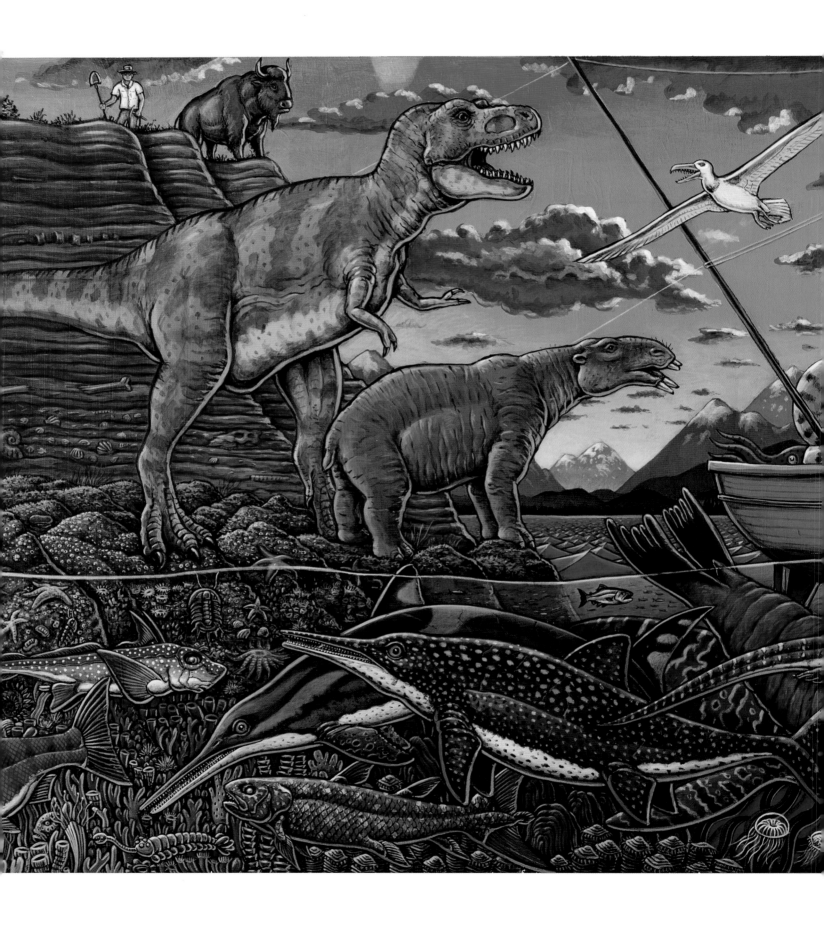

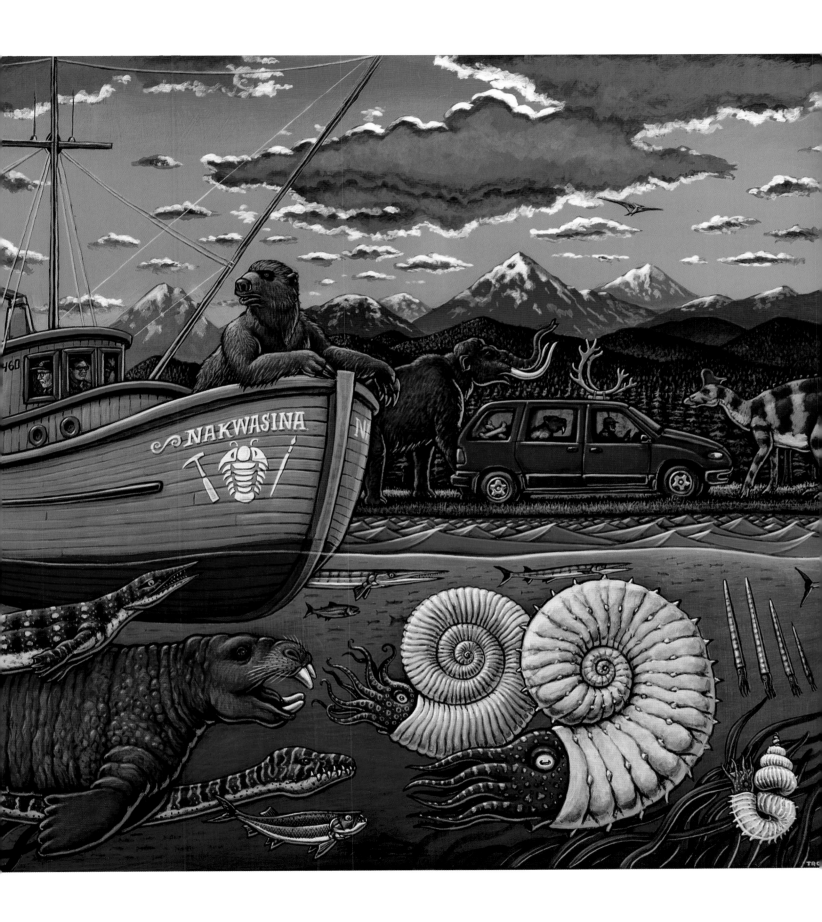

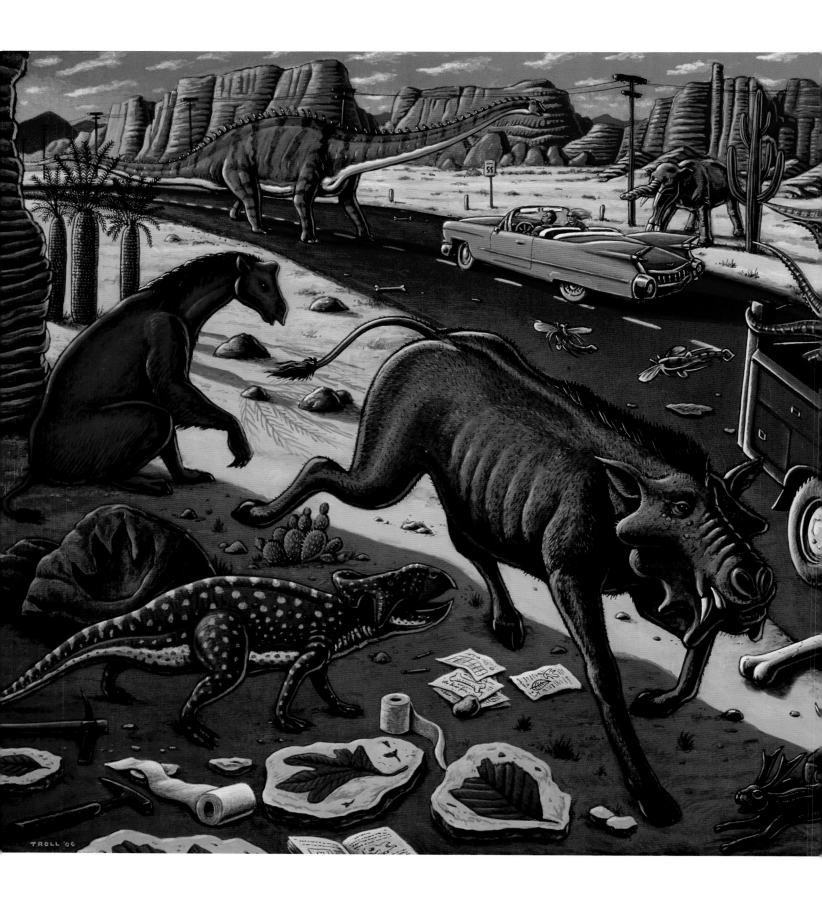

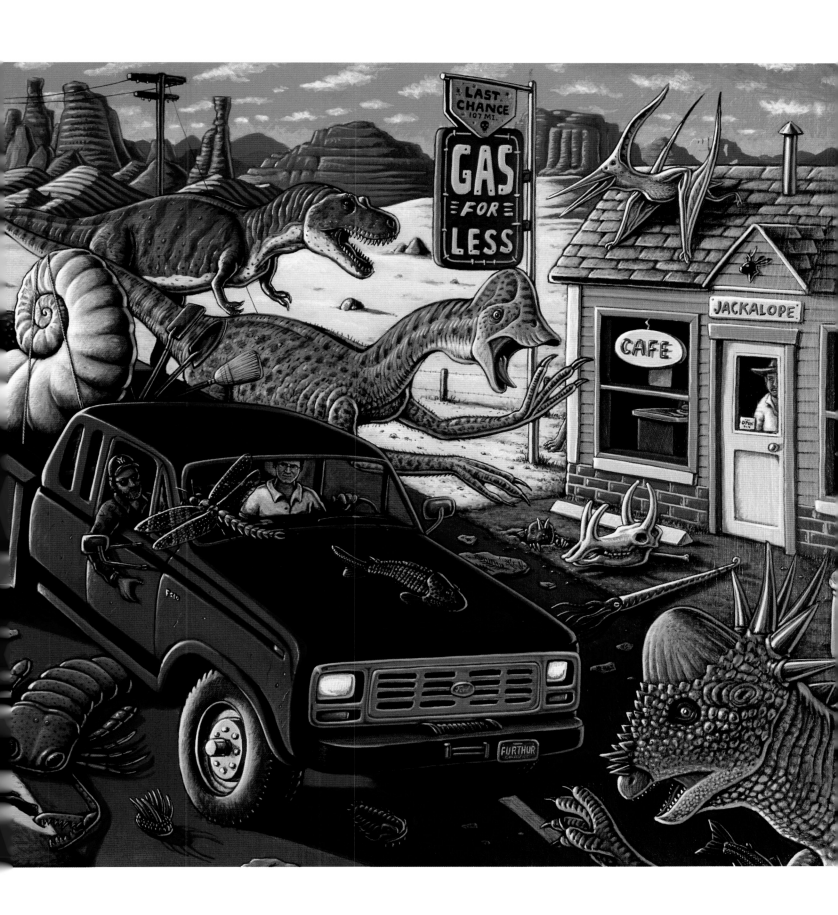

THIS SPREAD: Cruisin' the Fossil Freeway *FOLLOWING SPREAD:* Night of the Ammonites

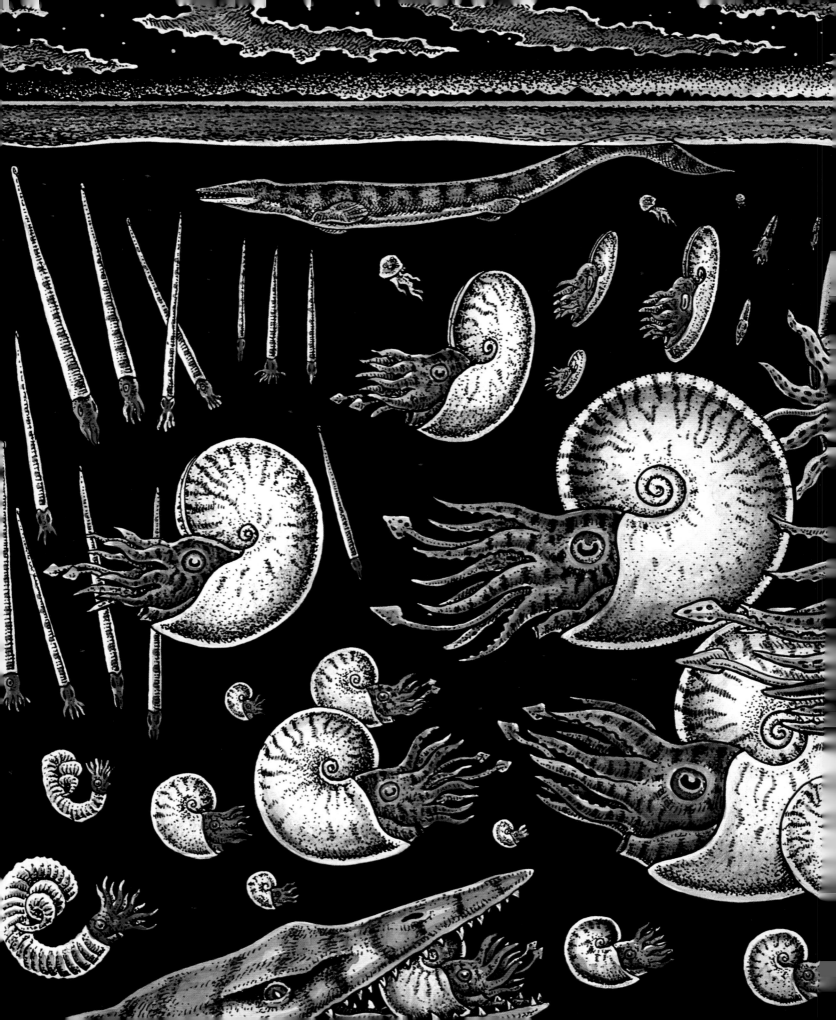

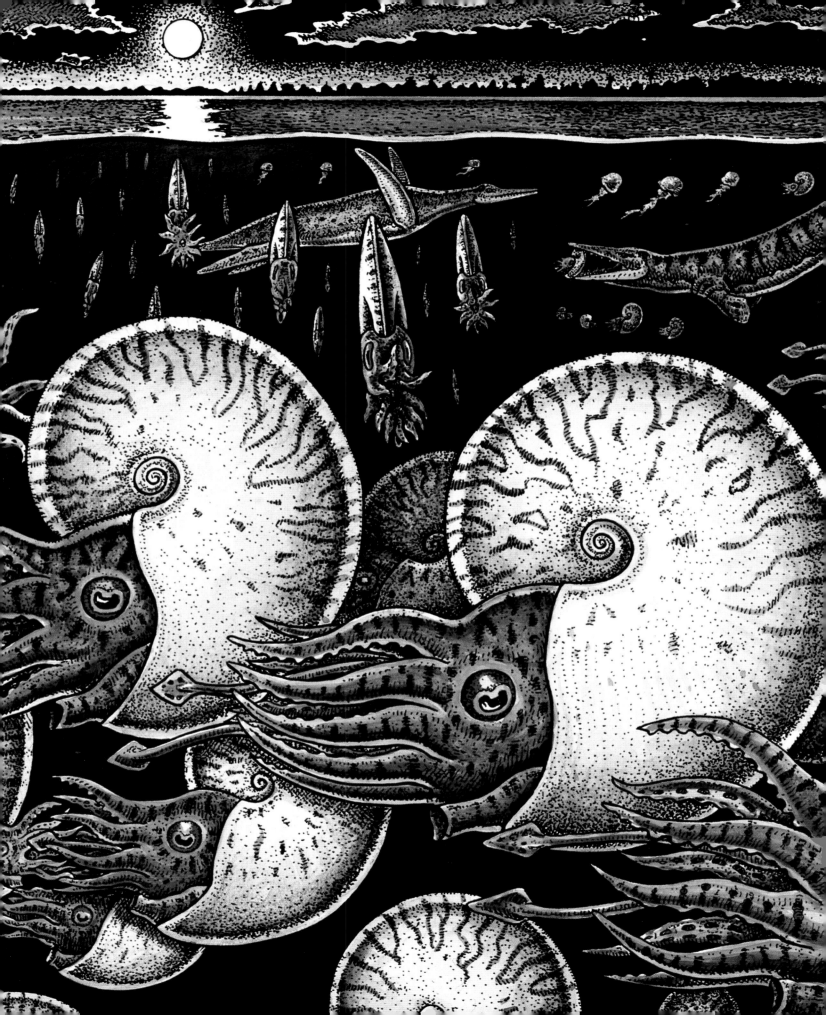

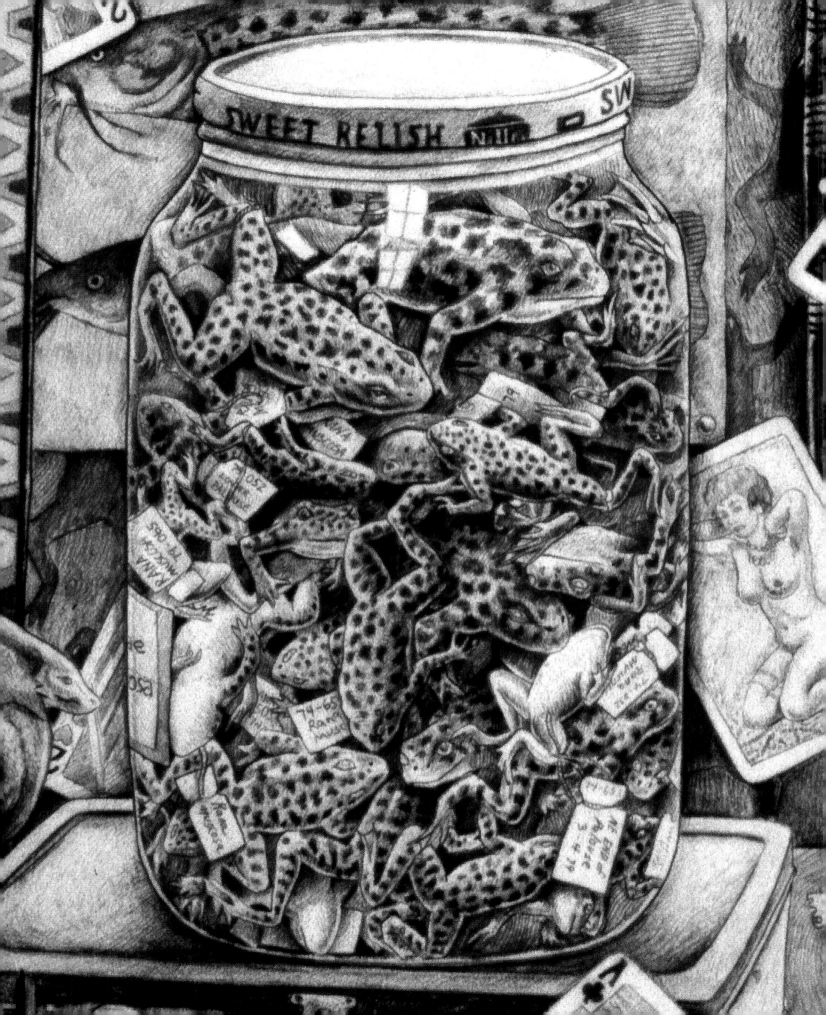

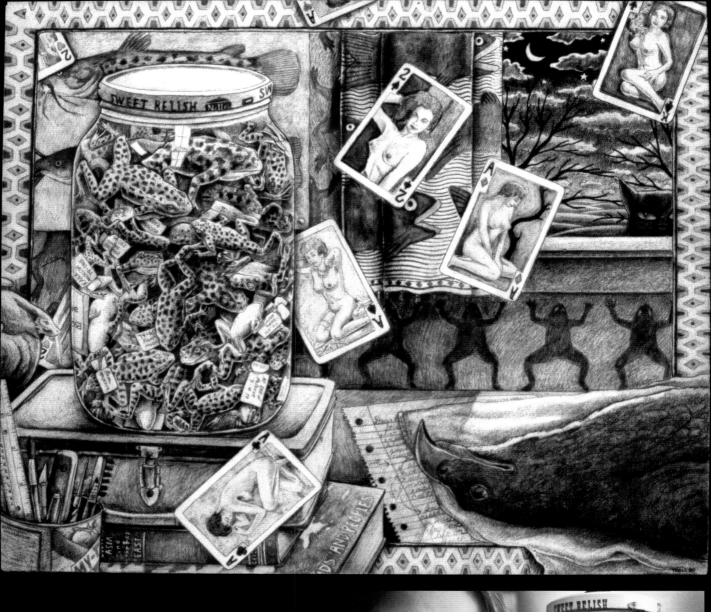

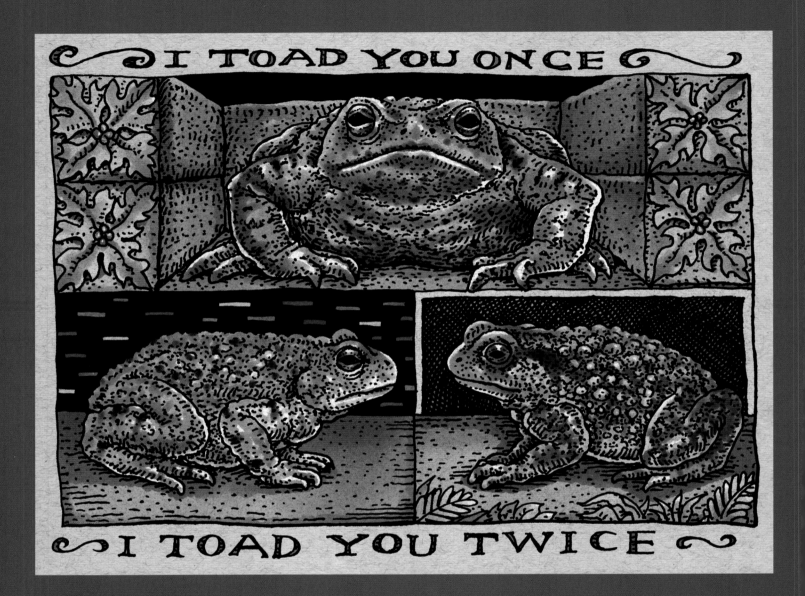

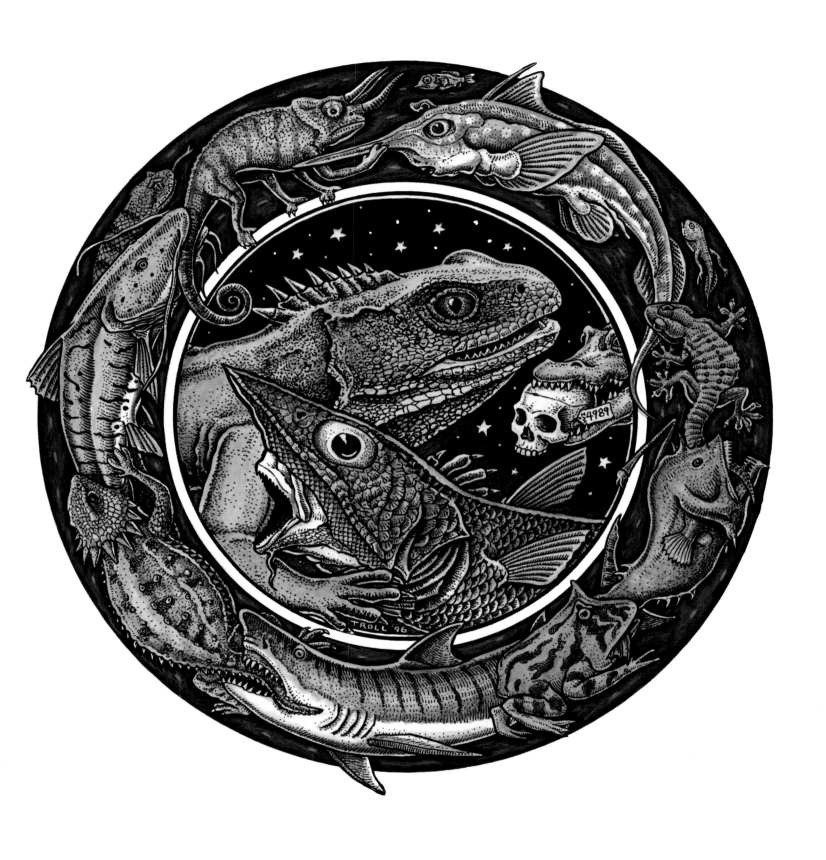

Logo for the 1997 meeting of the American Society of Ichthyologists and Herpetologists

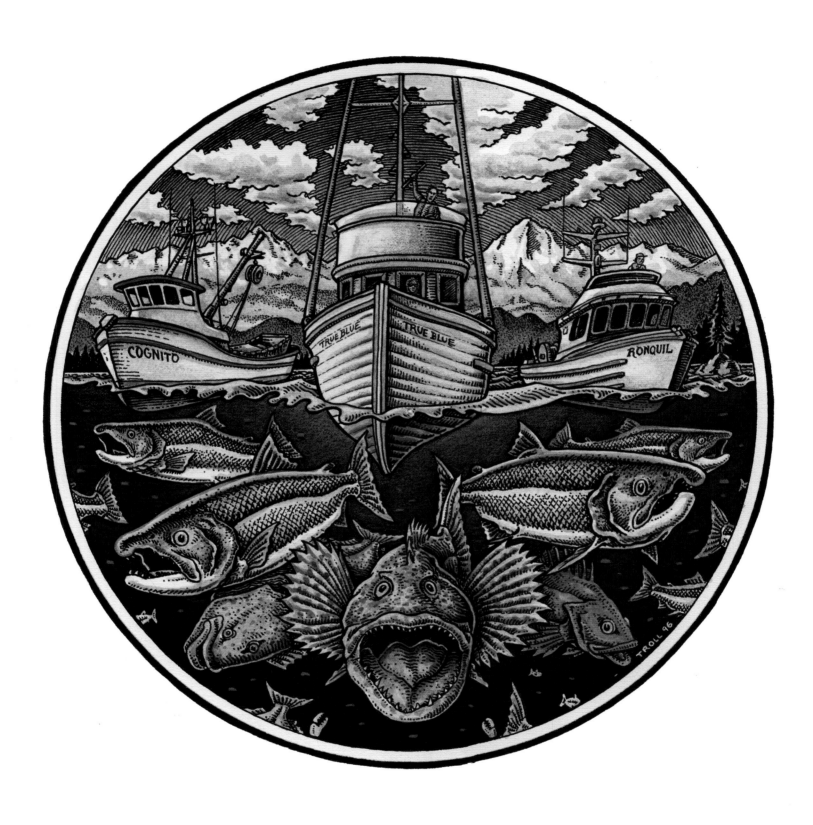

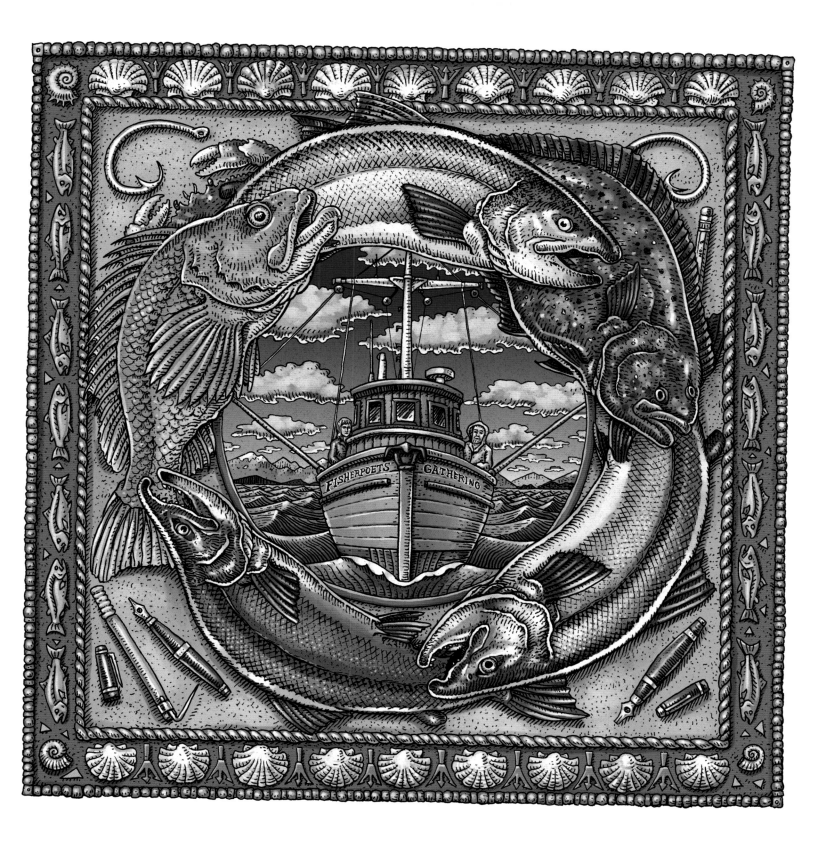

Our Life is the Sea/Fisher Poets Gathering Logo

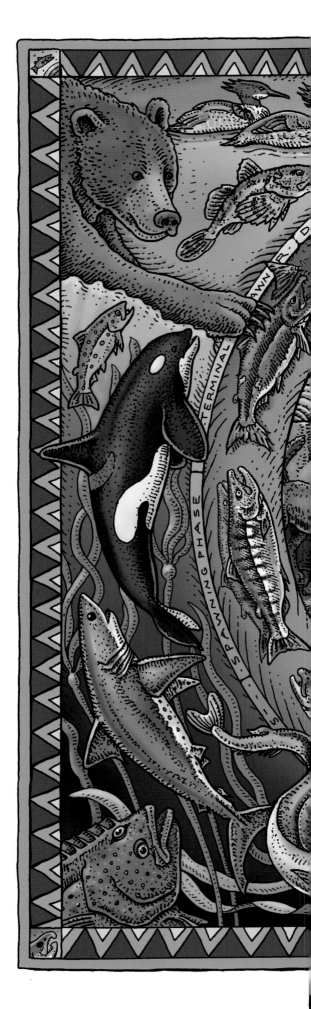

Salmon Life Cycle, *created with Karen Lybrand for the Ocean Hall of the Smithsonian National Museum of Natural History*

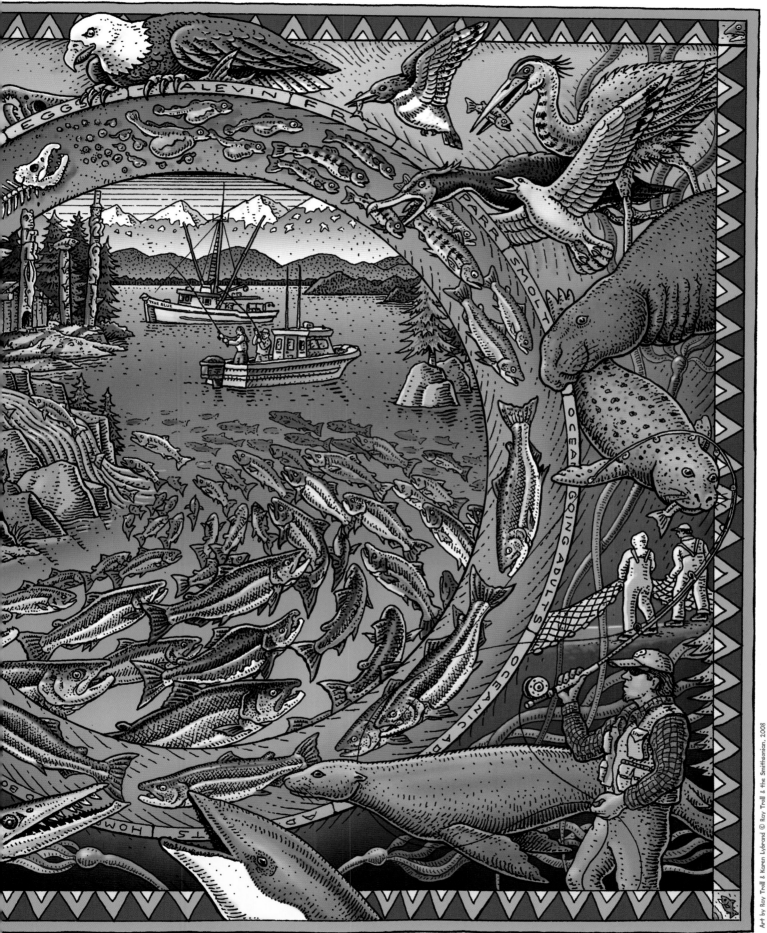

EGGS ALEVIN FRY PARR SMOLT OCEAN GOING ADULTS OCEANIC AD

TRUE BLUE

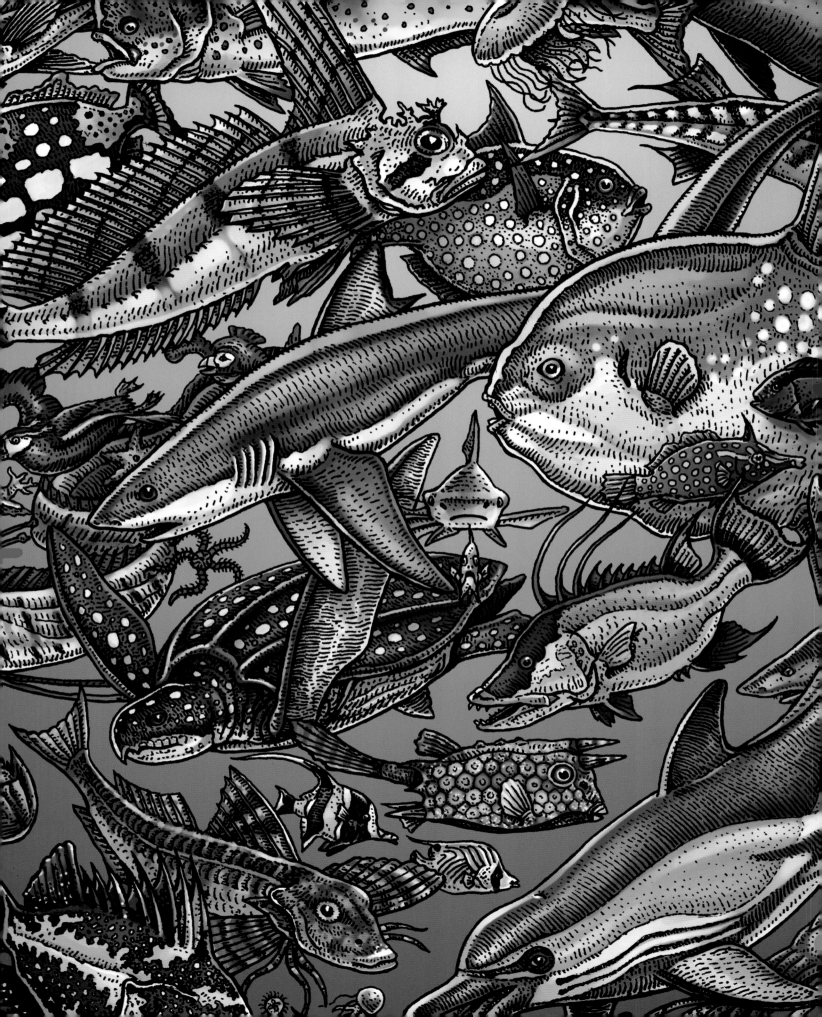

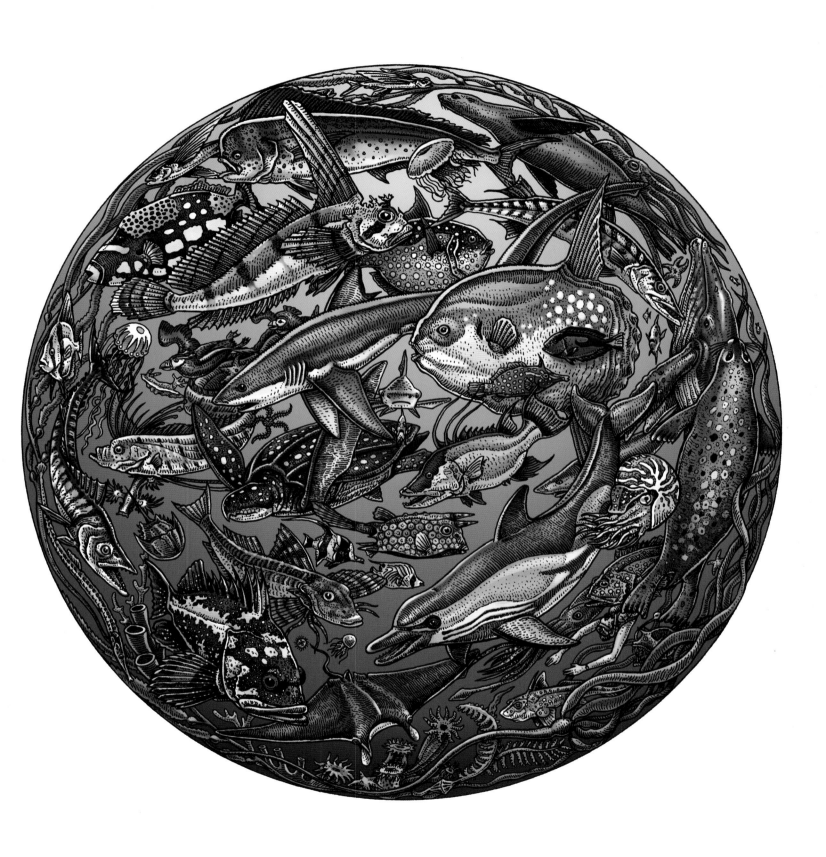

Planet Ocean

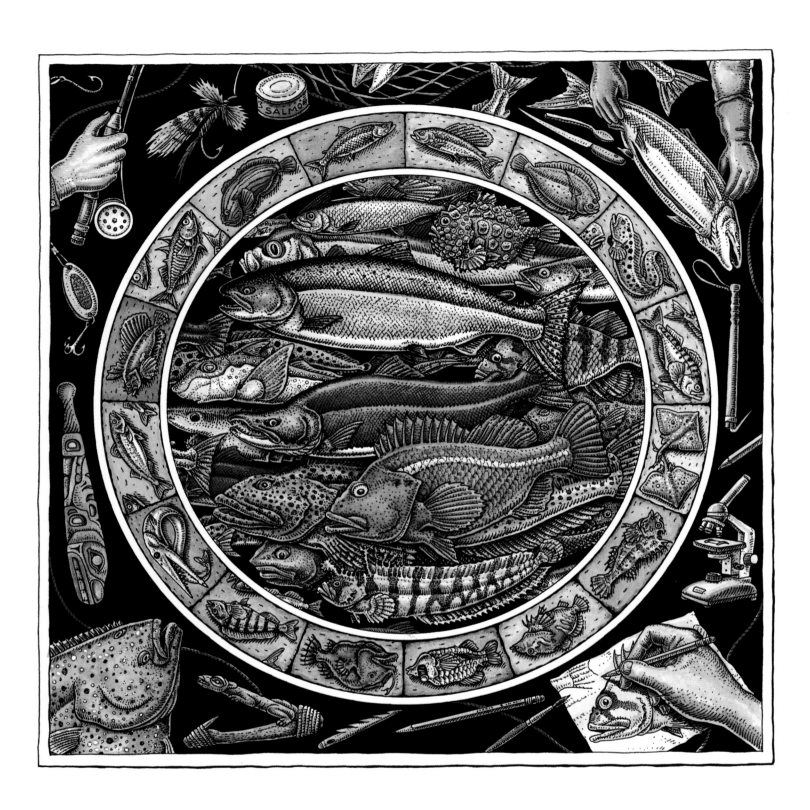

Live to Fish, Fish to Live, *created for the 2005 American Fisheries Society Annual Meeting*

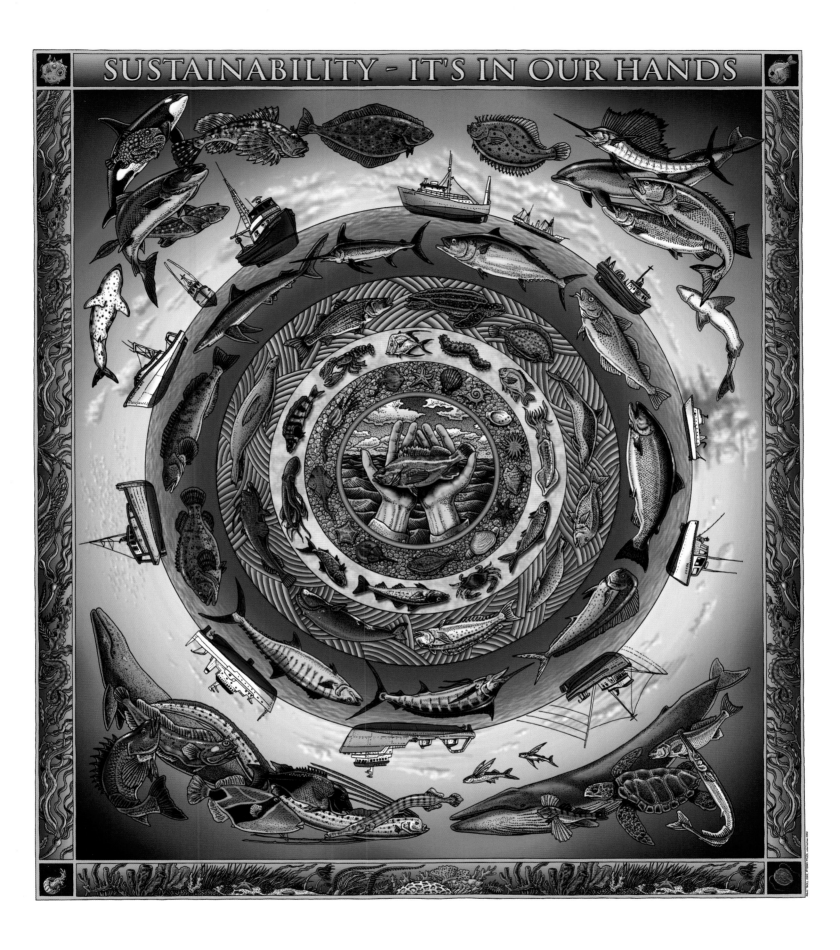

Substainablity, created with Terry Pyles for the National Oceanic and Atmospheric Administration sustainable fisheries program, 2002

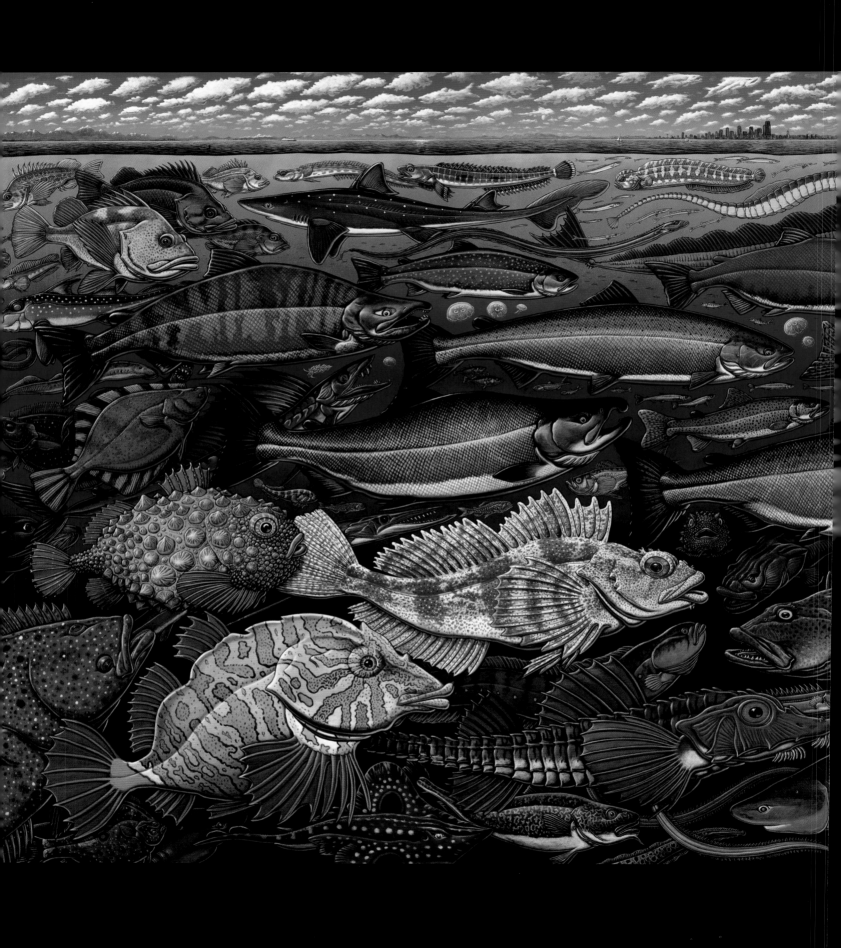

214

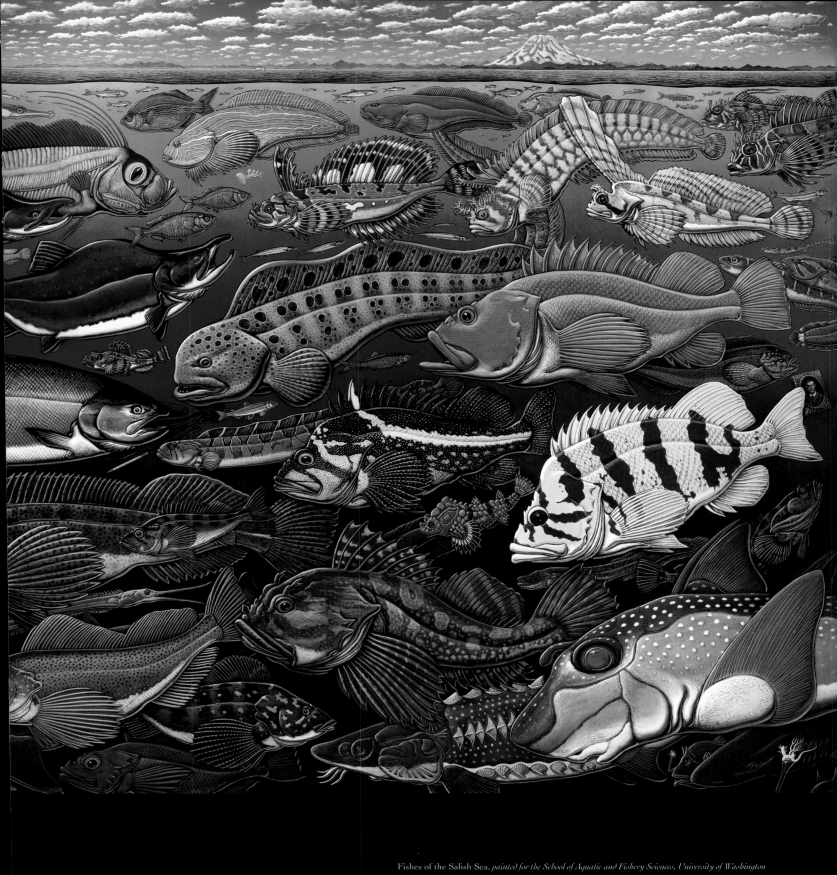

Fishes of the Salish Sea, *painted for the School of Aquatic and Fishery Sciences, University of Washington*

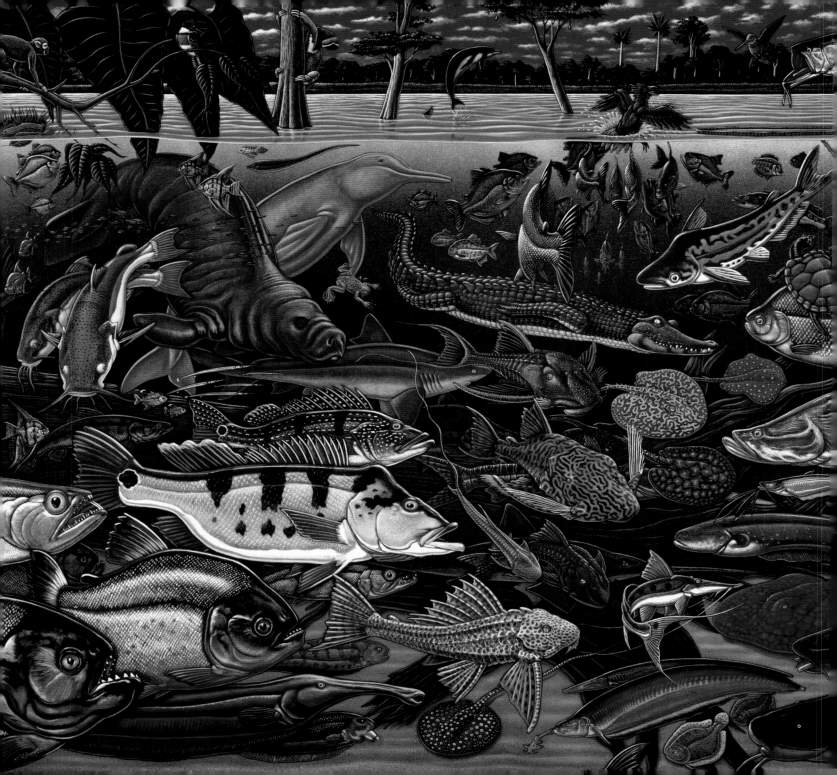

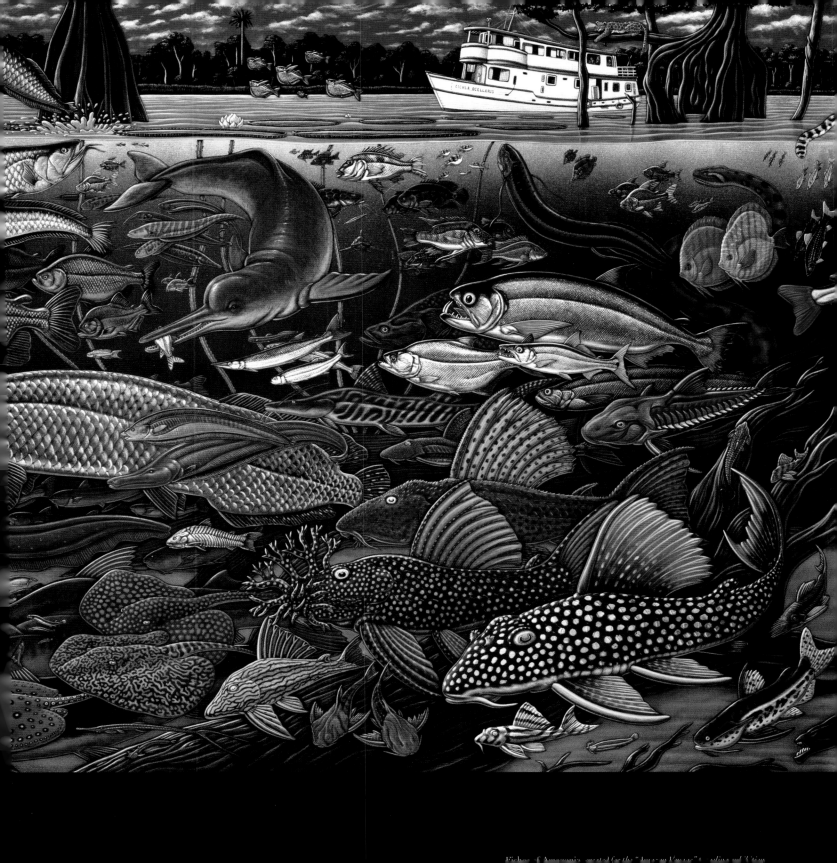

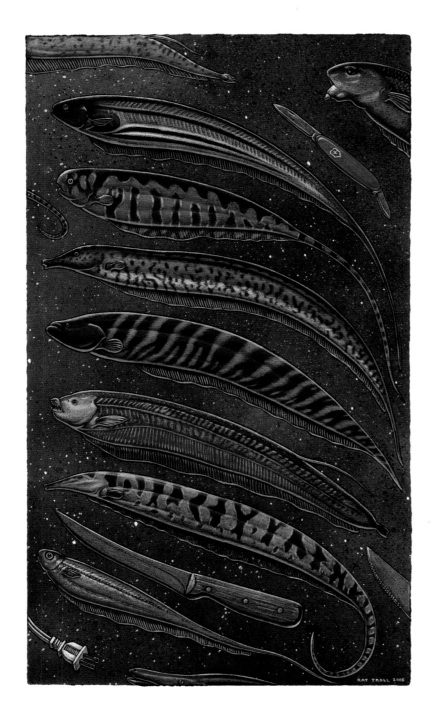

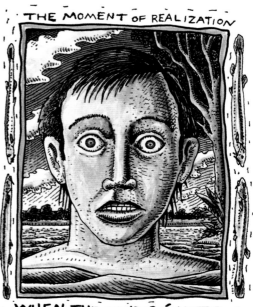

THE MOMENT OF REALIZATION

WHEN THE CANDIRÚ HITS

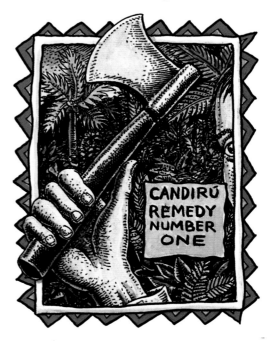

CANDIRÚ REMEDY NUMBER ONE

LEFT: Electric Knife Fish

THE SEVEN PLAGUES OF THE AMAZON RIVER

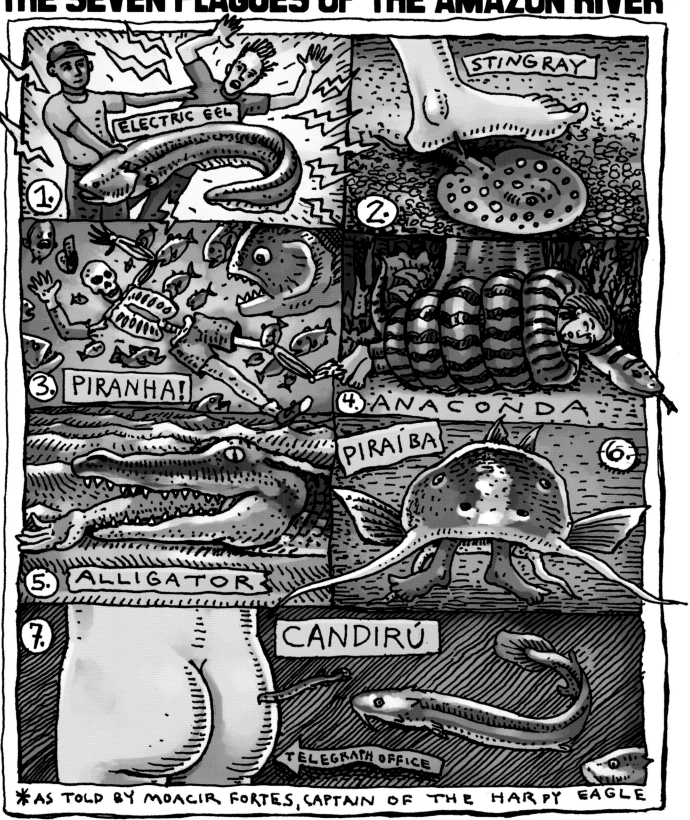

FOLLOWING SPREAD: Swimming with the Tetras

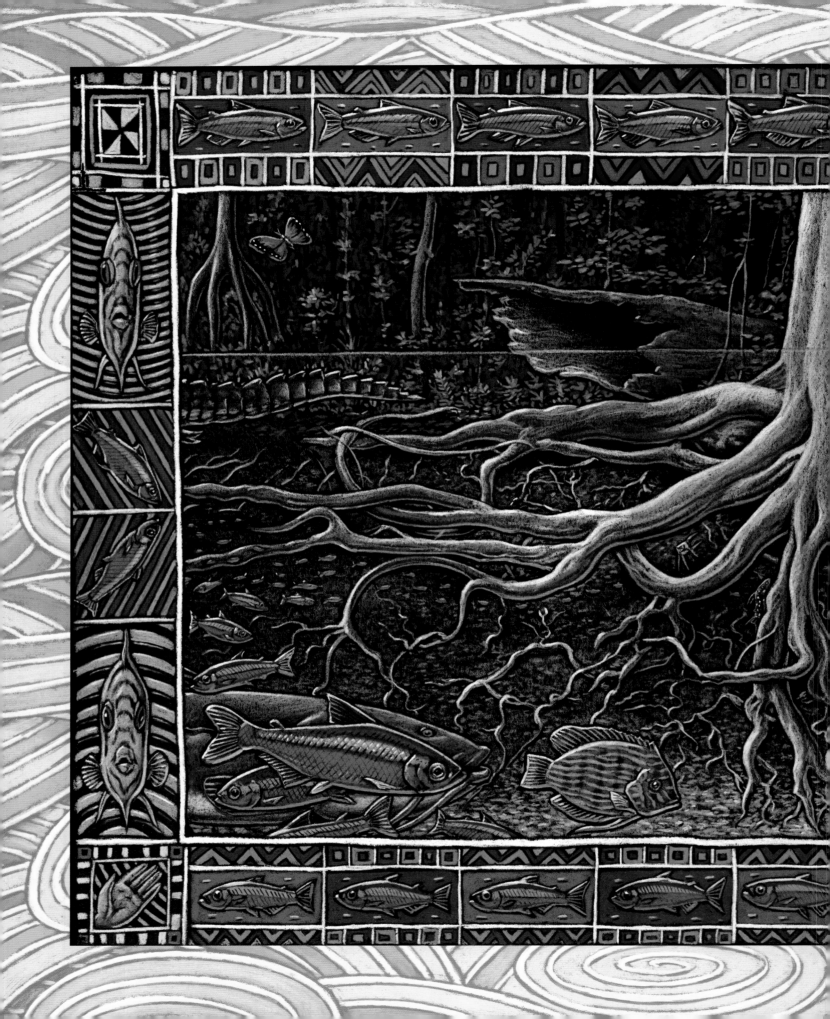

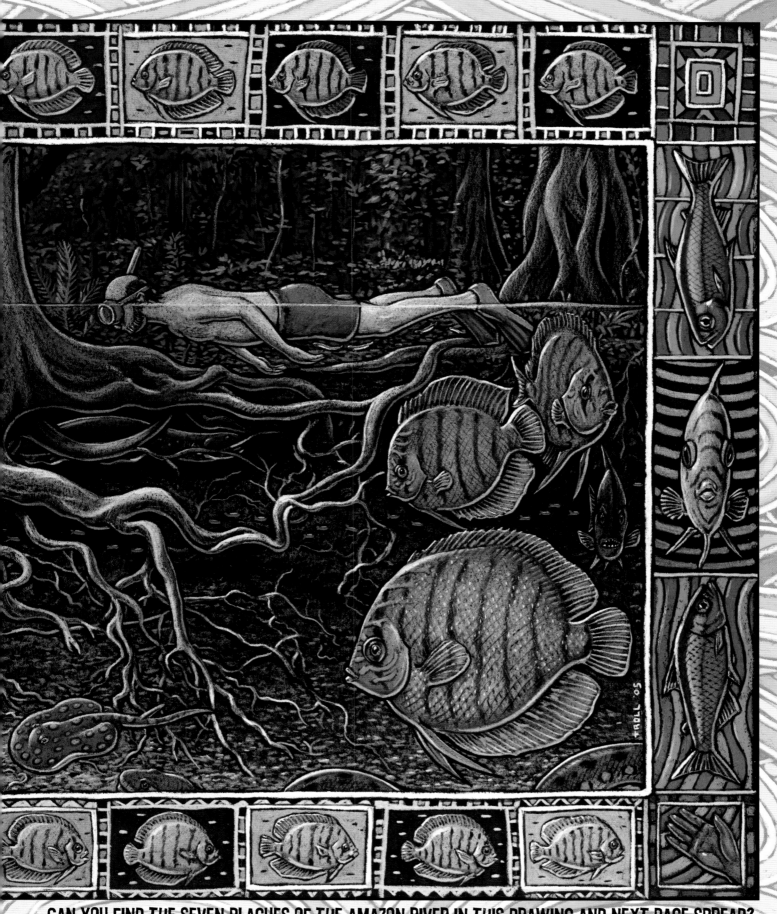

CAN YOU FIND THE SEVEN PLAGUES OF THE AMAZON RIVER IN THIS DRAWING AND NEXT PAGE SPREAD?

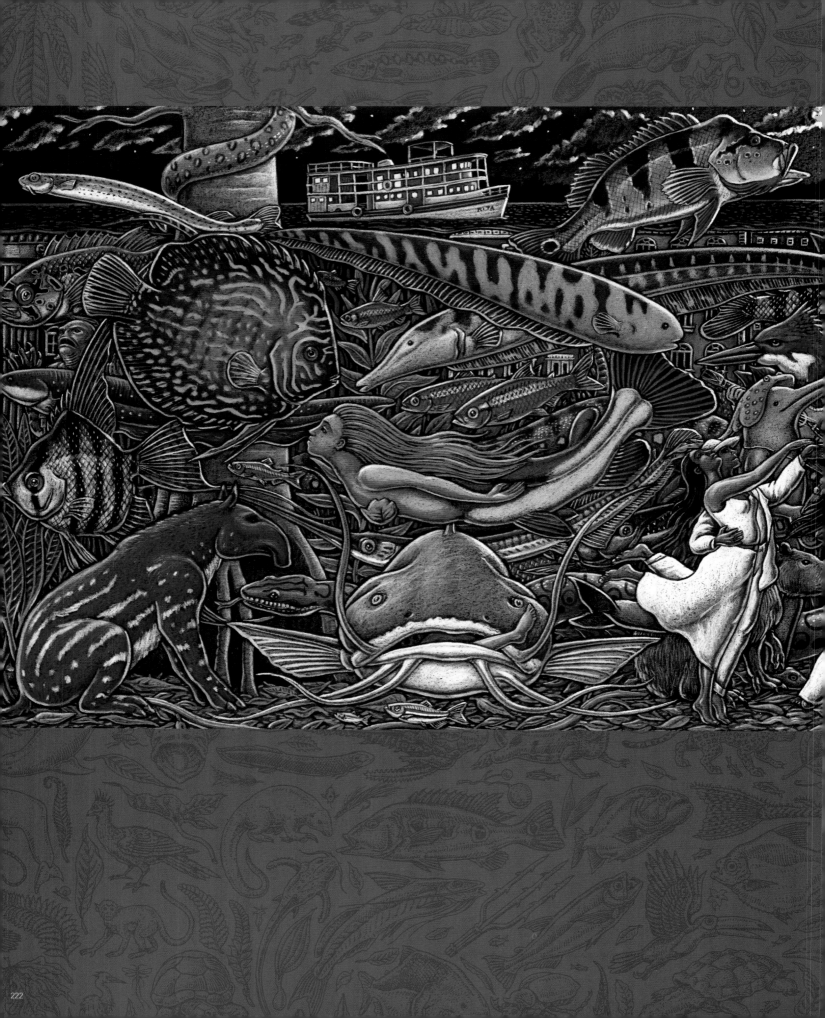

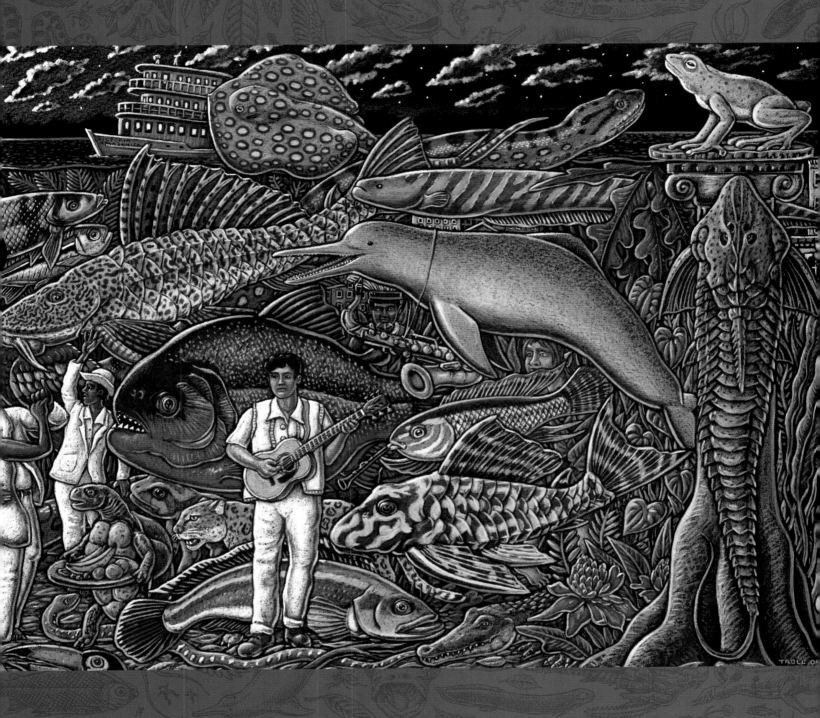

The Encante

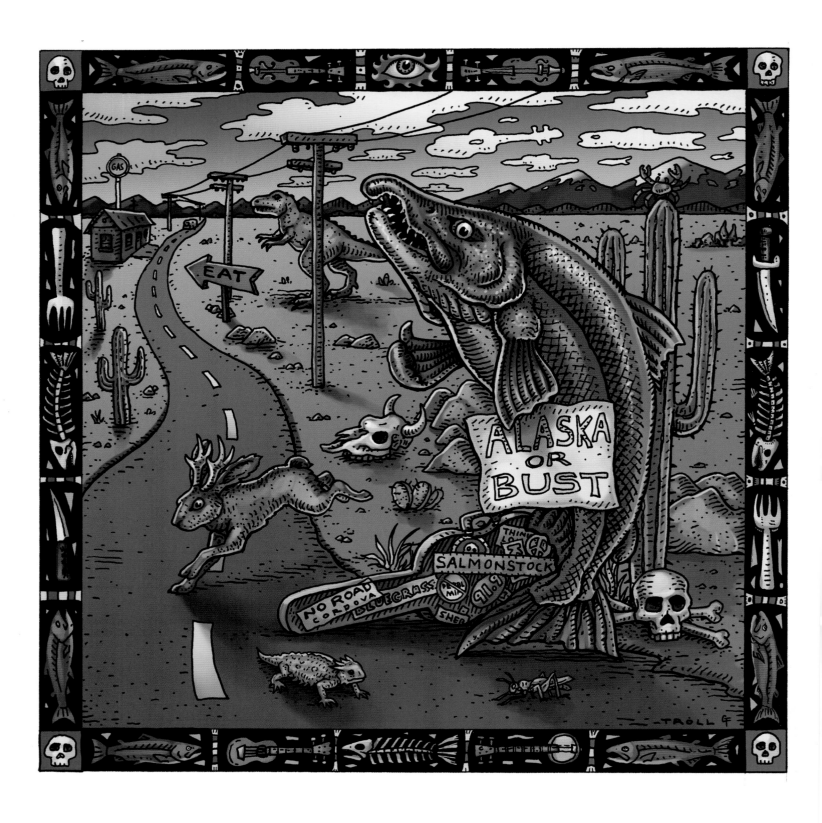

Homeward Bound

A note about the media:

Over the years I've used all kinds of materials to create my imagery, starting out with crayons as a kid, and moving on to pen and ink, graphite pencils, charcoal, colored pencils, oil pastels, chalk pastels, linocuts, scratchboard, serigraphs, watercolors, etchings, acrylic, alkyd and oil paint, spray paint, and just about anything I could get my hands on. With the advent of computer technology, I taught myself Photoshop and began to use it in combination with my pen-and-ink drawings. I found that I can only spend so much time in front of a flickering computer screen. I'm much happier in the analog world making a mess of things out in my studio. With that in mind I began working with younger, more digitally savvy artists like Grace and Memo, who've brought a whole new palette and vibrancy to my art. I am a true mixed media hopper, jumping back and forth as the decades flow by. The whole gamut is in this book, 40 years, worth, starting out when I hit the shores of Alaska in 1983 up to 2023.

Acknowledgments

I'm fond of saying that everyone should be in a band. Being part of a creative collaboration—making music or art together—is a profoundly rewarding and joyful experience that has been at the heart of my own life's work. With that in mind, let me express my gratitude to the members of the band that helped make this book, the art, and my life happen.

Thanks to Robbie Robbins and Hank Kanalz at Clover Press books for taking on this project and doing such a beautiful job of bringing it all together.

I owe a lot to the talented people who enriched my images with their own artistry. Grace Freeman did the digital coloring for many of my insanely detailed pen-and-inks over the years, and I am eternally grateful for her amazing work. Memo Juargeui has also lent a talented digital coloring hand to some of the more psychedelic-looking pieces. Karen Lybrand and I worked together on creating the salmon-themed artwork for the Ocean Hall at the Smithsonian Museum of Natural History. Fellow Ketchikan artist Terry Pyles did the digital coloring on the NOAA sustainable fisheries poster. David Rubin helped put the finishing touches on the massive Deep Forest oil painting.

Many thanks to David Craig and Brad Matsen for their insightful, amusing introductory essays. Brad's inspiring words, wise counsel, and enduring friendship over the years have helped keep me walking the artist's path.

I'm indebted to my good friend Kirk Johnson, who opened my eyes to the wonders of the prehistoric past and the deep history of our planet. Claudia Bach's inspiring advice at critical times in my career have made a huge difference for me. Gary Staab has collaborated with me a number of times in making my bigger exhibits come alive with his incredible sculptures. My late artist friends Sean Duran, Marvin Oliver, and Sid Garrison are forever a part of my creative DNA.

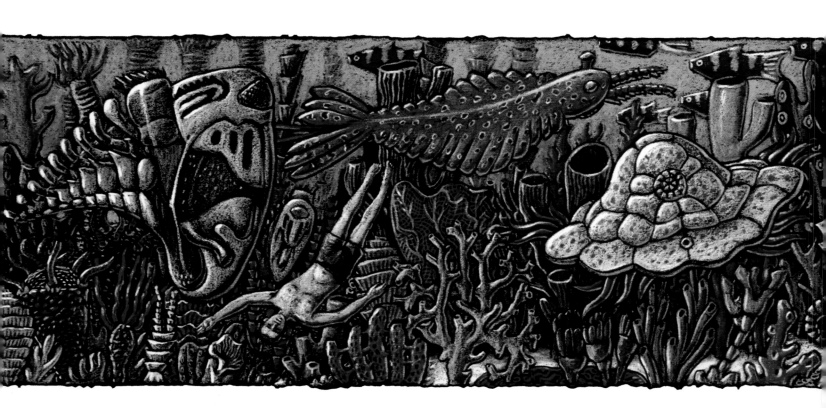

I owe enormous debts to my generous teachers over the years. Jim and Jo Hockenhull, Don Osborn, Bob Bosco, Linda Okazaki, Pat Siler, and Gaylen Hanson showed me that making art is a fulfilling way of life. I'm grateful for my friendships, endless conversations, and joyful work with countless other people, including Hall Anderson, John Straley, Bill Curtsinger, David Strassman, Nathan Jackson, Donny Varnell, Tommy Joseph, Frank Boyden, Jan Eddy, Marlene Blessing, Chuck Bonner, Tom Fowler, Marsha Howe, Joan Kimball, Evon Zerbetz, and Susan Ewing.

A full-hearted shout out to my beloved rock and roll band, the Ratfish Wranglers, my ratfish brother Russell Wodehouse, diva extraordinaire Shauna Lee, bass savant Chazz Gist, guitar god Brian Curtis, and my favorite drummer, Patrick.

Kudos and gratitude to Skip and Marie Jensen, who've run Post Industrial Press in Tacoma and printed thousands of my shirts over the last 25 years. Their craftsmanship and dedication to the art of screen printing have no equal.

My art and my life were able to happen at all because I had the love and support of my family, Michelle, Corinna, Patrick, and all my wonderful brothers and sisters.

I owe a lot to the town of Ketchikan, where I first found an audience for my offbeat work. I've been lucky enough to make a living in this beautiful seaside haven in the rainforest, the ancestral home of the Tlingit people and the shared waters of the Haida and Tshimshian. Alaska and all its wonders have been endlessly inspiring for me. Many, many thanks to the hardworking crew at the Soho Coho, our little gallery on a salmon-spawning creek for thirty-one years.

I am humbly most grateful to you. Yes, you. And to everyone who has acquired a painting, a drawing, a poster, a book, or a wearable rendition of my art over the years.

And, finally, I want to say, "Thanks for all the fish."

Ray Troll

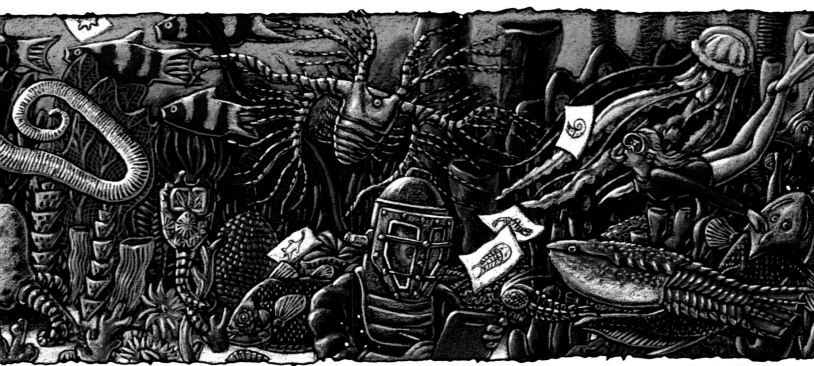

Deep Time Diver

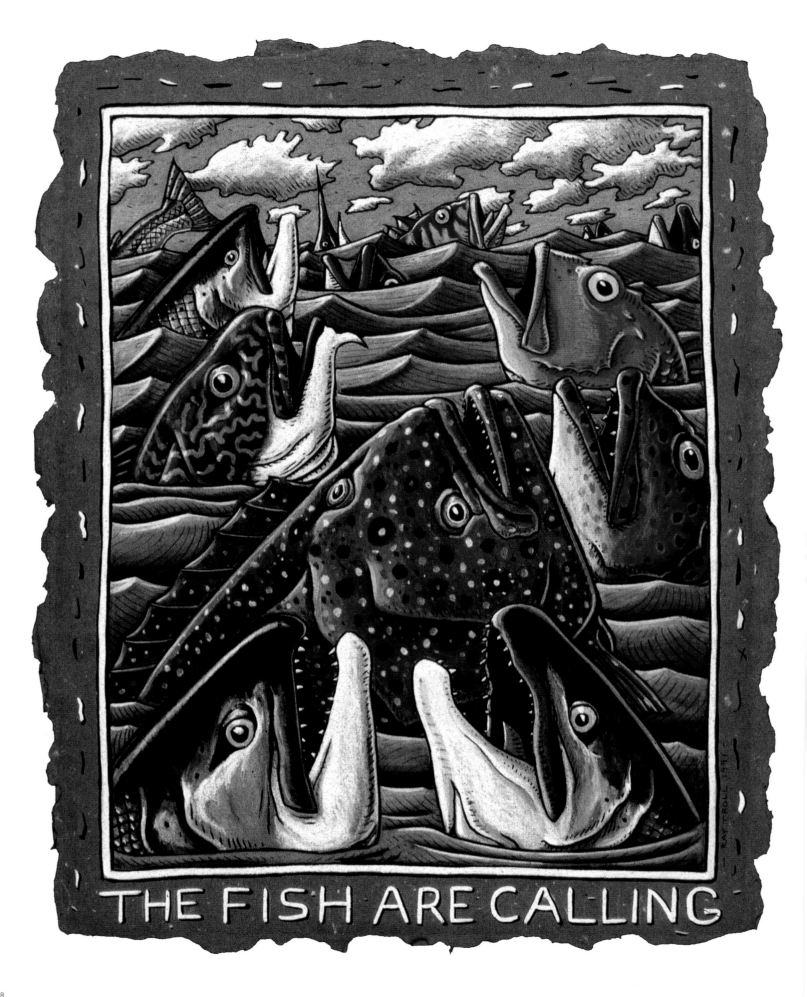

From the Artist

Moving to Alaska in 1983 exposed me to the forces of the natural world, changed my life, and transformed my art. Living on the edge of the Tongass National Forest with deep woods on one side and the deep ocean on the other is magical for me and informs my art like no other influence. It fueled my creative spirit and filled me with an urge to try and translate the raw power of the wild natural world to paper and canvas. Oddly enough, fish became my emissaries to that world.

It's fairly obvious when looking at my work that I'm obsessed with the creatures of the watery realm of our planet, but why? It's hard to explain an obsession rationally and I've been asked countless times. In short, I say, I find the fish fascinating and with over 25,000 living species to choose from, the selection is inexhaustible. I also say that sea creatures have become vehicles for my moods, my thoughts, and my opinions about the human condition and our own place in the grand biological scheme of things. Sometimes whimsical, sometimes menacing and edgy, the fish lead me on, diving deeper into creative explorations.

As I spent more time in the aquatic wonderland, my curiosities led me to befriend scientists and writers. I came to realize that scientific inquiry and artistic inquiry overlap beautifully, as both disciplines seek to "know the world" in complex and elegant ways. I've embarked on many an adventure since then and have found myself in some pretty strange places—crawling around on my hands and knees looking for trilobite fossils on a tiny Southeast Alaskan island or deep in the Amazon rainforest wrestling caimans at night. My creative batteries have been endlessly recharged by these associations with my scientist pals. The crosscurrents between art, science, music, and literature are the waters in which I prefer to swim.

I've also found it immensely gratifying to share my sense of artistic adventure with other inspired adventurers through collaborative art projects, exhibits, lectures, performance events, and books. It is especially rewarding to pass that sense of wonder and delight on to the next generation when I speak and teach at schools and universities. Those connections make my engagement with fish, science, and the natural world resonate beyond my own obsessions, for which I am eternally grateful.

Ray Troll

Past and Present Venues Exhibiting Ray Troll Art

ALASKA
Alaska State Museum, Juneau
Anchorage Museum at Rasmuson Center
SeaLife Center, Seward
Tongass Historical Museum, Ketchikan
University of Alaska Southeast, Juneau

CALIFORNIA
California Academy of Sciences, San Francisco
Former National Oceanic and Atmospheric Administration building, Pacific Grove
Monterey Bay Aquarium
Oakland Museum
Pacific Grove Museum of Natural History

COLORADO
Denver Museum of Nature and Science

FLORIDA
Florida Museum of Natural History, Gainesville
Phillip & Patricia Frost Museum of Science, Miami

IDAHO
Idaho Museum of Natural History, Pocatello

KANSAS
Sternberg Museum of Natural History, Hays
Birger Sandzén Memorial Art Gallery, Lindsborg

MARLYLAND
Calvert Marine Museum, Solomons

NEBRASKA
Hastings Museum, Hastings

NEW YORK
Museum of the Earth, Ithaca

MINNESOTA
Science Museum of Minnesota, St. Paul

MONTANA
Museum of the Rockies, Bozeman

OHIO
Cleveland Museum of Natural History

OREGON
High Desert Museum, Bend
Museum of Natural and Cultural History, Eugene
Oregon Coast Aquarium, Newport
Oregon Museum of Science and Industry, Portland

PENNSYLVANIA
Academy of Natural Sciences, Philadelphia
Carnegie Museum of Natural History, Pittsburgh

TEXAS
Museum of the Gulf Coast, Port Arthur
Texas Memorial Museum, Austin

WASHINGTON
Burke Museum, Seattle
Point Defiance Zoo and Aquarium, Tacoma
Seattle Aquarium

WASHINGTON, D.C.
Smithsonian Institution International Gallery

CANADA
Royal Botanical Gardens, Ontario

ENGLAND
Horniman Museum and Gardens, London

ITALY
Darwin-Dohrn Museum, Naples

Ray Troll Biography

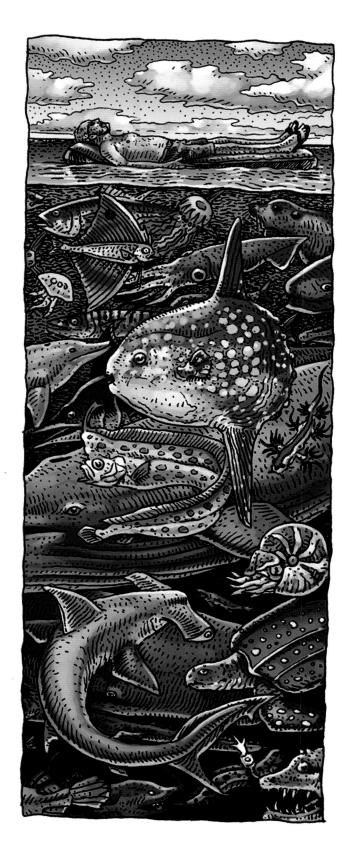

RAY TROLL is a world-renowned artist known for his scientifically accurate and often humorous artwork, inspired by fieldwork and research in marine science, paleontology, geology, ecology, and evolutionary biology. Ray's renditions of everything from modern-day salmon and marine mammals to bizarre creatures of the prehistoric past have become iconic in fishing, scientific, and environmental activist communities around the world.

His work, distributed from the Soho Coho Art Gallery in Ketchikan, Alaska, can be found on posters, hoodies, and millions of T-shirts sported by fisherfolk, the occasional celebrity, and many others. Ray's paintings and mixed-media drawings are in the collections of the Miami Museum of Science, the Burke Museum of Natural History and Culture, Alaska Airlines, the Anchorage Museum, the Alaska State Museum, the Ketchikan Museum, and elsewhere. His books include *Sharkabet: a Sea of Sharks from A to Z* and *Cruisin' the Fossil Coastline* and *Cruisin' the Fossil Freeway* with Dr. Kirk Johnson, now director of the Smithsonian National Museum of Natural History, for which Ray and Kirk were awarded a Guggenheim Fellowship. He and Port Townsend writer Brad Matsen produced four popular books: *Shocking Fish Tales*, *Planet Ocean*, *Raptors, Fossil, Fins, and Fangs*, and *Rapture of the Deep*.

Ray's recent ventures include cohosting the popular *Paleo Nerds* podcast, featuring informative and amusing interviews with leading paleontologists and scientists from around the world. He is the recipient of a gold medal for distinction in the natural history arts by the Academy of Natural Sciences in Philadelphia, a Rasmuson Foundation Distinguished Artist Award, and the Alaska Governor's award for the arts.

Troll has a ratfish species and an extinct genus of extinct round-bellied herring named for him. He also plays ichthyo-centirc rock n' roll music with his band, the Ratfish Wranglers.

FIN

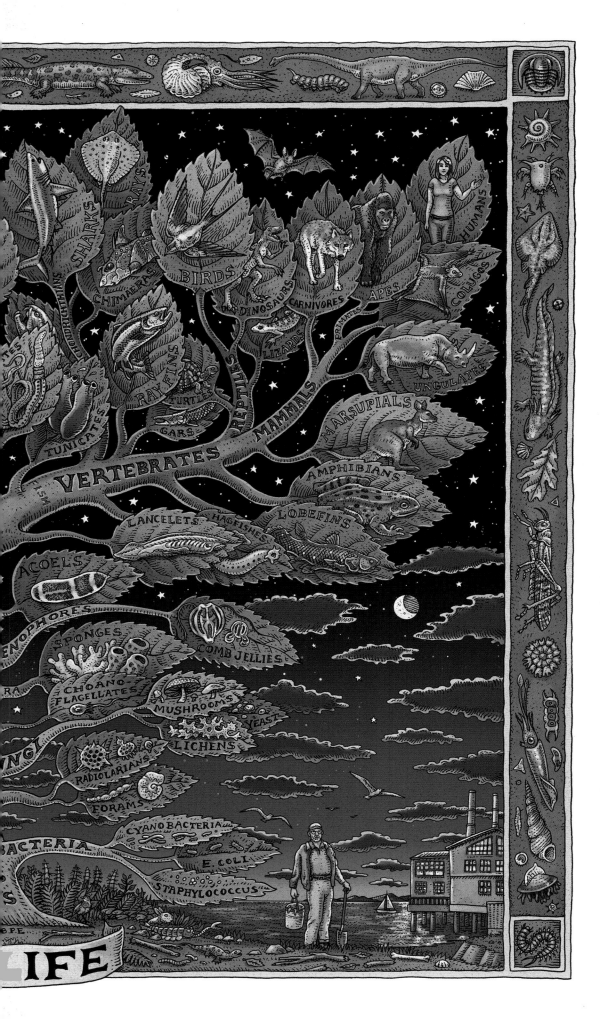

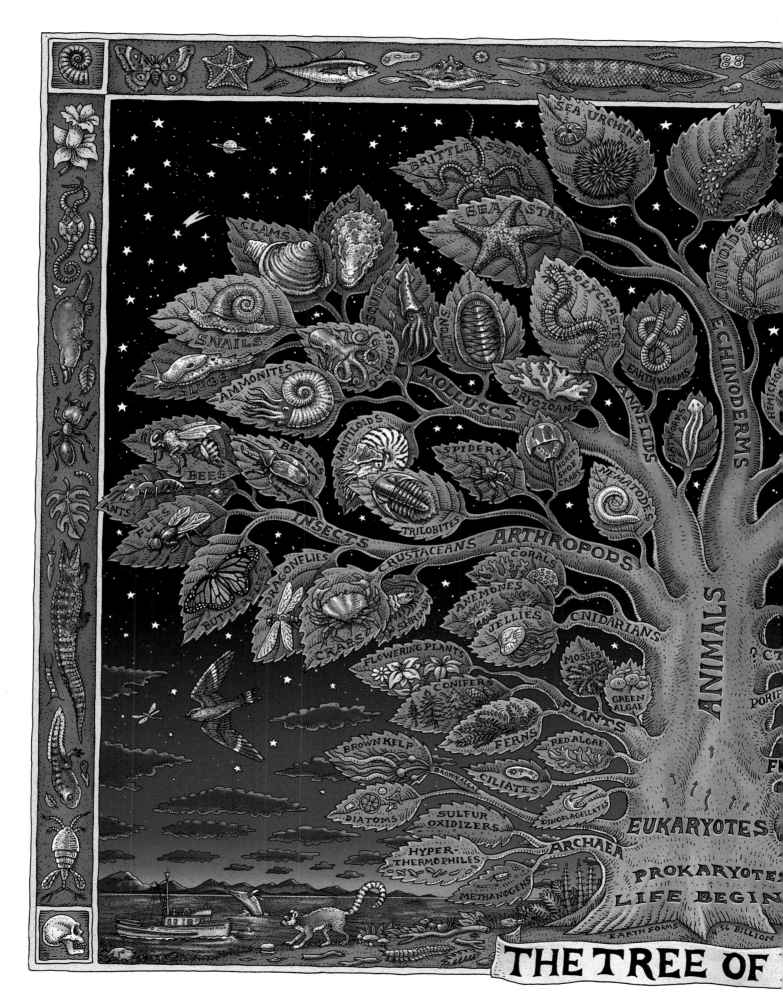

THE TREE OF

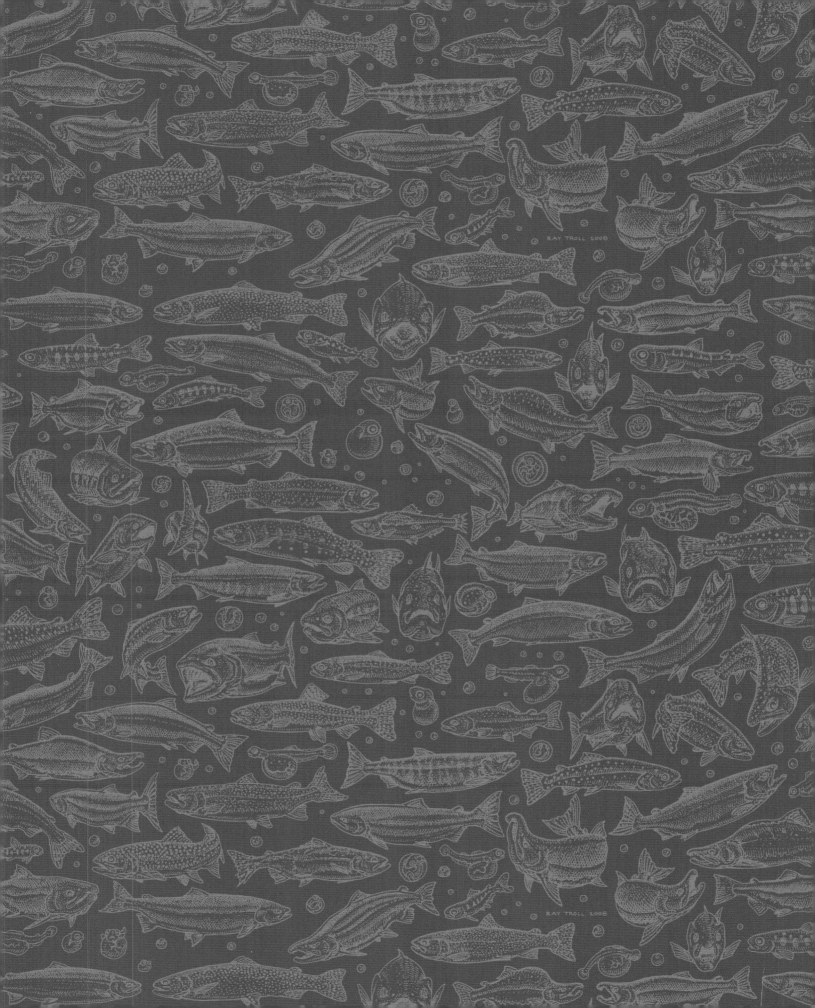